VERMEER

VERMEER

by

LAWRENCE GOWING

University of California Press

Berkeley Los Angeles

University of California Press
Berkeley and Los Angeles, California

Published by arrangement with Giles de la Mare Publishers Ltd.

Library of Congress Cataloging-in-Publication Data:

Gowing, Lawrence.
Vermeer / by Lawrence Gowing.
256 p.22.3 cm.
Originally published: London: Faber and Faber, 1952.
Includes bibliographical references and Index.
ISBN 0-520-21276-2 (alk. paper)
1. Vermeer, Johannes, 1632-1675. 2. Painters-Netherlands-
Biography. 1. Vermeer, Johannes, 1632-1675. 11. Title.
ND653.V5G6 1997
759.9492-dc21
[B] 97-20774
CIP

Printed in Hong Kong
by Colorcraft Limited
9 8 7 6 5 4 3 2 1

PREFACE

There are writings on art which are destined to remain valid, even when the evidence on which they were originally based has meanwhile been revised or expanded. One thinks of Walter Pater's essay on Giorgione, or Jakob Burckhardt's *Recollections of Rubens*, works of art in their own right which have vitally contributed to our perception of these masters. Lawrence Gowing's monograph on Vermeer of 1952 belongs to this class. No doubt the intensity of his personal response stems from his own experience as a painter who was deeply committed to the contest with appearances. Thus Vermeer's art that had looked to earlier observers like the cool and objective record of visual truth was suddenly revealed to us in all its emotional complexity. This multi-layered reading of the oeuvre surely remains unaffected by the progressive expansion of our knowledge that has occurred in the intervening years.

There are two such events in what the Italians would call the *fortuna critica* of Vermeer, which must here be mentioned. The first is the publication in 1989 of the book by Montias, whose archival studies have completely transformed our knowledge of the artist's milieu. We are lucky to have Gowing's reaction and assessment of this remarkable contribution in a review he wrote for the *Times Literary Supplement*, which has been included in this volume. Sadly, he did not live to experience Vermeer's ultimate apotheosis in the 1995-6 exhibitions of Washington and The Hague, which not only attracted enormous crowds but also left a permanent record in the form of a scholarly catalogue, in which the problems of attributions inevitably were once more aired. The two problematic works in Washington, *A Girl with a Red Hat* and *A Girl with a Flute*, also puzzled Lawrence Gowing, who had difficulties in making up his mind. Like the authors of the catalogue, he finally accepted the authenticity of the first, but questioned the second.

Art lovers may also remember, gratefully, that in the last years of his life,

Gowing added to his accomplishments the production of a series of television films on artists close to his heart. His programme on Vermeer is now also commercially available as a video, but for all the stimulation we owe to these new media, the old Latin tag *scripta manent* still applies.

London, December 1996 E. H. Gombrich

CONTENTS

PUBLISHER'S NOTE TO THIRD EDITION
(1997)

We are delighted to be reissuing Lawrence Gowing's *Vermeer* as a paperback for the first time in this third, updated edition. Jenny Gowing, his widow, has said that Lawrence Gowing told her he considered it to be his most important work. That judgment is all the more remarkable when one takes into account the multiplicity and outstanding quality of his work overall.

Lawrence Gowing's view of the state of Vermeer studies shortly before his death in 1991 is conveyed in a substantial piece he wrote for the *Times Literary Supplement* about *Vermeer and His Milieu: A Web of Social History* by J.M. Montias, which we have included. To bring the book up to date, changes in the ownership of pictures since 1970 have been incorporated and a brief bibliography of relevant literature published since that date has been added. The illustrations have been freshly reproduced direct from photographs.

We are extremely grateful to Professor Sir Ernst Gombrich for contributing a preface to introduce the book to a new generation of readers.

AUTHOR'S NOTE TO SECOND EDITION
(1970)

In this new edition no attempt has been made to alter or enlarge the view of the artist that the book recorded. Changes in the ownership of Vermeer's pictures are noted and a number of mistakes have been corrected. The opportunity has been taken to illustrate and list a further work which appears to be from his hand, perhaps the latest that we know (Plate 80). The essay that prompted the present study and continual help were due to Benedict Nicolson, and this book is dedicated to him. The writer owes much beyond thanks to the generous help of many friends, in particular to John Pope-Hennessy, Sir Kenneth Clark, E.H. Gombrich, and Adrian Stokes in England, and in Holland to H. Gerson, S. G. Gudlaugsson and, most tolerant of listeners, Professor Van Regteren Altena.

PLATES
PAINTINGS BY VERMEER

COLOUR
(between pages 24 and 25)

MONOCHROME

[1]

[3]

ILLUSTRATIONS IN THE TEXT
OF WORKS BY OTHER ARTISTS

ACKNOWLEDGMENTS TO THIRD EDITION (1997)

Thanks are due to the following museums and collectors for kind permission to reproduce works in their possession: Museum of Fine Arts, Boston, and M. Theresa B. Hopkins Fund, © Courtesy Museum of Fine Arts, Boston; Department of Prints and Drawings, British Museum, London (copyright © British Museum); Baron Brukenthal Museum, Sibiu, Romania; Isabella Stewart Gardner Museum, Boston; Iveagh Bequest, Kenwood, London (English Heritage Photographic Library); Kunsthistorisches Museum, Vienna; Musée du Louvre, Paris (© Photo RMN - R. G. Ojeda); Konincklijk Kabinet van Schilderijen Mauritshuis and Stichting Vrienden van Het Mauritshuis, The Hague (Photographic © Mauritshuis, The Hague, inv. nrs. 670, 564); National Gallery, London (reproduction by courtesy of the Trustees, National Gallery, London); The Trustees of the National Gallery of Art, Washington, D.C. (Widener Collection, © 1997 Board of Trustees, National Gallery of Art, Washington); National Gallery of Ireland, Dublin (reproduction of *A Lady Writing a Letter with her Maid* by Vermeer by courtesy of the National Gallery of Ireland); Rijksmuseum, Amsterdam; and for the generous assistance of the staff and libraries of the following institutions: Ashmolean Museum, Oxford; Department of Prints and Drawings, British Museum, London; Courtauld Institute, and Witt Library, London; Institut Néerlandais, Paris; Département des Peintures, and Département des Arts Graphiques, Musée du Louvre, Paris; Kunsthistorisches Museum, Vienna; Rembrandt Research Project, Amsterdam; Rijksbureau voor Kunsthistorische Documentatie, The Hague; Royal Academy of Arts, London; University of California at Santa Barbara, California; Warburg Institute, and Photo Collection, London. To the following organizations and individuals grateful thanks are expressed: the staff of Messrs. Christie's in Amsterdam, London, New York and Paris; *Times Literary Supplement*; English Heritage Photographic Library, London; Prudence Cuming Associates Ltd, London; Mme Catherine Belanger; Barbara Bernard; Holly Eley; Jennifer Fletcher; Dr. Enriqueta Harris; David Lewis; Alexandru Lunghu; Mary McFeely; Dr. Elizabeth McGrath; Mme Sanda Marta; Karen Otis; Martin Royalton-Kisch; Sybilla Russell; Dr. Wilfried Seipel; Frances Smythe; Adele Stevens; Dr. Paul Taylor; Barbara Thompson; Mme Van der Pol; Eve Poland; Professor Christopher White; Christopher Wright; and in particular to Mr. Kotting of the Rijksbureau voor Kunsthistorische Documentatie, The Hague, to Dr. Ann Jensen Adams of the University of California at Santa Barbara, California; and especially to Professor Sir Ernst Gombrich, OM, CBE, for unstinting and generous help and encouragement throughout.

ACKNOWLEDGMENTS TO SECOND EDITION (1970)

The Music Lesson is reproduced by gracious permission of Her Majesty The Queen. Thanks are due to the museums and collectors who have allowed their pictures to be illustrated, among others to the Chairman of the National Gallery of Art, Washington, and to the authorities at Brunswick and Valenciennes who gave special facilities in time of emergency under difficult conditions, and to the following: A.C.L., Brussels; Alinari, Florence; Archives Photographiques, Paris; Bruckmann, Munich; Dingian, The Hague; G. Schwarz, Berlin; R. F. Fleming, W. F. Mansell and Rotary Photographic, London, and in particular to the Rijksbureau voor Kunsthistorische Documentatie at The Hague. Apologies must be tendered to those owners of pictures with whom it has unfortunately proved impossible to communicate.

COUNTERFEITER OF GRACE

REVIEW BY LAWRENCE GOWING OF
VERMEER AND HIS MILIEU: A WEB OF SOCIAL HISTORY
BY JOHN MICHAEL MONTIAS

The prospects of shedding documentary light on the life of a painter as widely studied as Vermeer are not on the surface encouraging. From the 1870s onwards the archives were sifted unremittingly. John Michael Montias, an art-loving economist at Yale University, recounts that initially he believed that all the information about Vermeer must already have been extracted; this impression persuaded him to limit himself to the socio-economic purview of his previous book, *Artists and Artisans in Delft*. Nearly forty years ago I too concluded that 'there were no better archivists than the Dutch', and I saw no necessity to follow in their tracks. We could have no idea how wrong we were.

The returns for all the research had in fact been fairly uninformative. Documents seemed to record little except the studied reticence of the painter. Archives around the beginning of the seventeenth century are in any event deceptive. Apart from the habit of going before an attorney to lend or borrow quite trifling sums, law-abiding people left only occasional traces of their existence between birth and burial. Surnames were still in flux, quite unreliably adhesive, more like nicknames attaching by facetious habit. As Martin regularly becomes Pincher, Reynier, for example, commonly became Reynard and then Vos, meaning Fox, in place, say, of Van der Minne. It was easy enough to lose track of the record of the fact that this particular Reynier, in youth apprenticed as a worker in figured silk, later kept an inn which he called The Flying Fox before removing to another called Mechelen. At Delft he enrolled in the Guild as an art dealer, apparently because the family possessed saleable pictures, and adopted for no recorded reason the common surname of Vermeer.

Having caught the scent of his quarry, the biographer can return to records whose relevance he could never have guessed and begin again. Professor Montias is a splendid exponent of this serendipitous hindsight and the past is hard put to hide what were in all truth its secrets. Even so, having located the crucial record the inquirer may arrive to find that it has been sealed on account of imminent decay, or discover it all but deleted by an elder scholar privileged to take it home and underline his hunches with blue pencil. When all obstacles are circumvented and every line, ancestral and collateral, that was eventually obscurely relevant has

[8]

been retraced it remains to re-read eighteen archives in fifteen cities. Some leads, as Montias credibly warns us, are quite tedious. But some disclose the inconceivable strangeness of the past for which one is never quite prepared.

It was well known that at twenty-one Vermeer married a Catholic girl from Gouda. The marriage was celebrated at a village an hour's walk away, for the excellent reason that Catholicism was entrenched there and aroused no particular comment. It is now apparent that through the painter's youth the whole family lived in Delft at Papists' Corner, a virtual ghetto where the concentration of the faithful in the odorous vicinity of the Small-Cattle Market and the Jesuit Church were unconcealed. At betrothal, it emerges, he went to live in the superior household of his mother-in-law, chief of the domineering women who are prominent in the story. She was at odds with her husband, Reynier Bolnes, as well as with an unbalanced and pugnacious son. Montias has found more than one blow-by-blow account of horrific marital fracas in the Bolnes household. A pregnant woman, one notices, repeatedly bore the brunt of it. It is hard not to read in these pages a commentary on the gravid women in the pictures and on the serenity that had a special value to the painter.

One of the problems of Vermeer biography has always been that there is no record of the apprenticeship which was required for membership of his guild. Disentangling the extended family that Vermeer married into, Montias has discovered that the prospective mother-in-law, Maria Thins—not a woman to lose any advantage—had a cousin, more like a close friend and avuncular supporter (he was to buy the house in which the impoverished painter ended his days), who was also a nephew of no less a personage than Abraham Bloemaert, the leading master in the Catholic city of Utrecht. Bearing in mind Vermeer's first dated picture, *The Procuress*, which is reminiscent of the convivial half-lengths in red and yellow that were among Bloemaert's staple products, but annealed in the domestic atmosphere of Delft, one can agree that Vermeer's training is no longer a problem. Reynier owned at least three Utrecht pictures before his son was born; Vermeer furnished his interiors with such things and learned from their style. But, as Montias points out, in Vermeer's essentially eclectic start, there was also room for the influence of Amsterdam. Two of the artists whom he imitated, Jacob Van Loo and Quellinus the Younger, were active there. Vermeer's *Diana* and his *Martha and Mary*, though quite specific and consistent in their several varieties of Northern Baroque, together represented in the luxurious eclecticism of the combination a phase of distinctively Amsterdam-type style-formation, so very likely Montias is not wrong in this deduction either.

[9]

Unlike most other delvers in the archives, Montias has an acute eye for the most telling because the most public of records, the pictures themselves. He reads the contents of Vermeer's interiors, the furniture, the decorations and the possessions more closely and intelligently than most critics. I am ashamed not to have noticed that the crease in the map on the wall in *The Art of Painting* bisects the country along just the significant line. The prospective mother-in-law would not give her final consent to the marriage until Vermeer had rejoined the old Church. But she agreed not to forbid the banns and the wedding took place with the veteran history painter Leonaert Bramer as witness. Montias sees no point of contact with Bramer's work; I think that the still life of instruments in his allegory of Vanity in Vienna is exactly the context in which we should read the foreground viol in *The Music Lesson.*

Two days later Vermeer himself figured as a witness in an 'act of surety' which helped to collect a debt. The other witness was Gerard Ter Borch. Ter Borch was not known ever to have been in Delft until Montias 'came across this document a few years ago'. I find in Ter Borch the only parallel to the purity of a profile like that in the Dresden *Letter Reader.* Which other painter raised realistic observation to a quality of finish like that in *The Music Lesson?* It would be hard to believe that they were unknown to each other, but it is remarkable to find them acquainted so long before Vermeer had achieved anything like the mastery that became his own. It is remarkable that Vermeer documented contacts with so wide a range of sources, in Utrecht, in the international style, in Delft and with the leader of the genre school; these sources confirm exactly the mixture at which we can guess from his pictures. Perhaps most significant, the young Vermeer's very evident aim to excel in large-scale narrative pictures on a variety of models, which led me at least to infer an element of ambition in his character, is all the more easily and happily accounted for, now that the records encourage us to trace it to an ambitious mother-in-law.

Montias's reading of the documents is remarkable in confirming from the records traits that are evident in the pictures. Vermeer's faith is twice at least apparent in the subjects of his early pictures and twice more in the art of his maturity; once, it has been considered, to its disadvantage, in the allegory of the faith in the Metropolitan Museum, which is evidently the work of a painter who found it no drawback for a subject to be conceived in the Jesuit taste. Montias believes, as I do firmly, in a recently discovered painting of a rare subject, St Praxedes wringing out her sponge in the blood of the martyrs. It is peculiar in the same way as the other very early pictures, only more so. All of them take their cue from the

example of some earlier painter, but St. Praxedes is an exact copy of a picture that is known, a work by the Florentine Baroque painter Felice Ficherelli, with only minor alterations calculated to emphasize the pietism of the subject and intensify the brilliant orange-pink colour round which the scheme revolves. The copy is so unlike any of Vermeer's mature pictures that it has been widely doubted. But it is very probable that the signature is both original and authentic; it is hard to imagine how such a picture came to be inscribed thus except autographically to record the actual authorship.

None of the early pictures is of course much like any mature or characteristic Vermeer. Their unlikeness is a constant characteristic. But not the only one. Vermeer returned often to variations on the same orange-pink colour scheme. It recurs in his first genre pieces. His figure drawing remained consistently unsophisticated until he was able to pose his genre models and paint them from nature in the tonal system that he made his own. But the subjects are recognizable as his in the early works. They nearly always involve women who are discovered crouching, stooping or kneeling in positions that convey devotion. It is only in his mature pictures, but then with a recognizable and dominant serenity, that women come to stand upright in Vermeer's art. The devotional pose, kneeling in service to the martyrs, and the lack of fluency in the figure invention are both very evident in St. Praxedes. Yet the picture would certainly never have been claimed for Vermeer if it had not borne his signature. We should consider if we know any pictures that are in this very case, pictures lacking a signature that are thus deprived of the claim to be considered in relation to the beginnings of Vermeer.

One such picture suggests itself, in its affinity to St. Praxedes. It is her natural counterpart, a tender, in fact exquisite image of the Magdalen, dressed in orange-pink, crouched at the foot of the Cross. It figured in the exhibition *Vermeer Oorsprong en Invloed* at Rotterdam in 1935. When it was seen to be unlike Vermeer's characteristic work it was never, I think, considered in relation to him again. But it is not at all unlike St. Praxedes, and a devout young painter might naturally think of the two saints together; their feasts are celebrated on successive days. The picture hangs in Farnley Hall in Yorkshire where it is unnoticed by authorities on J. M. W. Turner.

Montias gives the impression of following the adventures and misadventures of several generations at once. One will read *Vermeer and His Milieu* several times, as he has read the archives; he is an indispensable companion for anyone who likes the seventeenth century. He is alert to the human consequences of economic vicissitudes. He guesses acutely which collateral branch is most plausibly on the

make. Plausibility is common: in one richly comic episode the grandmother falls victim to a smooth-tongued confidence artist who claims to secure permission for a public lottery as near as makes no matter to Delft, where such a thing is forbidden, making off with the proceeds and bankrupting Granny in the process. An uncle is credited with the skills though not the scruples of a military contractor and gains the concession to fortify the town of Gorkum, with an unauthorized profit for himself.

Such surprises recur. The milieu was raffish and evidently disreputable. The family stuck together in self-defence. The minor discoveries of Montias's reading are nothing to what is in store, ticking away in the archives like a bomb, waiting to demolish our preconception of what kind of refined background great painting springs from. As the page turns it seems that the writer is holding his breath. Then the secret is out.

Twelve years before the painter's birth almost everyone in the immediate family of Vermeer's mother – her father, stepmother, mother-in-law, brother, stepbrother and husband – seems to have been embroiled in the counterfeiting of currency. The plot, which was intended to help the Elector of Brandenburg pay for the acquisition of the Duchy of Cleves, providing the States General with a sympathetic power along their border, was after interrogation immediately unmasked. The two leaders were beheaded by the sword. The other members of the closely knit family who were involved combined to buy their way out of trouble; Vermeer's father stripped himself to the point of selling his bed – everyone's dearest possession – to find the money. 'Vermeer, who was born soon after his grandfather's death, must have heard from his parents or relatives about the adventure', Montias concludes. 'It was an inescapable part of his own background. He himself became a *"counterfeijter"*, an artist counterfeiting the visible world.' Montias wonders whether the linguistic coincidence ever occurred to him.

When an exact historian, such as Montias, permits himself such a speculation, who can resist? It prompts tempting reflections, with a critical relevance that Montias may not have had in mind. The conspirators of 1620 thought themselves justified, indeed in some respect authorized. One of the family plotters told an accomplice that if her husband was ever caught counterfeiting, he would be pardoned 'by reason of the services that he had rendered to the Prince'. What these might have been is mysterious: the hint of secret services is incongruous and fascinating. But there need now be no doubt about how Vermeer came to paint such a rare subject as St. Praxedes. In the shadow behind her there lie two decapitated martyrs, their expressions transfigured by grace. One cannot doubt

[12]

that martyrdom was still very real to the family.

In maturity Vermeer made his way to a conception of painting as a facsimile of the visual scene; it is reasonable to suppose that he thought of it as such. Nothing in genre painting before him, except occasionally the sheen of satin by Ter Borch, came as close to the likeness of appearance. With Vermeer the likeness was not primarily to a material texture but to the whole configuration of light that constituted an image, and constituted it in particular on the screen of a camera obscura, as anyone notices who looks at the image in the accessible camera in the collection at Oxford. Vermeer will have thought of the luminous objectivity that the camera captures as the absolute value of pictorial art, a visible essence of the untroubled household, which is the feminine world. One remembers that Vermeer was brought up with a sister twelve years his elder. When he was twenty-one his wife Catherine took her place, supported and directed by her mother, who opened to him the distinguished milieu that we know. Montias has enchanting reflections on where Johannes and Catherine may have met, and notes, almost reluctantly, on solid sociological grounds, the likelihood that romantic love had a part in the story.

Vermeer surely reacted against the miscellaneous eclecticism of narrative painting in the international styles. The purity of the household light replaced it. That is the object of his imitation. He fabricated it so irrefutably that we have no doubt of its truth. It retains for ever an unbroken harmony, the inherent value of what is real. The camera image is a projection of the very light that is emitted by what is seen. Its colour is the essence in which visibility consists. The household world lies flat before us in its own specific luminosity and pallor. It is this essence of a state that is blessed that Vermeer might have thought to counterfeit.

Times Literary Supplement, 16-22 February 1990 Lawrence Gowing

RELEVANT LITERATURE PUBLISHED SINCE 1970

Albert Blankert, with contributions by Rob Ruurs and Willem Van de Watering, *Vermeer of Delft 1632-1675,* Dutch edition, Utrecht and Antwerp, 1975; English edition, Phaidon, Oxford and New York, 1978

Christopher Brown, *Scenes of Everyday Life: Dutch Genre Painting of the Seventeeth Century,* Faber and Faber, London, 1984

Albert Blankert, John Michael Montias, Gilles Aillaud et al., *Vermeer,* Dutch editions, Amsterdam, 1987 & 1992; English edition, Rizzoli, New York, 1988

John Michael Montias, *Vermeer and His Milieu: a Web of Social History,* Princeton University Press, Princeton, New Jersey, 1989

Arthur J. Wheelock Jr., *Vermeer and the Art of Painting,* Yale University Press, New Haven and London, 1995

Jørgen Wadum, *Vermeer Illuminated: a Report on the Restoration of the 'View of Delft' and the 'Girl with a Pearl Earring' by Johannes Vermeer,* with contributions by René Hoppenbrouwers and Luuk Struick van der Luoeff, Mauritshuis, The Hague, V + K Publishing, Inmerc, Naarden, 1994; 2nd revised edition and English edition, 1995

Johannes Vermeer, edited by Arthur J. Wheelock Jr., with contributions by Arthur J. Wheelock Jr., Albert Blankert, Ben Broos and Jørgen Wadum, exhibition catalogue, National Gallery of Art, Washington, D. C., and Mauritshuis, The Hague, National Gallery of Art, Washington, D. C., and Yale University Press, New Haven, 1995

The Scholarly World of Vermeer, Klaus van Berkel, Anne van Helden, Jørgen Wadum and Kees Zandvliet, with a contribution by R. E. O. Ekkart, published to accompany the exhibition held in the Museum of the Book, Meermanno-Westreenianum Museum, The Hague, Waanders Publishers, Zwolle, 1996

Delft Masters: Vermeer's Contemporaries, Michiel C. C. Kersten, Danielle H.A.C. Lokin and Michiel C. Plomp, exhibition catalogue, Stedelijk Museum 'Het Prinsenhof", Delft, Waanders Publishers, Zwolle, 1996

Dutch Society in the Age of Vermeer, edited by Donald Haks and Marie Christine van der Sman, to accompany the exhibition held in The Hague Historical Museum, The Hague, Waanders Publishers, Zwolle, 1996

I
JOHANNES VERMEER
OF DELFT

★

Elements of his Appeal
Vocabulary and Style
Characteristics of his Thought
His Development: the Early Works
The Mature Style
His Subject
The Last Phase
His Reputation

I

The tide of style as it ebbs and flows follows a broad logic that we can often understand. When we approach closer each wave is seen to be made of fragments of thought, of personal feeling, all of them in some degree enigmatic. The flow remains unbroken. The seventeenth century carries with it in its current the greatest of painters: there is no losing sight of such giants. Yet the stream as we survey it is uninterrupted. If any man detaches himself to appear alone it is not the most powerful but one whose reticence, whose conformity itself, has a personal character which separates him from his time. The work of Johannes Vermeer is a slender and perfect plume thrown up by the wave of Dutch painting at its crest. For a moment it seems that the massive tide pauses.

It is simple, immaculate: the perfection of Vermeer no longer needs expounding. His pictures contain themselves, utterly self-sufficient. In each of them the surface and design alike mark an act which is accomplished and complete. Its limits are unconcealed. The scene is a familiar room, nearly always the same, its unseen door is closed to the restless movement of the household, the window opens to the light. Here a domestic world is refined to purity, to be conveyed on canvas in definite statement. On the surface of these pictures the forms of life lie flatly together, locked side by side in final clarity.

Nowhere else are the complicated references of Western painting so resolved. In one picture, a little to the left of the centre, is a square of smooth paint, yellow. Its colour evokes a luminous ripple in the tones of the picture round it. It describes a lighted surface, the reflecting epitome of a window that we do not see, and the surface forms the side of a book. It is resting solid and heavy against the arm of the girl who holds it, its golden yellowness complemented by the blue of the stiff folds she wears. The book, with its companions on the table, is a part of the life of the room, but it is also an emblem, an

attribute, like wreath and trumpet, of a Muse. And it is a shield tilted to deflect the glance from the femininity which it half conceals. The meanings recede elusively, indefinitely. The statement remains simple, a finite yellow plane. The play of tone is at the same time a definition of space, a domestic incident, an allegory and a record of an unspoken depth in the painter's nature. Yet it retains its independence. It is impersonal and lucid as a still pool; on the bottom lies the square of yellow, clear and precious.

The material beauties of Vermeer's world uncover themselves quietly, neither sought for nor unexpected. The nature of things is perfectly visible; objects receive the light as if by habit, without welcoming or shrinking. Encrusted, lustrous, or with the lucent enamelled facets of the later works, these textures are familiar companions of life: they make no claims. Their character is not spectacular, the drips of light take no account of it. They never remind us that they could be touched. Often it is not matter that occupies the eye, so much as the reciprocal play of nearness and distance. Overlapping contours, each accessory to the next, confine the space, an envelope of quiet air. And suspended in it, near or far, bound unresisting by the atmosphere, each object yields up to the light its essence, its purest colour.

Everything in the room knows to a nicety its place in the design, as unmoving as the walls that shut it in. There is an unshakeable logic in the divisions of space and surface. Each province has its cool and positive hue, each has an edge whose firmness forbids doubt. Along the window frames, across the floor, the perspective pattern extends until, against the wall, framed in its rectangular divisions, the human inhabitant is discovered. She has no thought in particular, no remarkable occupation. Her mooning is caught in a mathematic net, made definite at last, part of a timeless order.

VOCABULARY AND STYLE

Pictures, we know, communicate several kinds of information. They communicate information about visible things, about the painter's equipment to deal with them, and also, by inseparable implication, information about the nature of the artist himself. Some painting, that of Renoir perhaps, gives us the illusion that we can construe it with equal facility on every level. Others of the masters hold their secrets more tightly. They knit the consistency of their manner like a suit of mail about them. However definite and recognizable the weave

of paint in the style of Vermeer, inside it something is hidden and compressed. There is a curious note in many of his pictures. It is to be seen in the vocabulary of representation that he applies to the simplest form, the fold of a bodice or a finger. It is a note of ambiguity, a personal uncertainty that one cannot help feeling about the painter. His detachment is so complete, his observation of tone is so impersonal, yet so efficient. The description is always exactly adequate, always completely and effortlessly in terms of light. Vermeer seems almost not to care, or not even to know, what it is that he is painting. What do men call this wedge of light? A nose? A finger? What do we know of its shape? To Vermeer none of this matters, the conceptual world of names and knowledge is forgotten, nothing concerns him but what is visible, the tone, the wedge of light.

All should be well. Such might be the constitution of the simplest of painters. Yet something keeps one wondering. Perhaps it is the unvarying adequacy, the uniform success of the method. How did he earn such a gift, how did he cultivate it? What kind of man was Vermeer? Here is the ambiguity. We may examine the pictures from corner to corner and still be uncertain. It seems as if he was of a god-like detachment, more balanced, more civilized, more accomplished, and more immune from the infection of his time than any painter before or since. Or else he was of a naïvety beyond belief, all eye and nothing else, a deaf-mute painter perhaps, almost an idiot in the lack of any of the mental furniture that normally clutters the passage between eye and hand, a walking retina drilled like a machine.

I am considering for the moment not pictorial design so much as Vermeer's vocabulary of formal representation, his tactics rather than his strategy. There is something unexpected in the relation between them. Vermeer's design is usually considered to be classical in kind, a deliberate ordering of space and pattern, and in general the classical designer makes his deliberation visible, as do Piero and Poussin, in the smallest form he represents. Vermeer's representation is of the opposite kind, the kind which abhors preconception and design and relies entirely on the retina as its guide, the kind which in contrast to conceptual representation we know as impressionism.

Vermeer's impressionism is worth an examination. The definite patterns of localized colour which he presents are of course quite unlike the manner of the recent painters whom we call Impressionists. The element which I seek to

isolate here is not colour so much as an even more intimate characteristic of his style, his actual explanatory vocabulary. Like the impressionism of Velázquez and Manet it is a notation primarily of tone rather than of colour. And this use of tone in some of his pictures, those of the type which the *Lady Writing a Letter* in Dublin, the *Guitar Player* at Kenwood and the National Gallery examples have made familiar, the type of the Louvre *Lacemaker*, reaches an extremity which has few affinities in painting. It is indeed the most palpably personal feature of Vermeer's method. Where all else is so uncertain some attempt to describe it may prove useful, and some rather more technical reference will perhaps be forgiven, before direct consideration of more elusive issues.

Perhaps the plainest sign of peculiarity is the frequently almost complete absence in the darker passages of these pictures of that linear realization which we call drawing. Many who have glanced at the hands which rest on the keyboards of the virginals in the pictures in the National Gallery may have passed on thinking that they have caught the master in a weaker moment. But these details are quite characteristic; Vermeer's shadow does not only obscure line, it interrupts and denies it. Where fingers turn away from the light or an eye casts its hemispherical shadow Vermeer refuses, as it were, to admit to us that he knows what the darkened forms are, how they are divided, where lie their bounding lines. In the servant in the Dublin picture it is the mouth which is submerged, in her mistress the eye as well, in the lady seated at the virginals the whole form of finger and hand, a disappearance which becomes very clear when we turn even to a picture as close to Vermeer's influence as Metsu's *Music Lesson* which often hangs beside it.[1]* If we compare the arm of the letter writer resting on the table, with a similar detail conveyed in the conventional vocabulary in such a picture as Ter Borch's *Letter* at Buckingham Palace, the gulf is plain.[2] In Vermeer we have to deal with something quite outside the painterly fullness of tone which was so often the burden of pictorial evolution between Masaccio and Rembrandt. His is an almost solitary indifference to the whole linear convention and its historic function of describing, enclosing, embracing the form it limits, a seemingly involuntary rejection of the way in which the intelligence of painters has operated from the earliest times to our own day. Even now, when the photographer has taught us to recognize visual as against

* See Notes at end of Part I.

imagined continuity, and in doing so no doubt blunted our appreciation of Vermeer's strangeness, the feat remains as exceptional as it is apparently perverse, and to a degree which may not be easy for those unconcerned with the technical side of a painter's business to measure. However firm the contour in these pictures, line as a vessel of understanding has been abandoned and with it the traditional apparatus of draughtsmanship. In its place, apparently effortlessly, automatically, tone bears the whole weight of formal explanation.

Allied to this rejection of line there may be observed a similar indifference to conventional continuity of modelling. The critical point at which a change of tone becomes large enough to be worth recording appears to be decided by Vermeer optically, almost mechanically, rather than conceptually or in the interests of comprehensibility. Dealing with drapery, the blue turban of the head in the Mauritshuis for instance, and the skirt of the guitar player at Kenwood, he allows the lighted side of the fold to convey both. The delicately abrupt divisions which convey the features of the Louvre *Lacemaker*, like the accents of tone in the head of the *Girl with a Red Hat* at Washington, are so convincing that we hardly notice that they are entirely unexplained. Intermittence of modelling is in itself common in painting wherever strong effects of light are sought. What is strange in Vermeer is the authenticity of accent, however unsubstantiated. When De Hooch, Vermeer's close associate, attempts such effects in a head like that of the lady in *The Card Players* at Buckingham Palace he is apt to lapse back into the subtly insensate cockeyedness which is so lovable in the low-life genre paintings of an earlier generation. For him the accent of light always coincides with concept, the telling human particular, of which Vermeer seems to remain utterly unaware. When the Dutch followers of Caravaggio, in whom parallels to Vermeer's practice are often discovered, cultivate a sharpness of tonal division, it is in order that the transition when it is presented, the invariably sinuous drawing-together of half tones, shall be the more compelling. When Ter Brugghen omits linear drawing in areas of fleshy shadow, as he does in the head of a courtesan at Utrecht, it is, with his voluptuous intention, only so that the contour shall prove more piquant when we reach it. This artifice is foreign to Vermeer; tangibility is not the illusion that he seeks.

This surprising independence of conceptual continuity of modelling is equally clear in passages of still life. We can see it for example in the picture

frames which appear in the paintings in the National Gallery and Kenwood, in the lacemaker's accessories and her plaited band of hair, in the work basket beside the lady in *The Love Letter*. Vermeer's isolated accent of light is so assured, so convincing, that we are prepared to take the rest of the shape on trust. In general the painters of his school work very differently, exaggerating minor tonal incidents in order that the last inch of texture shall have its effect. In the frames and baskets of Metsu and Jan Steen[3] line and modelling work unremittingly to ensure that the smallest form shall be understood. The paintings which appear in these interiors themselves reveal the profundity of the difference. On the walls of Metsu and Jan Steen they are pictures in little, conceptual replicas. For Vermeer such a detail as the Finding of Moses, seen behind the lady writing a letter, is a pure visual phenomenon, a flat, toned surface.[4] The peculiarity of Vermeer's descriptive use of light is not only that the touch is so epigrammatic but that the epigrams imply no comment. His optical paradoxes come near to perversity but there is hardly a sign that he is aware of them or interested in them for their own sake.

The most conspicuous features of his handling of paint, the *pointillé* highlights, are a part of the same system. The striking thing about Vermeer's *pointillé* is that, however deft, it does not characterize more emphatically the particular shapes of the objects it depicts. Indeed the round, soft lights spread and blend, as if received by some minutely granular retina which diffuses a little the points of greatest luminosity. The tassels on the cushion of *The Lacemaker* have an enticing and baffling bluntness of focus. It is easy to imagine how sharply the bands of her book, and the silks which were recorded by De Groot as feathers, would have been characterized by the touch of any other painter of the school. Such diffusion is invariable, even in passages where Dutch handling was by convention most minute.[5] Indeed Vermeer's optical impartiality becomes increasingly inflexible as it approaches the crucial points in his subject matter. We need only compare the head in the Mauritshuis with the parallel piece in the former Boughton Knight collection by Michiel Sweerts to notice how remote Vermeer's manner is from the easy explanatory fluency which is so lovely a feature of the convention of his time.

Another kind of visual paradox makes an occasional appearance, the apparent deformation, the familiar object which, though it doubtless appeared on the occasion as it was represented, yet looks in the record grotesquely unlike

itself. Painters have always avoided this effect. Even Caravaggio, who sought the painfully convincing detail, accepted unconsciously a conceptual vocabulary of recognizability. We are now well accustomed to the fact that the photographer's lens does not. In Vermeer just such an apparent deformation is visible in the painter's hand in the picture at Vienna. The convention in such details, which we can trace in many pictures of his contemporaries and back through their forerunners to its origin in the iconography of St. Luke, was to ensure recognition by emphasizing the characteristic changes of plane. Vermeer seems unaware of it and by the hazard of his inflexible impartiality the hand takes on a fortuitous bulbousness which has few parallels anywhere in art. It is a startling intrusion at such a point.[6] But again there is no sign of Vermeer noticing it. His detachment was unshakeable indeed.

In these pictures Vermeer's style of representation is consistent and closely-knit. In this it is exceptional in his school; it is difficult to think of any parallel anywhere to his rejection of both the mechanics and the mental background of painterly perception. For anything like the impartial visual record which makes a sudden appearance in Vermeer's work in parts of the pictures at Buckingham Palace and the gallery at Brunswick we must look not only beyond the stylistic resources of his time but outside the normal experience of painters altogether. The riddle, or the technical part of it, is plain. And one answer is particularly suggested. It is likely that Vermeer made use of the camera obscura.[7] Certainly it is easy to think that an optical projection was a forming influence on his mature manner. Very possibly the darkness of the instrument's image did not prevent him from using it in the actual execution of many parts of the pictures that we know.[8]

The bare fact would not be extraordinary; several painters, notably Canaletto,[9] have used the device. But Vermeer is alone in putting it to the service of style rather than the accumulation of facts. He painted little that was not easily within reach of the ordinary technical methods. The optical basis of his manner is most visible not in the planning of his pictures, for that, except in such broad perspectives as *The Music Lesson*, is well within the compass of the common tools, so much as in the tonal recording of specific passages. However closely the internal indications agree, the precise technical solution remains a matter for conjecture. The truth is buried. The pictures, or some of them, we have; it would be a poor service to use them no better than as fodder for another of the

hobby-horses to which more than one study of the painter has been bound. What is important is to isolate the very unusual consistency that they present, of which the plausibility of a mechanical explanation is in itself evidence. We are unlikely to receive any more positive indication of the artist's nature. The real riddle is rarely discussed. Why did Vermeer, whether or not he painted with the camera obscura or learned from it, choose the optical way?

It is doubtful, whatever his method had to recommend it, if it was in any simple sense its technical ease. The painter of *Christ in the House of Martha and Mary* may have doubted his chances in the highly competitive production of the miniature genrepiece and anyone might well have hesitated to sink himself in so petty a descriptive technique as that of Dou. But this issue, however crucial for the talented young men of Leiden, hardly presented itself in Delft. Nor is there reason to think that the more obvious limitations of the genre convention left him in the least ill at ease. He remained happily bound by them to the last and although he might, if the *Diana* is evidence, have brought more grace to the Italianate style than any of its practitioners it is difficult to think that its gene-ralities were any more natural to him. Sometimes it is tempting to see in Vermeer's blandness a deliberately acid note, a critical reflection, perhaps, on the shortcomings of conceptual naturalism or the coarseness of the Caravag-gesque. There may indeed be a meaning in the air with which the *Lady Seated at the Virginals* keeps company with the Baburen on the wall – study of these pictures destroys the belief that anything enters them by chance – but the root of Vermeer's style does not lie in such embroidery.

It is sometimes almost possible to construe his manner, with the lustrous sharpness of its modelling, simplified but strangely authentic, as a distant reflection of Caravaggio's influence. But contacts with Italy and Utrecht, though they no doubt provided the painter with a precedent, do not by any means explain the case. A delicacy of discrimination without parallel is cer-tainly at work: we can almost believe that we owe this intricate orchestration of optical accident to the painter's eye for the decorative beauty of it alone. Beautiful in itself he surely thought it, alone in this extreme among all painters before Degas. Yet it is doubtful if the formation of his style can be understood simply as the evolution of a decorative scheme. The compound which has often been suggested, the mixture of the influence of Utrecht and that of Carel Fabritius, with a little of Haarlem and perhaps even, as one writer has proposed,

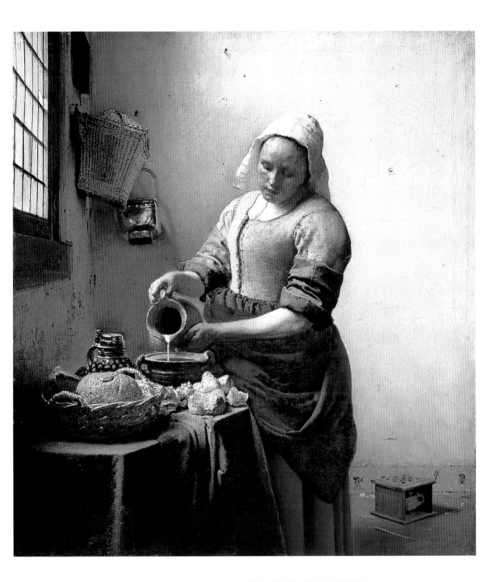

A. A MAIDSERVANT POURING MILK

Amsterdam

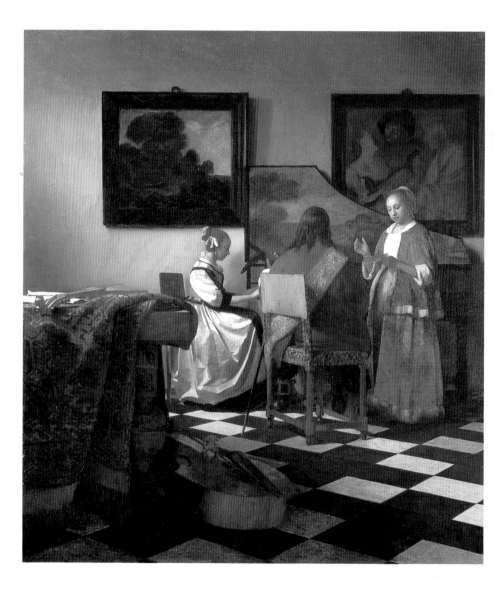

B. THE CONCERT
Boston
(Present location unknown)

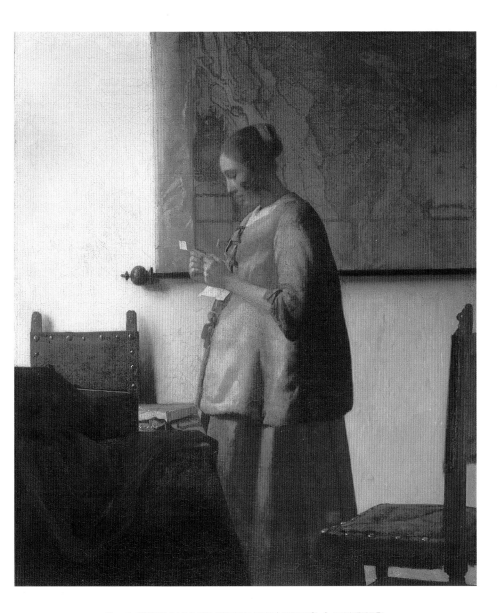

C. A WOMAN IN BLUE READING A LETTER
Amsterdam

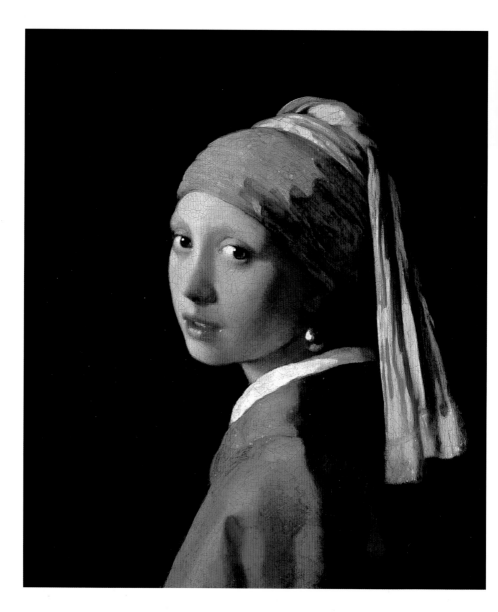

D. HEAD OF A GIRL
The Hague

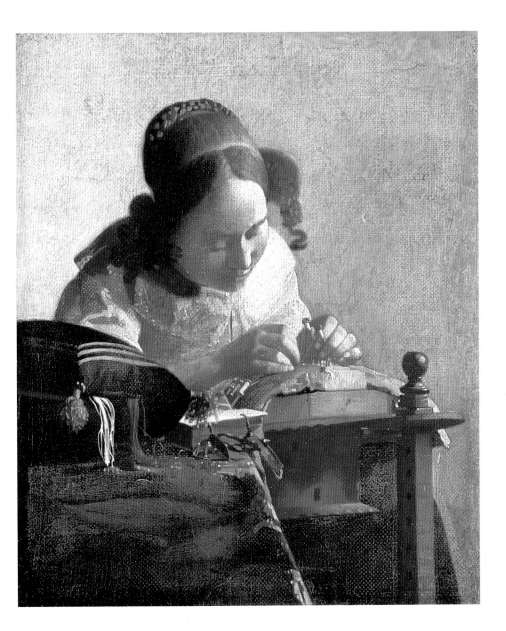

E. THE LACEMAKER

Paris

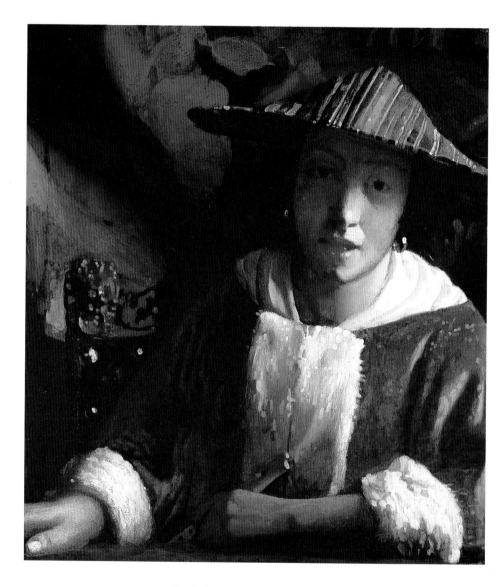

F. A GIRL WITH A FLUTE

Washington

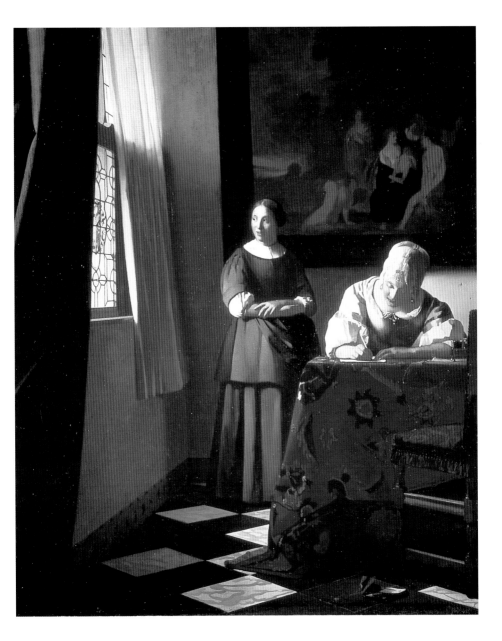

G. A LADY WRITING A LETTER WITH HER MAID
Dublin

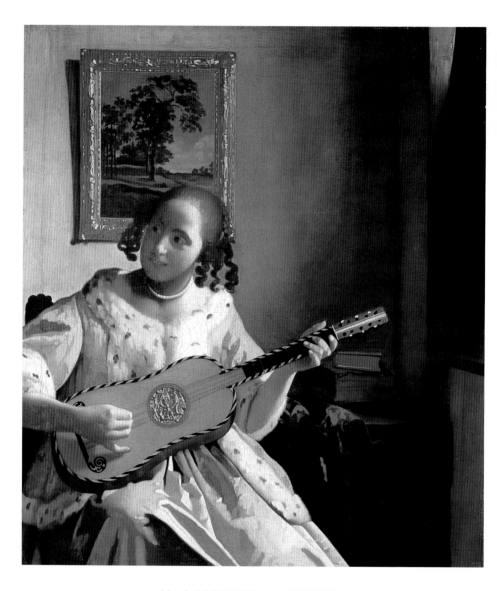

H. A LADY WITH A GUITAR

Kenwood

a trace of Paul Potter, is far from accounting for the result we know. Vermeer's perfection does not quite conceal that there are deeper roots to seek than the coincidence of a stylistic context and a marvellous freak of taste.

Nothing in Vermeer's painting is more distinctive than the insistence with which he pursues appearances. His work is marked by it almost from the first; it has the quality of pure visual experience in all its authenticity. The conclusion to which this pursuit led him, an extreme which is idiosyncratic in its very impersonality, is the optical method of the later works. His pictures are so invariably and completely convincing, they abstain so entirely from the suggestion of any other purpose, that at times we wonder whether the intention is not actually to deceive us. The record is so inflexibly impartial, so unchallengeable and perfect, that it is on the point of becoming a counterfeit. It is indeed only in painting which openly pursues this purpose, the painting of *trompe l'œil*, at first sight the extreme opposite of the stylistic refinement which we associate with Vermeer's name, that such unremitting closeness to appearance is elsewhere to be found. A strong *trompe l'œil* tradition was in fact current in Delft.[10] In Vermeer's time it left its mark upon both the still-life and the architectural painters of the town, and even the liberal and painterly style of Carel Fabritius was not quite untouched by it. In Vermeer's pictures it is possible to point to more than one motif with a distinct origin in the *trompe l'œil* school. It is of a *trompe l'œil* painter, the satanic Johannes Torrentius, that the use of the camera obscura is recorded among Vermeer's predecessors.[11]

Yet these connections have an incongruity about them. However deceptive Vermeer's intention, the result is at the opposite pole to naturalistic tactility. For him the play of light upon form not only conveys its substance but also subtly denies it. The illusion which he seeks is not closeness but distance. It is the refinement of *trompe l'œil*, to counterfeit not only the credibility of visual perception but also its intangible remoteness. Immediacy, touch, are excluded; his subject is the immutable barrier of space. It is for this, for the impalpable veil which it implies, that visual impression in all its genuineness is so precious to him. There is in his thought, the paradoxical accompaniment of its clarity, a deep character of evasiveness, a perpetual withdrawal. We can trace it in the diffidence with which he approaches the stylistic problem of his time, his negative reaction to the warmth and liberality which the influence of Rembrandt spread through the genre school. The peculiar composition which the

current genre subject matter takes on in his hands is full of evidence of it. It lies behind his lack of that facility of invention which the least talented of his contemporaries was able to affect. And here in the most intimate reflection of his thought, his vocabulary of representation, it is clearest of all.

CHARACTERISTICS OF HIS THOUGHT

In fact the zone of emotional neutrality in which Vermeer suspends the human matter in his pictures is infused with the profoundest personal meaning. Vermeer, when he is recording optically, is taking evasive action, extricating himself from the hazards which naturalism holds for him, leaving himself free to operate in the field where he feels at ease. His nature excluded directness; a condition of the investigation for him was that the angle should be oblique. It drew him to the point where he stands, farthest of all from his time, as a poetic illustrator of the subtlest and least expressible meanings of human aspect.

Eyes never meet in Vermeer, action is stilled. There is no speech, these almost unmoving figures communicate by letter or on the keyboards of the virginals. It is as if they were meditating on the barriers which lie between them. We may fancy that their relations reflect another, between them and their painter. For Vermeer the situation, technical and personal, was deeply tangled. His tonal method, his vocabulary of light, provided the solution. It was in the camera cabinet perhaps, behind the thick curtains, that he entered the world of ideal, undemanding relationships. There he could spend the hours watching the silent women move to and fro. From it he could record them with their peculiar magnetisms in their enigmatic courses, and remain as it were immune and uncommitted. He could record them and from the uncertainty he could distil something miraculously definite, pure and absolute.

The serenity which is often remarked in these pictures is of a somewhat equivocal kind. In the study of Vermeer's style we are dealing with an outlook far removed from the genial facility which is the characteristic of his school. And underneath this difference, lurking below his almost inhuman fineness of temper, there is an element very much at variance with any simple view of his character. However much more elusive Vermeer's emotional preoccupations may seem than those of other artists they were certainly not the less compelling to the painter. His style developed under an unremitting internal pressure.

On the surface there is little enough sign of it. Possibly we should be justified

[26]

in suspecting from the impeccable consistency of these pictures that underneath something is hidden. An element of concealment, of deception, of which perhaps the painter was as much a victim as any of his students, is never entirely absent from Vermeer's thought. Indeed his intractability to study is a kind of evidence of it; certainly his long neglect yields an indication of the nature of the peculiarity which lies at the root of his style. It can be imagined, I think, that until the invention of photography diffused such optical records everywhere the basis of Vermeer's method seemed to many eyes, if not incomprehensible, at least eccentric and of negligible interest. 'The effect of the camera obscura is striking, but false', wrote a Dutchman who was born thirteen years after Vermeer's death.[12] We have evidence, in the comparatively large concentrations of his work in the hands of single collectors in his own century, that it was, however prized, a special taste. The fact that our conception of the visible world is now so thoroughly conditioned by photography that we can call the academic painting of our time photographic tends to hide from us (and thus no doubt to obfuscate the present discussion) that the popular naturalistic convention in every age is made not out of visual data so much as from *idées reçues*, the current notions of the appearance of reality.

The objective facts of tonal distribution are now, in mechanical transcript, so ubiquitous that it is difficult to recall that they can ever have seemed strange. The style of Caravaggio and his followers raised in its time to a quite unparalleled pitch of violence the historic battle of the European artist to penetrate and enlarge the formulae of conceptual vision. It provoked resistance, of the kind that we now recognize as the typical concomitant of an *avant-garde* school; it opened the way to many of the most characteristic glories of seventeenth-century art and to the art of Vermeer, though hardly as directly as has sometimes been suggested. Vermeer's breach with convention is of a more subtle kind. He is reticent, even secretive, and the difficulty of imagining the climate of taste in his time is only the beginning of the obstacles which the study of Vermeer presents.

The expressive content of his style, its essential idiosyncrasy, its deepest beauty, is bound up with this very approach to visual credibility which, however blunted our perception has become, is in fact and must have seemed so to his time, so ambiguous, so perilously equivocal a basis for reproducing a world of which we know so much. The very closeness of his approach to a pure

visual standard of representation was in fact the vessel in which he contained a strange depth of emotion, a complex pattern of feeling in which the attraction of the tangible world and a rejection of it were at last reconciled. Such contradictory roots have no doubt nourished the style of more than one painter. But however tempting it is to seek a parallel among the artists of the last century, to do so would risk a simplification of the case. Vermeer did not command the inveterate analytical animus of Degas; it was not in his nature to deal so directly and decisively with humanity. It is in the appearance of diffidence and neutrality which his style assumes that its deepest revelation is contained.

The characteristics of Vermeer's thought reflect the conflict to which his attitude to life is subject. It is with this enigmatic, half-concealed contradiction that the study of the painter's development has to deal. Vermeer depends peculiarly closely on outside resources for the matter and form of his pictures but the essential factors in the formation of his style are internal and subjective. In the later works we can discover most clearly the essential obliquity of Vermeer's apparent directness; their complexity is hardly concealed. Indeed it is perhaps to the perceptible emotional tenor in its stylistic elaboration that such a picture as the *Lady Standing at the Virginals* in London owes its unpopularity with the painter's most devoted students. Yet there is a very evident dynamic purpose in his development. The deepening meaning of each lovely step, the Dresden *Letter Reader*, the mirror in *The Music Lesson*, the Mauritshuis head, the *Lacemaker*, allows us to discern the movement towards an ultimate solution. It is open to any student to feel a distaste for the later phase, and in particular it is comprehensible that those who have understood the genre school best should feel most at ease with pictures which agree with its conventions. There is nevertheless a sense in which no work is more peculiarly characteristic of the painter than the dozen pictures of his last phase. The conclusion of his style is far from inconsistent; the preoccupations which it half uncovers are the determinants of all his work. His circuitous course is a path of penetration towards the inscrutable yet revealing conclusion.

The detachment to which he clings as if in self-preservation, the tiny body of his work and the closed, hermetic perfection of the systems it presents are so many signs that the painter is facing an issue of some personal difficulty. His path is hedged about; his development is complex. He often looks backward, often retraces his steps. But however reminiscent and repetitive the forms there

is an unfolding logic in them; the problem remains constant. The simultaneous motion of withdrawal which complicates his approach to the world persists throughout. Round it he builds his elaborate, deceptive yet lucid manner until at last we gain a kind of knowledge of its basis in his deepest feelings.

HIS DEVELOPMENT: THE EARLY WORKS

The remarkable thing about the four immature pictures by Vermeer that we know[13] is that they are in every way so much more considerable than the works from which they derive. Their clarity and objectivity and their positive colour already reflect their painter; in all other respects their styles, like the motifs on which they are based, are discrepant and even inconsistent with one another. But the subjects of De Hooch and Maes in *The Procuress* and *A Girl Asleep* are pursued with the aid of an eclectic variety of devices to a point of perfection as far outside those painters' range as the size of the pictures exceeds their customary practice. In this first phase of Vermeer's activity–we have no reason to think that the view of it these pictures give is not a true one–he makes, in the course of a year or two and with all the resources he commands, a series of separate monumental essays in the four dominant conventions of his time. It is evidence of a powerful purpose; nothing indeed is more typical of all his works than the achievement in each of them of an unchallengeable technical standard, a quite exceptional consistency of style and accomplishment. The disparity of the aims to which he sets his overwhelming resources in the early pictures conveys quite clearly that this aspiration to a position beyond the rivalry of his associates has a personal as well as an aesthetic significance. The impression that forms itself is that of a man of ambition in fields very much less circumscribed (as well as less dependent on the discernment of posterity) than those of the rarefied triumphs that he was in fact to gain. Vermeer was apparently gifted with all the equipment to realize ambition, yet his course was very different. We have here a part of the background to the inescapable atmosphere of disappointment of the years of failure at the end of his life. De Monconys, who visited him, and Arnold Bon, who celebrated his fame in a chronicle of the town, agree on the esteem in which he was held in Delft. But when the French traveller called Vermeer could not, or perhaps would not, produce any pictures. It is likely that the narrowing of aim in Vermeer's mature work must be explained entirely in terms of his own temperament. If one thing emerges

from the development it is that his own nature provided an obstacle to the conventional ambitions which his early works suggest. Indeed a comparison of the *Girl Asleep* with the fluency and freedom of Maes is enough to indicate much of the course that he was to follow.

Vermeer's subsequent development is entirely within the boundaries of the genre school. He deals in particular with the prosperous and leisurely domesticity which Ter Borch had popularized as a subject in the early fifties and with which De Hooch, Metsu and Mieris were all occupied when Vermeer turned to it towards the end of the decade. The works in which Vermeer is closest to De Hooch and Metsu, the conversation pieces in the Frick collection and the drinking scenes at Berlin and Brunswick, already convey a great deal both of his stature and his peculiarity.

The descriptive method of the genre painting of the times serves a convention that is essentially picturesque. Vermeer's procedure is by contrast inflexibly empirical. He leaves no doubt at any point about the closeness of his transcription; within the exquisitely calculated scheme his method is almost dogmatically objective. It is not his taste only but his standard of genuineness that is so evidently higher than that of his contemporaries. Painting for him involves a quality of conviction of which they remain unaware. It appears that of the painters of Delft only he understood the visual authenticity which was the lesson that Carel Fabritius extracted from the studio of Rembrandt. Vermeer's temper rejected the fluent, hybrid idiom of his circle, just as it forbade him the facile inventiveness of incident which was the common endowment of the school. All this is comprehensible as the reflection of a naturally more profound intelligence. The early works of great painters show more than one parallel. But a consideration of the pictures suggests that the exacting quality of Vermeer's self-criticism had another side.

The figures in the Berlin picture have a mummified quality, shrouded and unmoving. The scene as we look at it takes on the character of an exquisite tomb. The arrangement of the figures is in the current manner, but hardly a shred of life remains to them. The immobile furnishings encroach upon the living matter until they almost submerge it. The girl's face itself is obscured; the head of her cavalier is precariously balanced on top of a heaped accumulation of particulars. The essence of the picture is the transcription of still-life. But for some reason it is not applicable to human detail; the curious and signi-

[30]

ficant fact which these pictures uncover is that the extension of the painter's method, in the easy-going manner of Metsu (as we see it in his painting in London of a rather similar group called *The Duet*), to the rendering of a whole domestic episode was outside Vermeer's range. The Berlin picture lacks the sociable fluency, the ingratiating inventiveness of the Metsu. Vermeer's understanding, though of a finer kind, is also narrower. The genial breadth of Metsu's grasp of feature and furnishing alike in one equable and unexacting rhythm makes all the clearer the dislocation to which Vermeer's approach is subject. When the hiatus is recognized it seems as if the very efficiency of his still-life method were a symptom in itself, as if the quality of surface observation sought to compensate for some deep impediment. The confident explanatory fluency of Metsu has a human as well as a decorative significance. Dealing with life his attitude is generous, relaxed; his gentle picturesque rhythm has a quality of sympathy, the quality of a caress. Throughout his life this gesture remains beyond Vermeer's power. Technically he neither attained nor attempted Metsu's magnificent conceptual grasp of fully-fleshed heads.[14] And in only one of the mature pictures known to us does he come near to the robust vernacular realism common to Fabritius and Maes, and De Hooch under their influence, as well as Metsu in his earlier work, with which the genre school reflected the example of Rembrandt. Vermeer approaches the flavour of common life as delicately as he does the picturesque convention. He analyses it into visual elements, statements of light purged of any other content.

For all the stature with which he endows the inhabitants of his world, indeed perhaps because of it, Vermeer stops short of humanity. The lack of facility in dealing with human issues, which emerges side by side with the elemental clarity of vision which is its counterpart, is the fundamental factor in the formation of his style. The lack itself is a common one. Vermeer's distinction is that, with the passivity characteristic of his thought, he accepted this part of his nature as a basis of the expressive content of his style. The instinctive seriousness of his assent to the requirements of his temperament is the sign of his genius. The lack of facility corresponds to a depth of feeling; his diffidence in dealing with the aspect of humanity is the measure of the meaning which he attaches to it. The virtue in an artist is often like a bare nerve; sensitiveness may not only qualify but disable. In this Vermeer's development reveals, in microcosm, a situation in which more than one later painter has found himself.

In *The Procuress*, whose consistency, like that of the picture at Edinburgh, is the consistency of an earlier generation, these problems are still unformulated. It was the naturalistic trend which the genre idiom took under the influence of Ter Borch that presented Vermeer with the crucial issue round which his style formed. Vermeer's development must be considered in relation to his immediate circle. There are indeed indications that the sources even of the apparently exotic elements in the early pictures were equally available to his associates. But, quite apart from the results of his temperamental antipathy to the humane and descriptive tendencies of the school, there is a significance in Vermeer's place in his age. He belonged to the third generation of the great epoch, and he was among its youngest members, almost the last remarkable figure that the school of Holland produced. The effect upon painters of arriving a little late, recruits in the hour of victory, upon a scene dominated by the achievements of their predecessors would make an interesting study. In another century it stimulated Seurat to a doggedly unremitting application: Ensor, after a few brilliant years, it broke. We can trace paradoxically in Vermeer something of both reactions. It is in this context that we must understand both the hesitation and the force of ambition which deeply mark the beginning of his career. And in his subsequent development from the acquiescence to the naturalistic genre convention in such pictures as the *Soldier and Laughing Girl* to the whole evasive nature of his ultimate accomplishment, as well as in everything we know of his later life, we can trace the other half of the story, his abandonment of the attempt to compete. The evolution of genre painting was in the hands of men of a tougher kind and Vermeer did not follow them. He could not imitate their voracity; the double edge of beauty and threat which his eye discovered resisted his attempt to swallow it. His companions moved on with unblunted appetite towards the surfeit and decay of the popular style. Vermeer was alone, disqualified by his nature and reserved for other things.

The structure of his style has been obscured by the habit once common among writers on the masters of discharging them out of hand from any suspicion of debt. Vermeer rendered no subject that was not in the commonest currency. This in itself is remarkable in an artist of his rank, singular even in the genre school of which nothing is more typical than the number of themes which were common ownership, passed from hand to hand like a patriotic treasure with which to defy the infinite fluency of the painters of Flanders and

[32]

the international catholic style. In his rendering of human incident Vermeer relied on his sources with a closeness which has few parallels. He was quite without the prosaic inventiveness which was the chief equipment of his associates. The work of De Hooch and Metsu abounds in more or less original arrangements of figures to demonstrate the easy freedom with which, on a not very exacting level, they dealt with the matter of life. This facility was utterly foreign to Vermeer; he never embarks on the fertile and supple evolution of genre motifs which we can watch in the drawings of Maes. It would be hard to find a theme of any boldness in his work which is not based on precedent; inquiry multiplies the evidence that the majority of his figure motifs were directly derivative. And so far from reducing his distinctiveness it is easy to recognize how characteristic this is of it, how inevitably enforced by that paradoxical quality of his, the barrier which impeded his handling of life.

Consideration of the sources of so pure a painter, and it will later be necessary to pursue them in some detail, has none the less an air of incongruity; we are apt to regard each debt as a new limitation. In Vermeer's case at least the contrary is more true. Iconographically it is his strength to stand so often at a meeting of many streams. The currents reinforce one another until the final composition, *The Procuress* as well as the *Studio*, seems to take on not only an aesthetic but an historical inevitability. The sources of the more intimate pictorial devices which his essentially original thought accumulates affect his integrity even less. Vermeer remains, as we see him clearly in the earliest works, one of those painters—we know them in our own time—who fortify themselves to face the world from every possible source. It is remarkable how much such artists, the constitutional as against the intellectual eclectics, are able to adopt without compromising their own concerns, and Vermeer is the quintessence of the type.

Such incidents as the motif from De Hooch which appears in the *Soldier and Laughing Girl* intrude a little incongruously upon the consistency of Vermeer's work as we later come to know it. The early borrowings are not only foreign to him but inconsistent with one another. Vermeer's own vein of genre is a very personal one; when it emerges, in a work of cardinal importance in his development, *A Lady Reading at the Window* which belongs to the gallery at Dresden, it is immediately recognizable.

The commonplace descriptive intention of his school vanishes. The ac-

cumulation of household detail dear to genre painters has disintegrated. And with it goes the humanity of genre, the unity of particular people pursuing their lively ways in characteristic places. All this has disappeared, distilled away. The girl herself is so stationed that we see only her narrowest aspect, so wrapped up in herself that the only indication of outwardness and roundness that reaches us across the barriers between is by way of a meagre, blanched reflection in the panes of glass. Her occupation is no more than a token; even undue engrossment might unsheath some inner power, some native personality. She is disinterested. The only act, the only life perceptible, is the simple, timeless life of a painter's model. We hardly need to recall the forms such subjects take in the work of Ter Borch and the school of Rembrandt to perceive how far this picture stands from convention. It presents to us the painter's essential theme; the composition recurs significantly throughout his career. Vermeer's handling of the genre problem, the description of current life, is an evasion of it, a solution more elementary and elemental than we could have imagined possible.

The space, inescapably defined, which divides us from the human matter in the *Letter Reader* and the curtain and table which squarely bar our way both point the meaning of the arrangement as it evolves in *The Procuress* and the *Girl Asleep* and foreshadow its development in later works. In Vermeer's hands the genre subject matter takes on a curious structure. In only three of the twenty-six interiors that we have is the space between painter and sitter at all uninterrupted. In five of the others passage is considerably encumbered, in eight more the heavy objects interposed amount to something like a barrier and in the remaining ten they are veritable fortifications. It is hard to think that this preference tells us nothing about the painter's nature. In it the whole of his dilemma is conveyed.

The *Letter Reader,* however, marks the emergence of more than the scaffolding of Vermeer's style. It is no accident that in it, alongside his peculiarly evasive handling of subject, there appears another and perhaps even more elusive invention, the inverted use of *trompe l'œil* which becomes so essential a part of his later style. The obviously deceptive motif in the Dresden picture, the curtain which challenges the spectator to believe that it is as real as himself, is only the beginning of the picture's complex play with credibility. Even the final wall which encloses the composition retains a certain flavour of subtle

[34]

deception from the fact that it is parallel to the plane of the picture. It is easy to discover origins for such devices in *trompe l'œil* practice; the curtain may have been suggested by the architectural painters of Delft, or by some work of the Leiden circle or the school of Rembrandt. Several influences may have contributed to the choice of it, although Vermeer's figure, still as a pillar, suggests a peculiar affinity with Gerrit Houckgeest. The innovation of the *Letter Reader*, the beauty of the deception, is precisely that she offers us no glass of wine, plucks no flower through the casement, casts no shadow across the frame of her niche. She makes no appeal; she claims no place in the tangible world. The whole purpose is to exclude her from it, from the world of touch, a magnetic attraction, to confine her within the envelope of space. We gather from her and the immutable terms of her confinement an impression of the forces that move yet stay the painter, and discover a tension of feeling that is in essence poetic.

All these resources, the evasiveness and the ingenuity, were directed to one end, to absorb and compensate for the peculiar difficulties which naturalistic figure painting presented to Vermeer's temperament. The *Letter Reader* was no more than the beginning of the process which developed in the pictures after *The Music Lesson* into an optical demolition of naturalism itself. In the Dresden picture the difficulty is already clear. The delicacy of Vermeer's approach to figure painting, his cautious advance upon humanity down the measured, fortified field of his perspective, suggests an element in his attitude of something like fear. The caution, the tentativeness with which he approaches the *Letter Reader,* the prototype of his typical theme, reveals the enigmatic significance that he attaches to her. It is a measure of value, a measure of the meaning that she holds for him. In later pictures it comes to seem the more profound for the circuitous course by which it is reached. To this search for a definite, impersonal solution we owe the characteristic beauties we are accustomed to recognize. It is this continual aspiration to purity that governs the lovely positiveness of his colour. The colour encloses life, distributing its impact; its tonality is an orderly coolness that nothing will disturb. The utter certainty of spatial interval, without equal in the whole of pictorial art, is enforced by a vital concern with immediacy and distance. Only the most certain spatial logic will serve, and from it colour distils, in succeeding pictures, an ideal vision of equable relationship. The space in which Vermeer's figures are disposed, so singular by comparison with other painters' versions of his themes, is

like a magnetic field. It is formed exactly by the tensions which the figures set up. The design precisely contains them. The humanity of the *Letter Reader,* the power which though so veiled hangs heavy in the air, dictates the height and breadth which frames her; the space is her arena. For Vermeer it is only in such unbreakable designs that the substance of life can be half uncovered.

This quality of feeling is Vermeer's alone. There is no kind of sign of such a depth anywhere in the productions of his circle. One other artist did discover in the painting of figures and the space around them implications of an equal profundity. His way was different; happily he was undeterred by the perverse pressure which such issues exercised on the development of Vermeer. But there is a particular interest in the links between Rembrandt and Vermeer. This is a sense in which Rembrandt's use of the genre framework, in his interiors of the forties, is more truly the precursor of Vermeer's work than any of the Haarlem and Leiden pictures from which its style derives. We may even doubt whether the antithesis in every respect, in frame of mind, in manner, in productivity, between the two masters is entirely an accident. Only Vermeer resisted the waves of humane warmth, of fertility and understanding, which Rembrandt's work as it unfolded diffused through the school: only Vermeer retained a character which was entirely his own. The daylight and the rectangular domestic architecture which were the common possessions of the school were not inspired again with feeling of such depth until Vermeer turned to them. For all the world of difference between Rembrandt and Vermeer's inverted and sophisticated expression the painters have in common their appreciation of the emotional ramifications of the art.

The work of Nicolaes Maes, who left Rembrandt's studio four years or so before Vermeer painted the *Girl Asleep,* was evidently known to him. Maes was a painter of the commonplace, his virtue lies in it. In his style matter rather than manner is significant, and from the matter Vermeer profited. But Maes was an inadequate vessel for the greatness of his master. The affinity, if there is one, is to a more profound student. In this respect too, among the painters of Delft only Vermeer appreciated the example of Carel Fabritius. He alone could have understood, foreign though its open aspect was to his thought, the emotional radiance which fills the space, high and wide, round the artist's head in the self-portrait at Rotterdam. Such comprehensive statements were not within Vermeer's range. He was bound by the contradictions of his

[36]

temperament. The emotional weights in the balance of his style in themselves presented a threat to the equilibrium. Few painters have reconciled such a conflict; in his predicament any productivity, however slender, is something to wonder at.

The surface of Vermeer's pictures remains clear and untroubled. No accident interrupts the deliberation; nowhere in his work is any momentary or impulsive stroke admitted to the perfect fabric. The technical aspect of Vermeer's perfection is, in the historical context, a little surprising. Neither the Italianate styles nor the school of Rembrandt, whatever other bearing they have on Vermeer's development, ever come near to suggesting his use of paint. Certainly the climate of taste which made it possible was much influenced by the painting of Dou.[15] But there is no sign of such a refinement among the *fijnschilders* of Leiden. Nor does the school of Delft approach it. Even the still-life painters, although occasionally in its more generous phases Vermeer's handling recalls them,[16] have nothing essentially like it to show. It is Vermeer's alone, an impeccable armour of his own invention.

THE MATURE STYLE

Vermeer's approach to his problem is a retreat to the elemental level on which alone it can be completely solved. Faced with the commonplace facility of invention with which the school abounds, he paints the *Letter Reader*. Presented with the hybrid naturalistic idiom of convention, he seeks, a little later, the ultimate element, the bare optical statement. Both are reductions, simplifications, of the human terms in which the painter must operate. In the two pictures called *The Music Lesson* and *The Concert* the nature of Vermeer's dilemma is openly conveyed. The problem, visible enough in the inconsistencies of the drinking scenes at Berlin and Brunswick, is as pressing as ever. Upon it the whole structure of the picture is now based; the purpose is to defer the issue, banish it to the uttermost point. The difficulty of describing life is met by reducing its prominence to a degree which is paradoxical. The device permits the painter a consistent vision, a new ease of mind. The surprise, although it is one with which Vermeer familiarizes us, is that his very evasiveness is poetic. And in one passage of *The Music Lesson* he propounds the solution which is to transform the condition of his art.

The crucial point in *The Music Lesson*, the human detail, is dismissed to the

farthest limit of the perspective, and when at length we approach it we find that it eludes us. The head of the cavalier, and with it his whole cloudy structure, dwindles beside the sharpness of the furniture round him. The lady abandons her identity to the pattern of rectangles against which she stands. Everything in fact is more visible than humanity; we are left to contemplate an accumulation of geometric intersections, a tower of ebony edges and, in front, the mountainous, carpeted table and the gleaming shape of the magnified jug. It is the signifying detail of life that Vermeer resists. He relegates it to the distance; *The Music Lesson* and its pendant recall the great monument of this phase of his thought, the *View of Delft*. In the landscapes the very absence of human tension allows a whole material poetry, a poetry of brick and vapour, of resistance and penetration to develop. We see in it how much is excluded by the terms of Vermeer's dilemma. Yet it was the human problem that he pursued to the end.

In *The Music Lesson* he seeks definition in a frame of geometry. The problematic aspect of the lady is measured and secured exactly upon the lid and keyboard of the virginals. In this refined solution the inconsistencies of the Berlin drinking scene achieve a systematic balance, but it is no more than a rehearsal for the complete balance of forces in later works. There is little to prepare us for the passage of the mirror; here, in the square reflection, the accent is suddenly decisive. It conveys neither line nor form but instead a flattened map of light and shadow. Within the optical boundaries incident, description, and with them a whole tradition of thought, are entirely suppressed. Instead we have in a pure form the manner of painting which Vermeer followed throughout the latter half of his work, applied for the first time, and to the crux of his subject matter, a woman's head.

The solution is pursued in Vermeer's later pictures and it is complete. The resistance, the temperamental contradiction, does not weaken. It is rather enshrined in style, incorporated with its emotional basis in its own oblique kind of affirmation. The mirror's image in *The Music Lesson*, which is a foretaste, does not relax the peculiar tension which we sense in the rest of the picture. But in it the technical evasions are reconciled in the emotional ambiguity of simple optical statement. In the mirror the mood of intentness, the half-restrained response to the cavalier's attention, which hangs unexpressed like a cloud over the rest of the picture, becomes explicit. Comparing the girl with her reflection we can notice that if the back of her head, directly seen, is more

conventionally perceived, more recognizable, perhaps more touching, her reflected face, its detail dissolved, its humanity suspended in light, has a deeper kind of completeness. The face is reflected not only in the mirror but also in the painter's temperament. For the first time we have the sense that he has a use, however oblique, for the whole of human appearance.

The change is a fundamental one and by the side of this essential innovation much else that is characteristic of Vermeer appears in his work in *The Music Lesson* and *The Concert*. Indirectness, a new appreciation of the barriers that temperament presents to human contact, infuses not only the style but the action of the pictures. The conviviality, the obtrusive attentions, the picturesque male interruptions of the scene, elements of genre inconography which intrude constantly and incongruously into the early work, are hardly seen again. Exchange of glance, expressive gesture, except in one characteristic piece of reminiscence and recapitulation, entirely disappear. Only the silent, brooding interaction of presences is allowed to burden the stillness of the air. Most often the ladies are alone. It is with the aid of the successors of the Dresden *Letter Reader* that the painter investigates the furthest ramifications of his relations with humanity.

Vermeer's later work is not only consistent but confident. As his method evolves, the key of tone unlocks for him a whole world of visual impression. He is equipped to embark on the development of his own themes; from *The Music Lesson* onward the pictures conceal under their simplicity a meaning that is both deep and elaborate. The reliance upon precedent and derivative matter never relaxes, but it does not intrude on the unique consistency of style. Vermeer's invention is rarely of any boldness; the inhabitants of his world evolve from picture to picture almost imperceptibly. When their two predominant types are finally assembled in the last genre scene, the Dublin *Lady Writing a Letter with her Maid,* they are as familiar to us as to their painter. Their natures and their circumscribed orbits are completely understood. Vermeer's hand never moves freely; he never gives the impression of that security against self-criticism with which the least well equipped of his school were so amply endowed. On his own superb level his technical balance remains delicate, even perilous. But the change was deep none the less. The access of confidence in the works which followed the Buckingham Palace picture, a serene and final detachment very different from the frame of mind which preceded it, is per-

haps the clearest of the indications that his thought was fortified by some external support. Perhaps he had become acquainted with optical devices; the process is of little consequence. The turn, technical and emotional, which his development took is clear enough.

We do not know the precise history of the change. It is unlikely that the passage in *The Music Lesson* represents the single historical turning point. Vermeer's development proceeds through the realization of resources which are within his grasp, rather than by any dramatic stroke. In this middle phase of his career his habit of thought retains a tendency which marked it from the first; it seems that, however much more modestly, he still pursues his purpose in several directions and on several levels at once. We have indications less of a clear evolution than of a varied group of half a dozen or more pictures, doubtless painted in the course of three or four years, of which the Berlin drinking scene is one of the earliest and that at Brunswick among the last, a group which as a whole, for all its discrepancies, brings the problem of representation near to solution, and from which there is only one outcome, the homogeneous development which led through the pearl pictures to the final works.

One work of this middle phase remains to be considered, and that perhaps its masterpiece. If only on account of its technical character we can hardly place *A Maidservant Pouring Milk* among Vermeer's early works. It belongs rather to his maturity. As the matter of life came within his compass his impulse was to turn from the artifice of his time, to revert, as it were, to normality. His first use of his new facility was to return to the source of his style, the genre painting of the early fifties, and rehearse its characteristic subject. He was able to give it an impersonal definition that not Maes or De Hooch nor even Fabritius himself had ever known, and it was accomplished with a deliberation quite foreign to them. The triumph and the course by which it is reached are characteristic of Vermeer's way. When we turn to the works of his contemporaries, not only to the corresponding subjects of Dou and Maes but even to a picture as close to Vermeer as Metsu's *Sick Child* which often hangs in the same gallery, it is clear how essentially he was now at variance with convention. And in the difference lies the value of the *Maidservant*. The bare notation of tone with which her head and arms are stated is unexplained and unsupported by any of the descriptive linear fluency which draws the eye to Metsu; it creates for her a distant world of her own. Her act is simple, customary, unrevealing. Her only life is that which

[40]

she shares with the matter about her, to receive the light with a passiveness remote from time and personality.

The *Maidservant* is never repeated: it stands alone. It is Vermeer's single approach to a positive and substantial view of human activity. By the standards of the humane painters it would seem his most considerable work. Yet its very positiveness excludes something essential and personal to Vermeer. The works which follow the middle phase are refinements on the same theme, the standing figure of a woman stationed by a table whose sharp corners separates us from her, a figure standing motionless in the same daylight. But the view which the pearl pictures unfold, though the development appears inevitable in retrospect, is almost the antithesis of the earlier work. Vermeer's evasiveness and his resistance to direct human response now reveal their intimate value. The idiosyncratic, even crippling traits of his temperament, far from being discarded, are embodied in the expressive matter of his art. The concentration and the constraint of the middle phase are relaxed; reality and physical substance have exacted the painter's tribute, characteristically both ambiguous and generous, and their claims give way. There is uncovered, not less real, the world that is Vermeer's own, growing out of light before our eyes. It is the field in which will be deployed, in all their immaterial gravity, the pure progeny of his eye. Here the forms of visual impression are to become the forms of his feeling; his purposes are to be reconciled at last. The unyielding forms of the naturalistic style and their characteristic surfaces, the forms of the Dresden *Letter Reader,* are far behind, and with them the clotted pigment in which they were rendered. Vermeer's world as it now develops towards its immaculate completion is the world of the mirror in *The Music Lesson.* It is a world that is autonomous and independent, not described but describing itself, in terms of its own element, in terms of light. The daylight is the same; it is the lucent whiteness of a veiled sky which in earlier works has decorated beautifully the real physical world, redeeming incidents that take no account of it. Now it outlasts them. Even the slight hint of natural substance that was given, of the lady's sleeve gathered into her bodice, for instance, in *The Music Lesson,* still carried an implication of activity and the possibility of lively natural contact. That vestige has gone; incident and material have evaporated and light is the sole active principle that remains within the confines of the picture. The window itself has a new significance. The inhabitants of the room turn to it as to the

source of their being: its light recreates them. The girl who puts her hand to the casement and grasps it, whose finger-tips we see as round pools of radiance through the glass, is translated. She steadies herself in the moment of rebirth. More and more fully in each succeeding picture there is presented to us a new creature. She is a being of authentic existence, a living presence, but one whose humanity is evoked as in a visible allegory. Tone, as we see if we turn for comparison to any naturalistic picture, is a symbol: this lady is rendered in the intangible terms of visual impression. Yet they are intimately and properly her own. The impersonal record of light is her emblem; through it she and the painter find liberation.

Each flowering of Vermeer's style is also a sophistication; there is a progressive narrowing of aim. The process is never clearer than at this crux in his development. We can follow the change as it is reflected in the accessories of his subjects, his passages of still-life. Earlier the pictures have been furnished with the ample domed shapes of loaves in round baskets or with spherical fruit in shallow dishes. The spherical white jug has been offered up to the light on its round platter: the shining ring of a wine glass has been cradled in careful hands. All are images of satisfaction, of natural volume that is in full, appropriate possession. They are images of a completeness which at the centre of his subject, where the matter is human, have not been within the painter's range. Then the horizon contracts and the worldly substance dissolves: in one picture we watch as a ewer in its basin loses its shape in a pattern of lustre and reflection. And the corresponding image in the latter phase is quite another. On the tables in the pictures that follow there lies an open box and drawn from it, among the feminine filaments, a string of pearls. They are the property of the lady who stands beside. We recognize them as part of her, an extension of female nature. The visible shape condenses the breath of an abstracted life, pervading everywhere.

At the turn of Vermeer's development it is for a moment in doubt whether space or light, in themselves, will not emerge as the chief of his motifs. But in the pearl pictures and their successors his subject is once again clear. From whichever side we approach him we find the same paradox: it is at the moment of barely human detachment from the last trace of tangible substance that he is able to turn freely to a theme whose humanity is its essence. In the refined medium through which they show themselves human beings now shed all

disquiet. The uncomfortable directness of the glance which was exchanged with the girl in the picture at Brunswick is dissolved. Defined in light, assimilated, it takes on the form of the Mauritshuis *Head*, the form for which the only simile is that which Vermeer offers us: it is like a pearl. Nothing is stylized, nothing is lost. The process is one of incorporation; it is a reconciliation. Seen as visible essences, in suspension, form itself and living presence are encompassed at last.

In these pictures Vermeer's detachment reveals itself as a quality of love. When his two purposes, to capture the world and to escape it, achieve resolution they are found to be one. And the latter element, the paradox, emerges as the fertile essence of his thought. To understand this grave and wonderful maturing we may need to recall a whole aspect of European tradition which we have overlooked. We can conceive of Western painting as being, perhaps always, a possessing. The difference, in this sense, the variety, is in each painter's valuation of what constitutes real property, of what most genuinely enriches himself. Vermeer put the violent acquisitive flourish of the baroque, a monstrous aggression as it seems, behind him with his earliest work. But even the modest exercise of naturalism itself evidently came to be felt as contaminating and damaging, not only to the painter but, at least as profoundly, to his subject, to the physical world, involving a loss of its very virtue, its separateness. Painter and subject both require to be free of the irksome material attachment. And separate at last both find their natural condition, their fullest life. The feminine subject is intact, entire. The painter has no part in her immemorial existence. She remains outside him, essentially and perfectly other than he. And being so she is to him the most complete enrichment. The necessary halves of a world have come together: it is a marriage of light.

Thus it comes about that we see Vermeer building the ideal shape of domestic and feminine life. The representation, the construing ever more closely of the aspect of the beloved as it moulds her mask of light, is also an independent, intact construction of the essential forms of female being, in their permanence. Looking back again to that first appearance of so much that is most deeply Vermeer's own, we find its beginnings in *The Music Lesson*. As if in visible lifting of the naturalistic burden the outer skirt of the lady who stands at the virginals, like that of the *Maidservant*, is drawn up in the common fashion, and beneath it is seen another. This lower skirt hangs in regular, vertical folds; it is

fluted and independent as a column, one whose capital momentarily shows itself in the curled volutes of the head-dress. Nothing intimate is uncovered. This is the unveiling of an impersonal core, the emergence of a principle which has been latent, held in reserve, since the Dresden *Letter Reader*. It is the discovery in female physique of the rhythmless quality of a monument. All its development is implicit here. We may foresee its growth, its accumulation of meaning until it appears entire, standing free in its final shape, the shape of the servant in the Dublin *Letter Writer* and the *Lady Standing at the Virginals*.

This is the particular theme of the pearl pictures, a gentle stillness of stature. The shape is vertical. The figure appears, tender and immaculate, out of the cleft shadow of the cumbrous furniture; it is rooted in it, rooted, as we see at last, utterly unmoving, to the floor. And besides this upright shape, this pillar, we come to know another, its antithesis that nevertheless easily and equally combines with it. It is the shape of a bell. It is noticed as the shape of the raised skirt in *The Music Lesson*. More essentially we remember it as the shape of rounded shoulders which is often the stooping shape of preoccupation, of a woman bent attentively over a table. It has a feminine quality of self-possession: in retrospect we realize that some of the incongruity of the conversation pieces, the first crude formulations of attentiveness, was that there it was applied to the egregious cavaliers. It is the shape which identifies itself, in *The Concert*, the *Lady Weighing Gold* and the Amsterdam blue *Letter Reader* at least, as the draped body of a woman with child.

With these two forms, the dual embodiment of an essence that is in the air, we meet a third. Among the furniture is a table, its great bulk covered with a carpet that reaches to the floor; there is no overlooking it. We might compare its shape with the time-resisting base of an obelisk, or with a tented pavilion, presenting to us its shaded, patterned face. It is flat-topped, pyramidal, infinitely stable; in one last daring, perhaps over-precise identification its form becomes the skirt of a seated lady. It is also the shape of the curtained aperture through which we see to the heart of Vermeer's grandest works.[17] As we know it best it is the carpet-covered table. Outwardly it has no life, this closed and weighty hollowness: deadness is its first virtue, as a neutral fortification. But in its repetitions and variations from *The Music Lesson* onwards it finds a kinship with the lady herself. It becomes an impersonal extension of her, her mediator, reconciling her special forms with the squareness of the frame. It has the

character of a buttress, with its leaning sides whose root-like fringes draw strength from the floor, and when the letter writer sits behind it, resting her bell-like shape intently on it, it is in fact her support, her inseparable pedestal. The carpet-covered table also renders a service of a less material kind. More generally we recognize its shadow as a gathering of any mystery that may have hung in the air. It is felt as the embodiment, perhaps, of whatever of the fertility of women has not been incorporated in this world. Thus it acts, in its stability, to bear the last burden of feeling, of femininity, to hold it in stillness. Through it, through this family of forms, female shape and nature are built indestructibly into the picture.

So we reach the summit of Vermeer's achievement, the peaks of a range whose whole length stands high above its surroundings. We come to the pictures which were painted in the middle sixties before Vermeer was thirty-five years old. When we recall the *Studio* there rises, first of all, a memory of the equality of forms. The subject, the description of a painter's life which is also an allegory of his art, fills the picture. There is no point of concentration: even the lovely object of attention delicately disowns it. The meaning is everywhere, evenly distributed through every shape. The equality is absolute. The picture, the representation, rules itself: it is the very visual consistency which establishes the perfect order that we see. Colour reveals itself as a general saturation, a vital principle which is manifest everywhere. It is the visible sharing of essence for which we have no words, which is yet the object of everything that is written of Vermeer.

We come upon a world quite separate, set apart of its nature: it might, as always with Vermeer, have met our eyes by chance. It concedes nothing to us: no recognition of the meeting disturbs it. Nothing interrupts or impoverishes its continuous life. Its parts exist together in perpetuity: none has precedence, each is distinct. And in the distinctness is uncovered the character, the open secret, of the assembly. Each form is coolly, positively itself, and being so finds a deep alliance, an identity of nature with all its fellows. It is their bond to hold in common a clear quality of being. The effect is that which we know when it is seen, in another picture, that the nature of the Amsterdam blue *Letter Reader*, her very pregnancy, is shared by the saturation of the wall behind her. Thus, together, forms discover to us their virtue, their fulfilment. Each, of its pure, still vitality, has its own untroubled access to an ideal retina. This world has by nature

the capacity to make itself seen, to give up without loss its gift of light, to provide its own intimate emblem, its own art. Only here, at last, we understand what it meant to the painter to watch the world of light in the real exercise of its autonomy. He was engaged in unfolding the deepest fantasy, the fantasy, as it seems, that visible things in their integrity were capable of coming together in the community of a perfect plane, were capable there of meeting him and of conferring on him all the enrichment of outward things, the fantasy that on a flat surface the world in essence could become his. The germ of it was in him from the first, sought yet hidden, covered by its very contradiction, seeming if ever within the grasp of thought, as it might seem to us, to lead at best to artifice, to abstracted pattern. Yet this was the fantasy which was confirmed in truth, in science, and in the contrivance with which he was equipped, perhaps by a friendly scientist, bodied forth under his eyes: imagining the experience we know the rapture of the camera cabinet. Before him lay the whole depth of the world. There lay the forms of life, disposing themselves in their luminous essence upon the table of his camera, lying in their final amity flatly together, intact.

Such was the consummation of Vermeer's purpose, preserved for us in its marvellous monument. Nothing else evokes the impression, certainly no printed reproduction, nothing but the canvas itself: we see, large and plain, a mosaic of shapes which bear equally on one another. They are clasped together by their nature, holding each to every other in its natural embrace. We see a surface which has the absolute embedded flatness of inlay, of tarsia. And in the instant we recognize its shapes as emblems which carry in their stillness the force of the real world.

If we seek the beauty of a style, it lies in its intimate necessity. Only this way, no other, could allow Vermeer to uncover the heart of his meaning. Only this distribution of the impact that life makes upon the eye could so contain its shape. In a form that is symbolic on every level he resolves the enigma that for him invests the act of representation itself. And turning, as if from the tree to the fruit, to *The Lacemaker* we find how much lies open to him in the great moment. Never before have we come so close to this other world and its creature. Weight and volume, the lovely bulk of head, seem in their lucent translation almost within our measure. Yet her distance remains; with gentle firmness the impartial tones convey it. Tangled defences are woven about her:

she is enclosed in the impenetrable envelope of space. We have come upon female life in its whole secluded richness: engrossed in itself it is seen entire and unimpaired. There is in the meeting a sense of personal completion. It is as if a need had lain unspoken from a time beyond memory, the need of an indispensable complement, the need of its achievement in this one delicate, immaterial symbol and no other. We share in a fulfilment; we derive from the tiny canvas as deep a nourishment as sight can hold.

HIS SUBJECT

It often seems that the criticism of painting should be printed in parallel columns, as simultaneous readings in the various levels of meaning which painting holds. The present inquiry has been founded, in the first place, on the nature of the pictures as representations, on their visible character. Other points of departure were equally open; they might have led to no very different result. The very opposite course, the investigation of the painter's relation to his sources and to his contemporaries, which will concern us later, in the commentary on individual pictures, yields a clear view, though a less intimate one, of his temperament. When the discussion reaches such a picture as the *Studio* the shortcomings of the present standpoint are apparent. In the *Studio* the invisible threads which have been felt in the web of Vermeer's meaning are gathered palpably together. The picture is a deliberate allegory, like the only other of a similar size among the mature works: it is symbolic of The Painter's Art, and was known as such in Vermeer's time to his own family. We feel no incongruity in the uncovering of this allegorical reference. The *Studio* appears quite consistently in Vermeer's development. Evidently, if the intention of his imagery is not to escape us, we must overlook none of its associations. His subjects exist in their own right, as did the subjects of all painting, invariably, until the latter part of the last century; we are perhaps no longer tempted to neglect the fact. Only in such a case as this, where the visible shape takes on so deceptive an appearance of purity, is it still difficult to take account of that level of meaning, often as rich as any, which pictures hold as illustrations.

Vermeer's world is the household; it is the setting of the great part of his work. He deals, that is to say, with a subject which more recent painters have shown us as lacking any content other than the sufficiently absorbing themes of daily life and its routine. Few of Vermeer's pictures expound the subject in this

simple fashion, in the fullest sense only one, the *Maidservant*. To apply to him the label which belongs to the great painters of household life in this century, the label of intimist, is to place a limit to our understanding. There is a gulf between Vermeer's view and ours. And it seems the greater when we notice that the subject with which his career as a genre painter so far as we know it begins has hardly appeared again in any memorable picture between his day and ours. The subject of *The Procuress*, venal love, was a common theme of secular painting in its earliest phases: in the seventeenth century it was a favourite among the painters of Utrecht and wherever in Holland their influence was felt. Nevertheless in 1656 when Vermeer turned to it, in its purest histori-cal form, it was already a little archaic: if such a composition were discovered among the works of Fabritius, De Hooch or Maes it would arouse some slight surprise. In Vermeer's picture the reminiscent flavour is hardly felt, for he clothes the design in the convention which was current in his own school in the earlier part of the decade. Its appearance is none the less exceptional. If we seek an explanation only one presents itself: the subject itself was of great interest to Vermeer.

This reading is confirmed when Vermeer turns again, a little later, to the illustration of a positive theme. The incident of the *Soldier and Laughing Girl* is drawn from the common stock; in the early fifties it was a typical subject of De Hooch. It is a legacy of the wars, the entertainment of foraging soldiery in a house that is more or less of a tavern, a scene in which the extent of the hospi-tality that will be exacted of the agreeable hostess is rarely open to doubt. In Vermeer's picture the subject is transposed into the setting of the latter part of the decade and rendered with the perfect mildness of his method; its intention might well escape us if we had not his prototypes. Its essence remains. This subject with its delicate hint of erotic *force majeur* is a translation into the do-mestic idiom of the formal theme of venal love.

During the years in which these pictures were painted the common matter of genre painting was developing in quite another direction. Under the in-fluence of Ter Borch its milieu was shifting to that of the most prosperous bourgeois life. In this new convention the characteristic happenings are leisurely and elegant; there is a show of gallantry. One element of this imagery particu-larly concerned Vermeer. Over the seated lady whose eyes meet ours in the conversation-pieces there bends a man, an assiduous visitor, in the picture at

Brunswick odiously attentive, breaking in upon the quiet life of the room. This theme, the motif of interruption, is an old one and in its origins, in the Merry Companies painted in Haarlem thirty years before, its significance is clearly conveyed. Often indeed it is seen that the man carries a few coins with which to press his proposal: Vermeer's contemporaries are more discreet. We are informed only obliquely, though none the less certainly, of the errand which brings the gentleman to the *Girl Interrupted at Music*. We learn it through the medium of the picture, Cupid as a messenger, which hangs behind him on the wall.[18] The possessive hand no longer finds its way to the girl's breast, no money is offered, but the motif of interruption in these pictures remains the civilized descendant of that which appeared in *The Procuress*.

Much of genre painting is coloured by an erotic element, open or half-concealed. We can understand it as lending to commonplace existence a quality of universality, a quality if not a status comparable to the older orders of subject matter, and as lending, too, a universal appeal. Both advantages may have contributed, distantly, to its appearance in the painting of Vermeer. But convention alone does not quite account for his persistent reversions to the theme, to one strand among many in the complex imagery of genre, and that in his time in Delft by no means the dominant. The line of his development makes the problem no simpler. In the later pictures we discover his creatures in moments which have at first sight no particular significance. Yet the emotional content is far from weakening. It seems that the essence of Vermeer's subject extends beyond its exterior happenings: in analysing it and its complex devices we enter upon yet a further level of his meaning.

Nothing is more characteristic of Vermeer's course than the transformation that the theme of *The Procuress* undergoes in his hands. At the outset it is the single and conspicuous subject of a great masterpiece. In succeeding pictures it is progressively refined into subtler and more elusive forms. Finally it is seen, as if in a marginal note, only as a picture hanging on his wall: it is a *Procuress*, a work painted early in the century by the Utrecht artist Baburen, that appears as a decoration, a collector's piece, behind *The Concert* and the *Lady Seated at the Virginals*. These last oblique references to the theme are certainly no more intended to escape us than was the Cupid in the conversation-piece. Yet it is not easy to accord to such devices their full value. Whenever an artist represents as part of his subject a work in which we can construe another, an image

within the image, we may expect that the conjunction will prove significant: the use of the artifice will be well enough known. Nevertheless we can hardly share the taste for allegory which Holland pursued to such incongruous extremes—where else did a man arrange to be painted with his betrothed as the Archangel Gabriel and the Virgin Annunciate? And we do not welcome an elaborate correspondence between painting and life. Courts of Law are no longer decorated, as was that in Delft, with the Judgment of Solomon, and the Raising of Lazarus would not now suggest itself as a symbol of civic and national renascence, as it did when a picture was sought for the townhall at Bergen-op-Zoom.

The meaning that Vermeer gathers from the pictures on the wall is his own. He does not often seek for his subjects and generalized philosophical enforcement, of the kind that Velázquez extracts from the decorations of his great genre-like works, painted in Vermeer's time. Vermeer's meaning is specific though by no means direct: he contrives, almost secretively, his own mythology. Only one precedent suggests itself for the personal quality of his devices. When Elsheimer's Jupiter takes his ease with Mercury in the house of Philemon his eye falls on a woodcut on the wall.[19] We see that the print depicts another of his exploits, a lustier one, with the same companion, and in the moment a recollection of the god's outrageous power enriches the scene. Goethe thought the stroke worth more than an arsenal full of antique crockery;[20] we may imagine that it would have been to Vermeer's taste.

The pictures on Vermeer's wall are an appropriate vessel for the complexity of his meaning. It is no chance that the Cupid and Baburen's *Procuress* were his favourites: they are relevant to the burden of his thought. It may be that whatever interest the manner of Utrecht held for him lay as much in its invariably lascivious application as in any deeper quality of style. It is a privately lascivious fancy that this device, a picture within the picture, first appears in Vermeer's work. Behind the *Girl Asleep* the corner of a painting is seen, hanging on the wall: it is, as only the artist and his intimates could have recognized, the Cupid which we know from later works. On the ground, beside the Cupid's foot, there is inserted a detail which never appears again, designed evidently for this occasion only and giving us our only evidence that any significance is intended here, the detail of a discarded mask. That is all, yet it is clear that lacking this passage the meaning of the whole picture would

be different. Without it we should feel in the *Girl Asleep* a certain oppressive-
ness: the subject would hold a sullen quality which is foreign to Vermeer's
thought. Here the moment is illuminated to show its hidden nature. Sleep is
revealed as the dropping of a mask, uncovering the fantasy which is the sleeper's
secret, a fantasy, as we may guess, of Love.

The picture which contributes its delicate and private overtone here is no
more than a tentative rudiment of the device as it evolves in later works. The
privacy of Vermeer's method remains: in any separate case we might almost
think that to pursue the meaning would be to force upon the work more than
it could ever yield of its own accord. We can seldom, in the work of any painter,
tell how much of his revelation was deliberate. But a possibility that presents
itself so often cannot be fortuitous: Vermeer's style, more than any, is closed to
chance and we can be sure that it is not to chance that we owe the meaning of
the *Girl Asleep*. The Cupid figures again, a little later, in the next unfolding
of Vermeer's method. We may wonder whether the broad lines of the map
behind the *Laughing Girl* do not add something to our impression of the
soldier's bold plan of campaign, but the effect of the Frick conversation-
piece is more positive. In *A Girl Interrupted at Music* the reference of the pic-
ture on the wall is of the simplest kind; the purpose, the erotic emphasis, is
not subtler than that which similar pictures serve in the works of Jan Steen,
though not before his contact with the school of Delft.[21] Vermeer's symbolism
is never so direct again. The later variation of the motif, the motif of inter-
ruption, shows us his way: it is the measure of his sophistication and detach-
ment.

The progressive refinement of Vermeer's subject reveals his paradox in yet
another aspect. The theme which has engaged his taste proves also, subtly, to
offend it. The whole of the ambiguity is seen in the conversation-piece at
Brunswick. The man, more villainous at first sight, more pressing than ever,
bends over the lady in his customary fashion: we feel for her. A second glance
shows that Vermeer himself now stands aside from the presentation. The
serpentine attentions of this cavalier are openly contrasted with the upright,
ideal man, painted in the style of Palamedesz, on the wall. The calculation is a
nice one. The suitor is transfixed. This perfect objectivity holds the possibility
of mockery: we may view him as we please, lusty or ridiculous, and the situa-
tion is saved. And looking closer, it is seen that the cavalier, rendered in so

simplified a pattern, is no more than a figment of the man he seemed, the man who pays his court in the works of Vermeer's simpler contemporaries.

This, evidently, was the point at which outward events, real happenings, ceased to hold the painter's imagination. Conventional incident disappears from the pictures that follow, and with it the brightly compelling local colour which expresses it. Vermeer is no longer concerned to fabricate the fictitious elegance and gallantry of the conversation-pieces: his figures are again discovered in the dress which was customary, as we may imagine, in his own household. The undramatic subject is found to hold a meaning of the utmost depth, the meaning which we first perceive in *The Music Lesson* and *The Concert*. Others of the genre-pieces set forth similar moments in which action is suspended that we may know the pure essence of relationship: the drinking scene at Berlin approaches, in more robust fashion, the mood of *The Music Lesson*. But never is so subtle a tension revealed as here. The painter's characteristic devices take on yet a further complexity. On the wall of the room occupied by *The Concert*, beside one of the romantically shadowed landscapes which often appear where otherwise an unfeeling formality might mar the scene, there hangs a more legible subject, Baburen's *Procuress*. As we construe its three figures, and something of their ruthless transaction, we become aware that they supply an ironic commentary on the performance of the trio in front of them; its immobility, its very innocence, gain a curious significance. *The Music Lesson*, possibly the pendant, sets forth the opposite theme. The amiable concord of *The Concert* is banished; instead a solitary lady fingers the keys, choosing to remain unaware of the gentleman whose gaze rests upon her. We see only enough of the painting on the wall to discern a man, a prisoner, kneeling with his hands bound behind his back. But it is sufficient to illuminate the rapt look of the gentleman in front of it. In fact it is part of a *Roman Charity*, calling to mind an inconceivably abject dependence of man upon woman. The antithesis is complete. We gather that over these scenes there rests, as gentle as the air itself, an allegory of liberty and bondage, an allegory, as the inscription informs us, of the pleasure and the melancholy of love.

Here the painter has reached the form and the meaning which are his own. His theme is purged of its grossness, its importunity. But so long as Vermeer has a positive subject, his subject remains the attention that man pays to woman. As he attains the pure form of his maturity we see again that in this evolution

nothing is stylized, nothing is lost. We find, looking back to the conversation-pieces, even to *The Procuress,* that what is most memorable, most lasting in their drama is the part which has been played in it by the lady. Under the pressure of male attention, neither resisting nor complying, she has remained of her nature intact. There is inherent in her being an inviolable status, a separateness. In Vermeer's maturity the subject of the conversation-pieces is incorporated in a single body, the standing figure of a woman.

The lady of the pearl pictures inherits a rich accumulation of meaning. Sometimes it seems that half the imagery of the genre tradition hangs about her, invisible. Yet she is usually alone, waited on only by the light. Daylight, the window itself, is indeed a presence in the room. It is to the light that the musician turns from her lute, as to a beloved visitor. And to the window the girl with her adornment, her necklace, turns no less than to the mirror first to show herself. These are fancies, though iconographic study lends them sub-stance; fancy, no less than the visible shape, is the fabric of these pictures. Their reference is rarely simple. Allegory and analogy are knit together: the whole of the painter's artifice is employed. The essence of his meaning remains parti-cular and personal. No doubt the picture of the *Gold Weigher* might have been painted and sold as an allegory of the Last Judgment, in accordance with the subject hanging on the wall. To us, and to the painter, as we imagine, the con-verse allegory is the more significant, that which gives a quality of the uni-versal, a cosmic balance, to the fact of womanly judiciousness. More typically Vermeer's parallels are purely visual. The richness of the last works is of the kind which we see in the *Guitar Player.* There is found in her ringlets the char-acter of hanging foliage: her bell-like shape is compared with the round head of a tree against the sky, painted in the style of Wynants behind her.

Vermeer's fantasy comes quickly to completion. The whole construction is finished in ten years or little more. At the culmination its creatures emerge in their independence, taking on, as it seems, their natural clothing. They appear in turbans, or in the beautiful skirt, seen between the furniture, of the model in the *Studio,* or in a wide, striped hat; their costumes, although there seems nothing surprising in them, nothing immediately exotic, are often such as no painting has ever shown us. We do not know the full associations that the dress of Vermeer's fancy holds, nor do we need to. Perhaps a hanging length of lovely fabric, a woven cascade gleaming distantly in the air, recalls to us that

his father, early in life, was a silk-worker: the brilliantly feathered hat of one of the ladies has more connection with the fashions of his childhood than of the decade in which the picture was painted. What is clear is that fancy brings to light the dress of a foreign world, an ideal orient, which is the immemorial world of femininity.

The fancy costumes are seen in a few pictures only and disappear. They are gone before we have any sense of a weakening in the painter's concern with existent things. His purpose is to isolate an essence at its richest, a symbol with the force of common life. The principle has been present in embryo from the first: the *Head of a Girl* is the successor of the *Girl Interrupted* and she of the girl who was seen in the company of *The Procuress*. From the grossness of the traditional subject, the force of erotic circumstance, Vermeer has distilled his pure theme: he has discovered the virtue of female existence, its separateness. We gather from the process the understanding of an intimate sense in which style and substance are one: we see his development again from this other standpoint as the uncovering of a love which leaves its object unimpaired. His theme becomes the theme of his own life. The attention of man to woman is finally identified with the attention of a painter to his subject. The *Studio* is not only the crown, it is the sum of the pictures which have led to it. The model is The Muse of History, and as such not only the fellow of painting and its inspiration but also the bearer of the fame which is its reward. More essentially the model is feminine, she is a young girl. Her disposition is characteristic. She both invites the painter's attention and as tenderly wards it off. Her delicacy is protected by the lustrous armour that she gathers about her; the impersonal quality which her emblems confer on her is also a precaution that the calm of the room shall not suffer interruption by the intimate charms of life. The painter, as always in Vermeer's world, remains an inscrutable cipher. He cannot reveal himself. But, typically, to supply an element whose lack would be felt, a male face does appear, a plaster cast. It is as if some of this painter, whoever he is, the heroic part of him, lay slain and dismembered under the goddess's glance. In this equilibrium action and passivity are balanced: in symbol as in style Vermeer's paradox is resolved.

We are still not quite at the heart of the painter's subject. The two pictures painted close together at the end of his career, the pictures in London, bring us nearer to it. The scenes are similar: two ladies idly occupy themselves at the

virginals. Yet between them an essential antithesis is felt. There is a contrast: it is presented to us by the pictures on the wall, the erect Cupid and the pliant courtesan. We find it again in the landscapes, one rocky, the other verdant, which decorate the lids of the instruments. Everything contributes: such a detail as the viol with a bow resting between its middle strings, extricated from the tangle of *The Music Lesson*, has its own undertone of meaning to add. There is an intimate significance in these pictures. Each is the final embodiment of a principle: together they expound a dual view of female nature, challenging and receptive. We have come upon a deep pattern of Vermeer's thought.

The antithesis is very familiar. We have known it in every stage of development. It is the theme which has from the first opposed the seated lady to the standing, the attentive to the active, the shape of bell to that of pillar. Neither statement is complete without the other; they evolve together, at every turn revealing their complementary essence. The lady standing aloof in *The Music Lesson* supposes the existence of the mild, amenable creatures of the pendant. And in *The Concert*, perhaps originally designed alone, the seated lady requires the presence of her standing companion. The Dresden *Letter Reader*, most sufficient of pictures, must still be followed by the *Soldier and Laughing Girl*.[22] In its most memorable, most permanent shape, the opposition is the theme of mistress and maidservant as they appear in the Dublin *Letter*. But equally it is the theme of Mary and Martha. Involuntarily Vermeer unfolds his double subject, his definition of female nature. In the definition, nowhere more, something of his own nature is defined.

THE LAST PHASE

The achievement of Vermeer's maturity is complete. It is not open to extension: no universal style is discovered. We have never the sense of potential abundance that the characteristic jewels of his century give us, the sense that the precious vein lies open, ready to be worked. There is only one *Lacemaker*: we cannot imagine another. It is a complete and single definition. When the great works of the middle sixties are accomplished something, a quality of tension, goes out of Vermeer's thought.

The final phase has none the less its own marvels to show. At the time of *The Lacemaker* there are signs of a wonderful boldness. We have no longer to deal with elusive intimations: in the *Guitar Player* and the portraits in Washing-

ton Vermeer's method is openly revealed. Technically the change is remarkable. The veils of thin paint which have lent a semblance of continuous modelling are cast off: the *Red Hat* presents an optical record, bare and authentic, just such a record as we know to have formed the basis of earlier pictures. Now the mosaic of tone is seen naked, justifying itself. Light and shadow proclaim their own epigrammatic statements: they override the logic of form and paradoxical unities are discovered, unknown in the whole of pictorial art. Life surprises us with the face of optical abstraction. Eyelid joins to temple, irrespective of shape or surface: the prominence of a nose unites in flat shadow with the plane of cheek or lip: a boundless forehead imperceptibly becomes hair. Then, progressively, the paradoxes become patterns. Perfectly polished, they take on a garment of pigment that is immaculate as enamel; they shine with an adventitious glitter. There is gathered at random from shadow and substance, from marble and satin as much as from the light, an endless display of decorative device. The pictures find a place at last for the busy neatness of everyday things. They share the pride of the domestic world; they wear its own charming, spotless surface.

Vermeer's impressionism has always a cryptic quality. The obscurity of its expressive function is a part of its nature. Its lucid surface holds suspended a contradiction; its purpose is as near to concealment as revelation. But when he makes with every device at his command his last attack on the anecdotal convention, there is a brazen quality in his manner. Under the brilliance of *The Love Letter*, behind the liveliness of the scene, there is a perversity in his purpose. No design shows his paradox so boldly. The picture is a sidelong advance along a forbidden road where each ingenious step involves the painter in a greater virtuosity in extracting himself from the predicament. The incident is unmistakably human, active, even vivacious. It tells a story and lest the story should escape us it is painted with a dapper violence, in contrasts of tone and colour of a sharpness which is never approached elsewhere in his work. Even the handling of paint affects, in the veins of the marble floor, the free calligraphy which earlier was outside his range. Nothing is lacking of the lively descriptiveness which Vermeer has skirted so cautiously in all his work. Yet he contrives to preserve his detachment. The aperture through which we are allowed to glimpse the whole morbid fascination of the genre world is not only a frame but a screen, an impregnable defence. However violent the juxtaposition of

blue cloth and yellow satin, the zone of neutrality around it insulates it from us. However black the ebony frame against the white linen cap, the shadow of the curtain and the broom waiting in the foreground are a fraction darker; they confine the impact inescapably in an envelope of light.

The Love Letter is a curious demonstration. Perhaps it has some of the quality of a retaliation for the discomforts that the genre convention has often seemed to inflict on the painter's temperament. A challenge which his circuitous approach has not quite met is disposed of at last; the prosaic descriptiveness which was a commonplace in the style of his contemporaries is here, with every precaution and the most ingenious saving clauses, brought within his compass. The gesture of liberation, and the wilful glitter which conveys it, allow us to guess how far his submission to the limitations of the earlier style has been involuntary. He assures himself of his confidence almost too openly in this shining, impeccable paint. We see Vermeer, clothed in its armour, reaching out again to the real world. The gesture is full of ambiguity: fundamentally he does not change. The substance and movement of life remain beyond his grasp. Nevertheless there is a discord: the consistency of the development is broken. And *The Love Letter* is not the only breach. Another letter picture, in the Frick collection, is so little characteristic in its present state that we can hardly be sure of the authorship. A third of the late works departs even further from Vermeer's way, in another direction. The genre setting and his own room are made the frame for a grandiose religious *Allegory*, arranged on the most conventional lines and as conventionally represented.

Vermeer's character retained the trait which marked his earliest works. And at the climacteric, when his development within its limits was complete, when the restraining purpose relaxed, we see his art again as the art of an ambitious man. He still lacked the real triumph to which the early works had pointed, the grand eclectic consummation of the styles of his school: he had hardly sought it. But at the moment when his preoccupation with the primary element of painting, the act of representation in itself, reached its conclusion it must have seemed that the tangible reward lay open before him. It is no chance that in the still lives of the last phase the characteristic shapes, the globes, the ball hanging from the ceiling, the bitten apple, are spherical: they are idealized descendants of the round forms, symbols of a comprehensive vision, which decorated the early works. There is an opportunism even in the

[57]

style itself, with its wooing of the distracted forms of the everyday world and its accumulation of adventitious decorative detail. The pictures have again the character of isolated, marvellous gestures toward the worldly horizon, the character of the first works. As claims upon fame we find them in their directness less potent by far than the symbolic tribute which preceded them. Yet it was such pursuit that contributed most to *The Love Letter*. And thus, in another mood, Vermeer came to throw off the most intimate tie which bound him: the figure of the *Allegory* was perhaps the only one of his maturity which was not painted largely from life. An irksome problem was discarded, and with it the unique character of the solution. The painter's own consistency of representation was replaced by linear generalization, the consistency of the baroque.

We discover here an element, submerged and held in check since the earliest works, which had none the less a deep significance. The *Allegory*, even *The Love Letter*, are best understood as gestures of emulation, gestures incited by the apparition which was rarely far away even from the purest of Dutch painting, the spectre of the baroque. The baroque provided the example which dominated Vermeer's beginnings. And while other Dutch painters could carry its rhythm as a kind of trophy, a personal adornment, could wear the baroque, with Rembrandt, as a feather in the hat, Vermeer was compelled to take it more to heart. For him its force was not so much as an object of imitation as in its underlying character of careerism incarnate, a character of assault upon the world. The principle was of all most foreign to him. Yet he was aware that it lay about him, that not far away there worked great artists who had established a real worldly dominion and wrought their own ineradicable monuments on it. We can imagine how far the awareness went to stimulate his inveterate development of the antithesis. If any element in the art of an age were lacking all its products would be different. The impediment which lay in the way of the painter of *Christ in the House of Martha and Mary* necessitated, we can now gather how deeply, not only the pursuit of a perfection as far beyond rivalry as any baroque triumph but also a perfection that was formed around the very converse of the baroque principle, confronting to it the opposite essence of passivity and withdrawal. Buried among the profound motives of this single-minded detachment there lay the attraction of the opposite course, waiting to be let loose.

Vermeer's idiosyncrasy was not to be discarded. Only one way lay open to

him. Such genuine liberation as he achieved was achieved only in microcosm, hardly ever but on the scale of pictures measuring no more than the span of a hand across. The consummation of naturalism and the typical rhythms of his century eluded him. In the last works we detect no more than a momentary capitulation to the international style and elegant surface which were overwhelming the whole of his school. Occasionally as the epigrammatic renderings that Vermeer devised for marble, satin and gilt moulding became each more perfect and independent of the rest he conceded something to the descriptive standpoint of convention. But however elaborate or decorative his style, it remains a code of light, a symbolism beyond reproach. Even its quality of decoration belongs to no convention but his own. It is the decoration of a distant world: in the calligraphic marbling we find an inconsequent perfection unlike anything in the European tradition, recalling only the Chinese. We may wonder whether the painter of *The Love Letter* had not in mind some narrow vertical design from oriental art, in lacquer if not on silk, the leaves, perhaps, of a screen. It may be that these tenuous connections represent a last stage in Vermeer's appreciation of every available resource. The achievement of the final works was on quite another level. It was to realize with all the brilliant positiveness of his thought in this last phase the enduring essence of his style and his meaning, to sum them up in three pictures. These three, the pictures in Dublin and the National Gallery, illuminate the whole of his work.

The visible definition of female shape had been his continual purpose: progressively he had discovered in it the character of a monument. But for its fullest form and proper setting the discovery waited to the very end of his career. Representation in itself no longer presented its crucial problem. The dynamic element in his development had reached its end. The matter of life was within his control, perhaps too completely to sustain him longer on his pure and difficult course. There was both loss and gain in the conclusion. At the moment when the very motive of the development was solved the monumental principle found its fullest extension. Vermeer was able to give his designs their logical geometric shape.

Everything of Vermeer is in the Dublin *Letter Writer*, set out with a deliberation which was never his before. Form is seen plain, free of all that has ever seemed particular or accidental. Light carves in flat facets the simplest shapes. In the bare and perfect design two characteristic creatures meet at last, in the cen-

tre the standing maidservant, carved as simply as a pillar, exerting her gentle government over the space around, and before her the bell-like lady, engrossed in herself. They are the poles of Vermeer's world, revealed in the complementary character and held together in equilibrium. There is no impact, no drama: the balance is unshakable. It is a weighing of vertical against horizontal. In the square lines of this design there is made visible a reconciliation. The geometric furniture of life has come to share its nature: attended, as by judicious counsellors, by the long planes of hanging drapery, leaning inward one against the other, life and geometry stand together, made as one, perfectly still. The rectangular shape of a picture's frame, the rectangle which intrudes upon *The Love Letter*, is here locked finally into the subject itself. In the London pictures, painted rather later and seeming to stand a little apart from the rest, providing a gloss to the whole of Vermeer's work, we are shown the culmination of the agreement. The space around the *Lady Standing at the Virginals* is bound to her and to its frame more exactly than ever. Nowhere is the design of such economical symmetry: not movement nor even the magnetism that light itself has sometimes exerted now disturbs the shape. We cannot think that this world extends behind the frame, it is complete and utterly enclosed. The space is revealed in its essence as a hollow cube. The last doubt is removed by the lid of the virginals, raised like a third wall yet offering an ideal reflection of the opposite prospect, a painted counterpart of the view from the window that we never see. Precisely at the middle point of the structure, presented as in a box from which our eye has no escape, we find its essence, the central principle. From the standing lady we learn something of the painter's nature that we have hardly known before.

The common characteristics of all the painter's work, the remarkable order which he extracts from the world, his elaborate evasion of its human claims, suggest the imminent possibility of opposite qualities, a fearsome anarchy, a formidable, exigent principle not to be trifled with. Whether he skirts it, as he does in the earlier inconsistencies of style, or covers it with the merciful veil of light, the presence of the threat is equally clearly conveyed. It is as if he imputed to the visible world something of his own nature, the insistence with which he lays hold upon its likeness, the determination with which he makes it his own. Around his central subject, the figure of a woman, to which he makes so many approaches, each complicated by a simultaneous gesture of withdrawal,

an enigmatic meaning accumulates. The woman's detail, the complexity of her being, conceals a disturbing element. Examined too narrowly she will become a source of danger. The painter's style develops along a line of self-preservation; its infinite ingenuity is all directed to isolating from these latent, intimate perils the visible beauties among which they hide.

Upon such depths the criticism of style does not embark. But among the latest pictures we may notice statements whose ambiguity has the profoundest personal force. From the lady who stands at the virginals the last vestige of particular substance has been refined away. The play of light has itself a barely credible economy; never was a system of tone more closed to those unwilled gestures of sympathy in which so much painting finds its justification. Yet out of the impersonal pattern of reflecting surfaces there emerges a palpable image, a human being. She displaces the light with measured purpose. Her existence is positive, her unshrinking nature, her very delicacy, extend the meaning. Her presence has the force of a challenge. The picture has no other theme; lest we should elude it the imponderable map of the woman's head is linked in ebony bond, inescapably, to the erotic emblems that are urged with equally inscrutable gesture on the wall behind. The cupid's support lends her an inflexible air. Her very height is a part of her armoury; her stature reveals itself as a quality of native power.[16] Concealed in this glance, in the pattern of satin, ebony and lace, we meet at last the ultimate quantity round which the painter's work has revolved, the force of female aspect.

It is a triumph of Vermeer's passivity. The poetry of the painting, here and elsewhere among Vermeer's last pictures, is involved in its very closeness to simple statement. The impressionism, now so perilously lucid, yet contrives to hold the image in suspension. The cryptic weight of expression which the tone carries, the index at once of the eye's insistence and the unmeasured, devouring depth which awaits the heart, is easily, immaculately borne, without gravity or gaiety, precisely balanced. We can almost gather the message of the picture from a single passage, the sleeves and shawl perhaps; it is there that the pregnant neutrality formulates. And there, as the eye moves across the surface, from corner to corner along the rectangular avenues and returns, we are reminded again of the limit of its meaning, paradoxically both narrow and bottomless, reminded that the grace of Vermeer's world is to wear to the last the garment of a retinal impression, to claim no greater depth than the play of light.

HIS REPUTATION

The painting of Vermeer's nearest associates belongs recognizably to their time, to the same stylistic fabric as the interiors which they represent. The rhythm of Metsu has a natural kinship with the picture frames on his wall. In Vermeer this affinity lapses. The possibility of an art in which issues of immediacy and withdrawal, nearness and distance, play such a part certainly hardly existed before his age. Tone itself and pure visual phenomena were not in any earlier century capable of the autonomy he allowed them. But the essential content of his style has no local reference. Vermeer disengages himself; there is no understanding him in terms of a decorative scheme. The vision which his style reflects, at once a way of seeing and a rejection of common perception, follows its own logic and reaches its own characteristic and unique solution.

When we consider Vermeer's forms and seek their like it is not to any of the painting of his school or his century that we turn. The shapes that he discovers for female life and the consistency of his pictorial form recall an earlier and purer season, the spring of European tradition. The affinity is with Italy: other critics have had much to say on the subject. It will be clear that as we approach the essence of Vermeer's art the parallel which has been often considered, the painting of Caravaggio and his time, no longer applies: none indeed could be less relevant. We think rather of the early Renaissance and the purest of the constructions that it gave the world. There is a difficulty in following such a connection, and one that will be particularly felt at a time when the idea of historical determinism takes on so many specious and popular forms.

We are not here concerned with influence of the kind with which historians are used to dealing. We have no reason to think that Vermeer saw any of the works which none the less must be considered with his. History presents many such problems. Where the essence of form is concerned, the common notion of influence often seems misconceived. No doubt we are sometimes the victims of our own method. The criticism of style is naturally and usefully concerned with separation, with the isolation of one picture or one artist from the rest. Yet history appears to require equally the opposite conception, that of the radical unity of a tradition. To us the idea is clearest when we consider a distant art, the art of China perhaps; it may be with surprise that in discussing western

painting with a Chinese connoisseur we meet it nearer home. In fact we can hardly dispense with it if we are to understand our own artists. We need to recall how each of us first came to know of European painting. Perhaps in childhood, in that strange time when no image could be more than half construed, one saw the printed likeness of some vivid, undistinguished picture hanging on the wall, it may have been a calendar reproducing a picturesque old academy piece, or an oleograph which came with an advertiser's blessing. As likely as not that was all, a visible mystery pondered deeply and long. But years later when one found one's way to the masterpieces, to Giotto and Cézanne, they were not, except in their intensity, unexpected: one had known that such forms, such articulations of form, must of necessity exist. In vestigial or rudimentary shape one had met them already, as possibilities awaiting fulfilment, and taken them involuntarily to heart. Through some such memory we may realize how much may exist in how little, ready to be unlocked by whoever has the turn of mind for it. One Italian picture, and that an indifferent one, may contain all Italian painting. It seems that all the achievements of a tradition are present in embryo in every one of its works.

In this light we can well conceive how form is transmitted, how one strand in a tradition may long be lost and yet, as if spontaneously, reappear. We can understand, in the present subject, the miraculous durability of the rarest essence. We need imagine no fabulous chances or peregrinations: the principle waits from age to age, concealed in many vessels, for the man that has the turn of mind for it. No doubt it was thus that it reached Vermeer. And so, for assuredly such recurrences are not accidental, his mature work discovered forms which had hardly emerged fully for five generations. In the presence of his bell-like ladies, *The Lacemaker* or the Dublin *Letter Writer*, we think of the shape which was the special property of Giorgione. And in the maidservant who awaits the letter, rooted like a column to the floor, we come upon the affinity which was felt when the *Studio* uncovered its natural, simultaneous revelation to the eye. With her we are near to the creatures of Piero della Francesca. There are signs enough that in the years to come Piero's name will be often and idly invoked in unworthy causes: it may seem preferable to resist the comparison here. There are more serious grounds for hesitation. We no sooner discover the affinity than we doubt it. Understanding of Vermeer confirms what must be evident from the first; this relationship of final forms is belied by all that we

know of the way which led to them. Nor is the contrast simply that between the possibilities which were open to the Quattrocento and to Vermeer's time. The character of Vermeer's method is indeed beyond our reach until we see it as the antithesis of Piero's.

The opposition is as clear as the affinity. A recent writer, and whoever traces such a thread as this will have him often and gratefully in mind, has noticed that in the Giorgionesque *Apollo* at Hampton Court the rounded tip of the flute with its square opening provides a key both to the forms and to the mood of the picture.[24] It happens that Vermeer provides us with a similar example and the same key to it. And when we turn to it the gulf which divides the *Girl with a Flute* from all its predecessors is clear. With the *Studio* in mind, and the memory of Piero, it may seem to us that the essence of Vermeer's art, the art also of Giorgione, is to let the world reconstruct itself intact by its own law and that here only the law has changed. In that change there is none the less conveyed the whole of Vermeer's temperament, his strangeness by the standards of any time. And more: we gather from the affinity and the difference something of the intervening age that its marvels have concealed. We understand the power of its artists as exerting, with all their achievement, a hidden tyranny over one principle of their tradition. We see for a moment in mannerism and baroque, even in Dutch naturalism itself, a quality of obscurity, a resurgence of medieval night. Thus when the *Girl with a Flute* came to be painted the standpoint that in the fifteenth century had seemed the ideal, the perfect normality, was so suppressed as to be encompassed only as if by chance in a wonderful sport of history. The normal form was attainable only through the most idiosyncratic; it was beyond the reach or even the knowledge of any temperament but that which had found in the human world not only the necessity for representation but also its peril, its impossibility. So it is that of the tip of Vermeer's flute we know only two wedges of light, outposts of the pattern which is the mask of human form. They mark the surrender of comprehension as a pictorial function; for this painter the active mood was a distant, enviable arrogance, beyond possibility. Only passivity was left, the last, extreme virtue. No other art, certainly not that of the fifteenth century, has this immaculate gesture of withdrawal to show. The affinity remains, embodied for us in the *Studio*, the *Letter Writer*. They afford us a knowledge more welcome than any historical connection; they are evidence that, below style, deeper even than any

obvious trait of temperament, it is to a radical disposition to the world that we owe these forms, forms which of all that our art has given us perhaps remain the most precious.

Considering Vermeer across the gulf between us it is difficult to discard the preoccupations of more recent times. His reputation as we know it is the work of the nineteenth century. It is largely due to the essays published in 1866 by Théophile Thoré. The revelation came at the time when *la belle peinture* was penetrating to popular understanding; not even Velázquez appeared to expound the beauties of tone and execution better than Vermeer. And to us he is apt to seem a creature of the age that canonized him. He has been so completely the patron of cultivated taste that we can hardly conceive of him outside its frame. The later nineteenth century did not breed its Vermeer. It produced instead the artist from the tomb, from a century when the material of life wore a confident aspect, from the lost heroic age of everyday things.

Taste, with the painting it follows, has turned another way. Simplicity is not a quality of genius in which we easily believe. We have the integral preciousness of matter less in mind than the power that it unleashes when it splits. The corresponding view of painting has similarly declined. Thoré's approach has suffered with each generation an inevitable deterioration of gravity. When a writer on the Mauritshuis *Head* observes that 'if you smile at her … she will after a while smile back at you' it is clear that the response has degenerated to an automatic recognition of the photographic tonality which is familiar and comforting. No doubt the optical understanding spread by photography contributed to deciding the moment of Vermeer's rediscovery. Today such appreciation is clouded by staleness and habit. There may seem little chance of recapturing the force either of Vermeer's originality or of its ironical conventional mask; there is little hope that Vermeer's style as it is now understood will inspire us again with the enthusiasm which breeds new pictures. If an artist travelling now feels Renoir's lifelong regret at being unable to go to Vienna, it is rarely the *Studio* which chiefly occasions it. The stature of recent painters might almost be measured by the degrees of their indifference to the master. Clausen eulogized him;[25] Steer confessed that he could not see what the fuss was about.[26] The precious material of Vermeer's pictures does not attract the old devotion. The symbol which we used to find in the *petit pan de mur jaune* of aesthetic altruism, the apparently generous disinterest with which

artists enrich us, is no longer quite convincing. It often seems that the study of Vermeer, like Proust's Bergotte,[27] with his fear of the last indignity, transmutation in death into the substance of a newspaper paragraph, has been killed by the very magnetism of its object.

The study of Vermeer was not, as it happened, even to be spared the newspaper paragraphs. After the Second World War it was found that a catastrophe had overtaken criticism. Half a dozen fabrications had been accepted with enthusiasm by leading authorities. Yet the confusion itself perhaps shed light on accepted ideas about the painter. We need not conclude that van Meegeren was a master of a rank comparable to his predecessor. Nor is it likely that the decline at that stage of serious interest in Vermeer indicated merely that he had been over-rated. The vicissitudes of his reputation are a warning; the truth is that Vermeer with his incomparable evasive talent has eluded us. The view of him which has obtained from the time of Thoré to our own lets slip something of the painter's essential nature.[28] Vermeer hardly maintains his place among the masters simply as a humane poet of domesticity nor even, although it is a more profound estimate, as a pictorial designer of the pure classic kind. He does not fill either bill; his shape is more eccentric. He is not only too big but also too small to fit. It is necessary to see the barrier which his temperament opposed to the demands of his time and his own ambition as an element as positive in his originality as any of his more conspicuous gifts.

Vermeer's reaction to humanity was too idiosyncratic to allow him a place within the humane tradition as it has developed. By comparison with the comprehending embrace which its masters extend to physical matter his painting reveals little but its limitations. But when his standpoint and the perfect style in which he enshrined it are understood, as they yield their strangely emotional content, it becomes clear that his position is if anything rarer, his achievement with its complexity more incomparable than the most devoted apologist has claimed. Vermeer's passivity, the very style which conveys it, achieves a classic and solitary statement of a truth upon which many artists have been broken. He stands outside our convention because he cannot share its great sustaining fantasy, the illusion that the power of style over life is real. However an artist love the world, however seize on it, in truth he can never make it his own. Whatever bold show his eye may make of subduing and devouring, the real forms of life remain untouched. Matter is stronger, at any moment it may

turn and crush him; finally it surely will. Vermeer's delicacy is not to provoke the foreign power of the life outside him. He knows that all that the eye can possess is light. Uncongenial his statement may be, but it is one that we are well able to understand.

A prolonged analysis of Vermeer runs the risk of seeming to undermine his clearest quality. Yet as we examine some of the tangle which assumes such an inscrutable mask of light we value Vermeer's simplicity fully for the first time. It is the weight of feeling so perilously suspended which distinguishes this marvellous equilibrium. The painter of *The Lacemaker*, doubtless against his will, leaves signs which allow us to unravel something of his ambiguous miracle. If they escape us there is lost both the essence of a rare and wonderful style and an unexpected illumination of its surroundings. Without the contrast of his solitary opposing gesture our understanding of the positive hold on the world characteristic of his century and its masters would be less complete. Yet Vermeer reaches, and it is our last, abiding view of his paradox, a deeper recognition than any of the fact of the existent world.

NOTES

Abbreviations

H.: A.M. Hind; A Catalogue of Rembrandt's Etchings, *London, 1923*.

H. de G.: C. Hofstede de Groot; A Catalogue Raisonné of the Works of the Most Eminent Dutch Painters of the 17th Century, *I, Jan Steen, Gabriel Metsu, Gerard Dou, Pieter de Hooch, Carel Fabritius, Johannes Vermeer, London, 1908;* Die Handzeichnungen Rembrandts, *Haarlem, 1906.*

K. der K.: Klassiker der Kunst; *W. Martin, Gerard Dou, Stuttgart, 1913; W. R. Valentiner, Pieter de Hooch, Stuttgart and London, 1930.*

Other bibliographical references are given below and in the notes to the list and commentary which follow.

(1) The precisely analogous passage is to be found in Metsu's rendering of the subject in the Louvre, H. de G. 158.

(2) Sometimes, by the converse process, the lightest parts also lose their linear divisions, an optical simplification (if it is not occasionally due to the pictures having suffered damage) analogous to that commonly seen on a heavily exposed photographic plate, e.g. the fore-shortened tip of the right hand in the picture at Kenwood and a similar passage in the Dublin *Letter Writer.*

(3) E.g. the baskets in Metsu's pictures, formerly in Lord Ellesmere's collection (H. de G. 95), and the Wallace collection (H. de G. 186) and the frames in his *Letter Writer* (Dublin, H. de G. 185) and Jan Steen's *Music Lesson*, also at Hertford House (H. de G. 412). The distance between Vermeer and even the closest approaches of more conventional painters to his style is well demonstrated by such pictures; it is unlikely that any of them were untouched by his influence.

(4) A final turn in the story of Vermeer's treatment of other pictures is worth notice. Having discounted naturalistic convention and achieved a technique of condensation which pays no more attention to human detail than is optically justified, he introduces in at least one case a barely perceptible bias of his own. The emotive points in the painting in the *Lady Standing* at the National Gallery, the Cupid's eyes and his bow, are possibly very slightly darker and more prominent than is justified by their position in the scheme. The total effect is of simple mechanical reproduction which has been most delicately and artfully retouched. This case, one of the very few in which we seem to catch Vermeer half out of his shell, is of interest in considering the themes of his pictures.

(5) The effect of diffusion is in some cases increased by changes due to time. The apparent softness of drawing of the fingers in the *Pearl Necklace*, for example, in fact arises from the numberless minute pentimenti which are now visible round their contour, the results of a long process of tracing and retracing the boundary between the tones.

(6) A painter's hand typical of the conventional rendering appears in Dou's *Self-portrait* (*K. der K.* p. 16) in the National Gallery; it is the direct descendant of that of St. Luke as depicted by Rogier van de Weyden. The nearest parallel, on a smaller scale, to Vermeer's

[68]

passage in the works of his associates known to the writer is in the hand of De Hooch's *Woman Spinning* at Buckingham Palace (*K. der K.* p. 42). Comparison with it indicates Vermeer's departure. Once such a breach with conventional formula is recognized other cases may be noticed throughout the later work. The nose and shaded side of the head in the Kenwood picture provide an example made the more conspicuous by the old copy in the Johnson Collection at Philadelphia (Hale, *Vermeer...*, London 1937, pl. 29) in which the passage is reduced by an accomplished hand to conceptual standards. If it be thought that the comparisons drawn here with painters who are by no means Vermeer's peers remain inconclusive, an illuminating point of reference, though a more distant one, may sometimes be found in the work of Georges de La Tour. The style of La Tour was evidently formed in very much the way that it has often been thought was the style of Vermeer; it is a classic and humane development of Caravaggesque painting, in particular the painting of Utrecht. Perhaps an awareness of the possibility of such a development had some part, in the absence of a knowledge of La Tour, in suggesting this reading, and as we believe misreading, of Vermeer. At all events the comparison provides a profound demonstration of the intimately graphic, which is to say comprehended, character of form, however fully modelled and conceived in light, which is in the broad stream of western tradition, and of the absence of that character in the mature work of Vermeer.

(7) The principle of the camera obscura, observed by Aristotle (who did not pursue it) and recorded by Vitello, Roger Bacon and Leonardo (whose experiment was not published until three hundred years later), became common knowledge in the course of the seventeenth century; its previous history may be briefly summarized. Cesare Caesarino (Como, 1521) included an account of it in his version of Vitruvius; Erasmus Reinhold, to whom the practical form of the instrument is due, made use of it for solar observations and noted its application to terrestrial objects (Wittenberg, 1540. A. Kircher, *Ars Magna Lucis et Umbrae*, Rome, 1548, was perhaps aware of Leonardo's manuscripts in the Vatican). Giambattista della Porta's *Magia Naturalis* (Naples, 1558) was largely responsible for popularizing the device and its invention for long remained associated with his name. Reinhold's example was followed by the great astronomers who succeeded him, Copernicus, Tycho Brahe, Moestlin and, in 1607, his pupil Johann Kepler (*Dioptrice*, Augsburg, 1611) who gave the camera obscura its name and recorded with it the transit of Mercury; for more than a century it remained an instrument of every kind of optical inquiry. In 1620 Sir Henry Wotton described to Lord Bacon the portable dark tent which Kepler used for sketching landscapes (*Reliquiae Wottoniae*, 1651, reproduced in *Graphice or the Most Excellent Art of Painting*). Kepler's pupil Descartes experimented with the device in Leiden (*Dioptrique*, 1637). The natural philosophers of Vermeer's time continued to interest themselves in the camera obscura. In England, where a translation of G. della Porta appeared as *Natural Magick* in 1658, Boyle's box camera for landscaping drawing was used and imitated some years before 1670. (*On the Systematic or Cosmical Qualities of Things*, ch. vi.) Robert Hooke, Boyle's assistant, described in 1668 the portable camera which he was accustomed to use and demonstrated it at a Cutlerian Lecture. In this context it is of interest that Vermeer's executor, his exact contemporary in Delft, with whom at least his widow was acquainted, was Antony van Leeuwenhoek, the Dutch pioneer of such studies and Hooke's correspondent.

Van Leeuwenhoek was one of the most indefatigable makers and users of lenses who ever lived. Perhaps we need look no further for Vermeer's source.

(8) G. della Porta noted (lib. iv, cap. 2) the possibility of laying colours on the projected image. Such may in fact have been Vermeer's method; the evidence of radiography in this connection will be considered in relation to the *Head of a Young Girl* in the Mauritshuis.

(9) Even here an affinity has been noted. Maxime du Camp wrote of the *View of Delft* 'C'est un Canaletto exagéré' (*Revue de Paris*, October 1857.) There may indeed be a direct connection between the two artists: the possibility will be discussed in reference to *The Music Lesson*. The camera obscura was on sale in England at the beginning of the eighteenth century (John Harris, *Lexicon Technicum*, 1704). Algarotti wrote: 'Les plus habiles peintres de Vues, que nous ayons aujourd'hui, tirent un grand avantage de cette chambre obscure et sans elle ils n'auraient pu rendre les objets si fort au naturel.' He named as an example G. M. Crespi. A portable camera appears with the painter's tools in J. J. Haid's mezzotint of the Bavarian painter and etcher Joachim Franz Beich (1715). Sir Joshua Reynolds' camera is preserved in the Science Museum in London. (Meder, *Die Handzeichnung*, Vienna, 1919; Waterhouse, *Journal of the Royal Photographic Society*, XXV, 1901; B. Cohen in *Enc. Brit.*, 15th edn.) A. Hyatt Mayor (*Bulletin of the Metropolitan Museum of Art*, V, 1, 1946) has reached conclusions similar to those of the present study. He quotes G. J. s'Gravensande (b. 1687): 'Several Dutch painters are said to have studied and imitated, in their paintings, the effect of the camera obscura and its manner of showing nature which has led some people to think that the camera could help them to understand light or chiaroscuro. The effect of the camera is striking, but false.' (C. A. Jombert, *Méthode pour apprendre le dessein*, Paris, 1755, p. 139).

(10) In Vermeer's time Evert van Aelst painted in Delft until his death in 1658: his nephew Willem returned there from Italy in 1656. Among the painters admitted to the Delft guild in the forties were Pieter and Harmen van Steenwyck. The latter, apart from a voyage to the Indies in 1654-5, remained in the town during the following decade. Vermeer's more specific debt to the perspective *trompe l'œil* painting of Carel Fabritius and his circle is discussed in the commentary on *The Music Lesson* and *The Concert*.

(11) B. W. F. van Riemsdijk in *Bredius Feestbundel*, Amsterdam, 1915.

(12) G. J. s'Gravensande. See above, n. 9.

(13) *Christ in the House of Martha and Mary* at Edinburgh, *The Procuress* at Dresden, the *Girl Asleep* in the Metropolitan Museum and the *Diana* in the Mauritshuis at the Hague. Vermeer's development is discussed in further detail in the commentary on the pictures which follows.

(14) Metsu's *Cello Player* at Buckingham Palace (H. de G. 156) may be contrasted with the male heads in these pictures by Vermeer.

(15) Consideration of Dou's significance to the genre school, and even to Vermeer, is now hindered by a certain prejudice against his petty style. But no artist has a clearer notion than Dou, on his own prosaic level, of pictorial self-sufficiency; few pictures contain themselves more completely than his.

(16) A. van Beyeren is particularly indicated. Cf. the *Still Life with Fish* in the Boymansvan Beuningen Museum.

(17) The aperture which frames the *Studio*, the *Allegory* and the Dublin *Letter* is the very shape of stillness and seclusion. It may be compared with its antithesis, the opening character-istic of the early works, as it appears in the forms of the Edinburgh picture, for example, the *Laughing Girl* and the *Street*, a springing, barely balanced V-shape.

(18) The passage has suffered with time and is now barely legible; it was formerly overpainted with a still-life of musical instruments. The pictures represented in the earlier works, rendered for the most part in very thin paint, have all deteriorated. The evidence of photographs is further misleading. The picture in the Brunswick conversation piece appears less clearly in the present reproduction than in the original while that in *The Concert* is said to be better seen in the photograph than it now is on the actual canvas.

(19) Dresden Gallery. The picture was well known in the engraving by Hendrik Goudt.

(20) Quoted by W. Stechow, *Journal of the Warburg and Courtauld Institutes*, iv, 1-2.

(21) Compare the *Doctor's Visit* at Apsley House (H. de G. 137, there are numerous variations on the theme). The erotic reference of these medical scenes is well known; it is given a curious turn in H. de G. 797 (St. Petersburg) where the interest of an elderly invalid in his nurse is made clear by a Rubens *Susanna and the Elders* on the wall. In *The Choice of a Suitor* (St. Petersburg, H. de G. 126) the scene is decorated with a popular woodcut of *The Ages of Man*. In a picture at Frankfurt, *The Importunate Guest* (H. de G. 788), the visitor's presence is explained by a print of travellers on horseback. More general references include that of the *Allegory of Fortune* which decorates the overmantel in the pictures of Jan Steen feasting on oysters (*Easy Come, Easy Go*, a version dated 1661 is in the Boymans-van Beuningen collection and another of 1660 exists, H. de G. 854, 856); the list might be pro-longed.

(22) In Vermeer's development successive works have often a complementary char-acter. We might find an antithesis between the drinking pictures at Berlin and Brunswick, one not unlike that which has been noticed between the Brunswick cavalier and the picture behind him on the wall: they propound opposite kinds of relationship between man and woman. It is unlikely that the two works were intended as pendants. The interest is rather in the light which such relationships throw on Vermeer's habit of thought. Pictures on which all the painter's resource has been lavished are found repeatedly when they are finished to be in a subtle sense no more than partial statements, and in need of immediate correction and completion, often on a canvas of the same size in a similar scheme of colour, by a second supplementary piece. The characteristic links in the chain of Vermeer's development are pairs of pictures rather than single works.

(23) Not least of the implications unfolded in this picture is that of the painter's habit of working seated. His eye is on a level with the lady's sleeve.

(24) Adrian Stokes, *Art and Science: a Study of Alberti, Piero della Francesca and Giorgione*, London 1949, p. 61.

(25) In *Charlton Lectures on Art*. Delivered at Newcastle upon Tyne. Oxford 1925.

(26) Steer's remark, made on the occasion of the exhibition of the *View of Delft* at Burlington House in 1931, is recalled by Mr. Rodney J. Burn. A similar comment on the same picture is recorded of Jozef Israëls. The only direct reflection of Vermeer in contempo-

rary painting known to the present writer, aside from the academic imitations and the forgeries which will be familiar, appears in the work of a painter who is concerned with *trompe l'œil*, Salvador Dali.

(27) *La Prisonnière*, Paris (1923), (1927), Vol. I, p. 255. The incident was based on an experience of Proust himself; visiting an exhibition to see the *View of Delft* he had suffered a seizure which seemed likely to prove fatal. He is said to have dictated revisions of the episode a few hours before his death. Odette de Crécy, it will be remembered, took little interest in an artist of whom no love affairs were recorded. Yet in retrospect it does not seem that she was one of Vermeer's least perceptive critics: the notion of pure painting emanating from a personal vacuum is not an inviting one. Happily it is without foundation in fact.

(28) One or two French writers of the nineteenth century discerned the peculiarity of the case. The judgement of Maxime du Camp has been quoted; Charles Blanc, quoted by A. B. de Vries, wrote in 1861 that 'in no school of painting do we meet with such an artist, unless perhaps among the modern realists'. Fromentin's famous, and from his standpoint justifiable, dismissal conceals a similar point: 'il a des côtés d'observateur assez étranges.' It has been the misfortune of criticism to have neglected such warnings.

II

THE PICTURES

★

*A List and
a Commentary*

II

Although there are no better archivists than the Dutch the records of Vermeer's life remain as scarce as his pictures. They have all been published;[1] it will be sufficient to summarize them here. On October 31, 1632, the son Johannes of Reynier van der Meer, a silk-weaver and art dealer who was later also an innkeeper, was baptized in the New Church at Delft. Twenty-one years later Johannes Vermeer married and was received into the local Guild of St. Luke. In 1656 he dated a picture which we have, *The Procuress*. In 1663 a French traveller visited him and found the painter had no pictures to show him.[2] His baker had one, of a single figure, but it was expensive. In 1667 a Delft publisher, in a book of a thousand pages on the glories of the town, celebrated Vermeer as rising phoenix-like from the ashes of Carel Fabritius who had died in an explosion of the powder magazine thirteen years before.[3] Vermeer took office twice as one of the six syndics of his guild and was chosen as president. A number of financial transactions which may refer to him are recorded; the painter appears to have been most often the debtor. In 1672 he let his house and moved to a smaller one. His mother-in-law, a lady of substance, entrusted him power of attorney in 1675 but before the end of the year he was dead. On December 15th he was buried in the Old Church at Delft. He left eleven children, eight of whom were minors; they do not appear in any of his remaining pictures.

He died insolvent. His widow, in her petition, stated that he had been able to earn little in his last years. The inventory of Vermeer's effects shows a number of the possessions which appear in his pictures and his front room contained two easels, six panels, ten canvases, three bundles of colours and a walking stick with an ivory head. His widow gave two more pictures to the baker against a large bill, and another to her mother, to whom she was in debt, a representation of 'The Painter's Art'. The post of trustee was taken by Antony

van Leeuwenhoek who was occupied at the time with a drapery business and the position of chamberlain to the sheriffs of the town, in addition to his optical researches. There was some dispute with the mother-in-law for possession of 'The Painter's Art'; it is not clear that the transaction was beyond reproach. But it evidently did not disturb Van Leeuwenhoek's relations with the widow and in the next year he appeared for her in the legal settlement of another family matter.

Twenty-six of Vermeer's pictures in the custody of a Haarlem painter and dealer were put to auction in the year after the painter's death. Nineteen were sold at the death of a Delft printer in 1682. Twenty-one appeared at auction at Amsterdam in 1696. They were described in a catalogue and fifteen or sixteen of them can probably be identified at the present time.[4] But if the list was without errors of attribution or description it was unique of its kind; it is curious that the one item in it which is quite certainly lost, a picture of a gentleman washing his hands, would also have been singular in Vermeer's work in dealing with a subject that was not in the most general currency in his school.[5]

Historical and subjective considerations make a dangerous mixture. But here no other method has proved less hazardous. We may expect that Vermeer's vocabulary of representation, which has formed the starting point of the present study, should bear some relation to the history of his development. It is the most intimate visible constituent of style. There is significance none the less in every feature of the pictures, their dimensions, tonality, handling of paint and subject matter; each seems to yield some sign of the order in which they were painted. Of the two pictures which Vermeer dated one was painted in 1656 when he was twenty-four and the other when he was thirty-six, seven years before his death. The earlier shows less of the personal vocabulary which has been examined than almost any other of his works while the later is in the manner which elsewhere displays it in its maturest form. From this standpoint the pictures that we know, as we place them nearer to one or other of the dated works, fall into three groups. In the first, the pictures up to the Dresden *Letter Reader*, the painter's style is different from contemporary convention in quality rather than in kind. In the second group, comprising such works as the Brunswick picture and *The Music Lesson*, elements of a very unconventional vision are apparent. In the remaining twenty pictures, which we suppose to follow *The*

Music Lesson, these become the basis of a consistent manner of representation. Within the three groups the indications of chronological order are tenuous: the history of the middle phase is particularly uncertain. An impression nevertheless forms of the movement of Vermeer's style and his thought.[6]

The commentary which accompanies the list of pictures that follows provides in a few cases opportunity to pursue the evolution of style and meaning in further detail. Its more important purpose is to consider the historical matter on which some of the generalizations that have preceded it are founded. The examination of Vermeer's sources is based on the belief that where a painter has made use of iconographic tradition or subject matter that was in general currency, as Vermeer in so many cases evidently did, it is of interest to inquire in what forms they may have come to his notice. It is rarely possible to carry such studies to a conclusion, but we are at least fortunate that the idea, to which more than one consideration of Vermeer has been sacrificed, that they in any way diminish the stature of the painter is no longer widely held. Some of the more conspicuous cases of Vermeer's immediate influence are indicated. The histories of the pictures have been well treated elsewhere; they are referred to only where it is possible to add to them. Serviceable bibliographies of the subject are available and there would be little purpose in detailed discussion of the extensive, and somewhat repetitive, literature here.

(1) What knowledge we have is largely due to the discoveries published by F. D. O. Obreen (1881-2) and Abraham Bredius (1885-1916). The documents are reprinted with English summaries by P. T. A. Swillens, *Johannes Vermeer*, Utrecht, 1950. Recent bibliographies are given by Swillens and by A. B. de Vries, *Jan Vermeer*, London, 1948. The histories of the pictures have been dealt with by De Groot and De Vries; they are referred to here in notes 65, 79, 99, 102, 124 and 144.

(2) The *Journal* of Balthasar de Monconys was published in Lyons in 1666 (II, p. 149).

(3) D. E. van Bleysweyck, *Beschrivinge der Stadt Delft*, 1667 II, p. 854. The verse is said to have been written after the explosion of 1654 but it seems likely that the reference to Vermeer owes something to the growth of his reputation in the intervening years.

(4) The works which can perhaps be identified are the *Gold Weigher* (no. 1), *A Maidservant Pouring Milk* (no. 2), the pictures at Kenwood and Buckingham Palace (nos. 4 and 6), *The Love Letter* (no. 7), the *Girl Asleep* (no. 8), the *Soldier and Laughing Girl* (no. 11), *The Lacemaker* (no. 12), the two landscapes (nos. 31 and 32), a letter picture, either that in Washington or Dublin (no. 35), the *Pearl Necklace* (no. 26), one or other of the National Gallery pictures (no. 37) and the two portraits (possibly among nos. 38, 39 and

[77]

40). A 'Gay Company' (no. 9) might be the Brunswick picture. One of the cheaper items (no. 3) was a 'portrait of Vermeer'. It can hardly be the Vienna *Studio,* nevertheless it is possible that we have the picture (see n. 115).

(5) No. 5: 'A gentleman washing his hands, in a room with a through view, with pictures, artistic and unusual'. Prof. Van Regteren Altena suggests to the writer that the subject may have been related to that of Pilate and that the picture was perhaps an early work in the style of Rembrandt's school. (Compare the work in the Metropolitan Museum.) In Vermeer's nearest approach to this style, the *Girl Asleep,* two of the features described, a view through into another room and a picture on the wall, also appear. Representations of ladies washing their hands with the assistance of a page are not uncommon. The subject was painted, for example, by Ter Borch and Eglon van der Neer (Rothschild sale, Sotheby 19. iv. 1937, no. 13, dated 1675). On these analogies Vermeer's picture, if one existed, might have been nearer in date to *The Love Letter.* No certainly early works are recorded in the 1696 catalogue.

(6) Recent work on the artist has tended to agree with the general outline of the chronology proposed in the first edition of this book. Within the main stylistic groups, attempts to allot precise dates to the pictures remain speculative. It now appears to the writer that *The Concert* and the *Head of a Young Woman* in the Metropolitan Museum were previously dated too early. The approximate dating that now seems likely may be summarized as follows. From 1656 and the proceeding years two pictures seem to remain: Plates 1 and 4. About 1657–9: Plates 6, 8, 10, 12 and 14. About 1660–2: Plates 16, 18, 21, 24, 30 and 33. About 1663–5: Plates 38, 40, 42, 43, 44, *The Concert,* Plate 22, whose affinities are with the pearl pictures, and Plates 47, 49 and 50. About 1666–9: Plates 53, 56 and 57. The inscribed picture, Plate 58, and Plate 59 were clearly painted in about 1668. The writer would not attempt to date the dubious picture in the Frick collection, Plate 54. About 1669–72: Plates 62, 64, 68, 71, 74 and 75. The *Lady Seated at the Virginals* which is now included, Plate 80, may have been painted after Vermeer's move early in 1672.

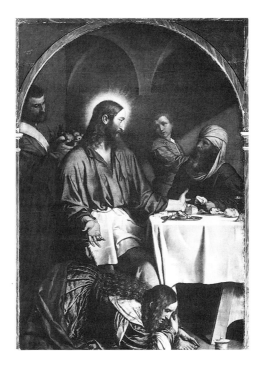

Plates 1–3
CHRIST IN THE HOUSE OF MARTHA AND MARY
$62\frac{1}{8} \times 55\frac{1}{2}$ in. (1578 × 1410 mm) Signed
National Gallery of Scotland, Edinburgh

 The four immature works by Vermeer that we have, the Edinburgh picture, *The Procuress*, *A Girl Asleep* and the *Diana*, have one element in common, their considerable size. In style they are discrepant; the conventions in which they are painted, like the figure motifs on which they are based, are far from characteristic of Vermeer's manner as we later come to recognize it. It is commonly assumed that the four pictures represent only the peaks of the

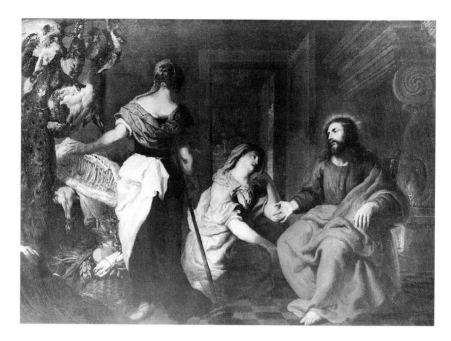

ERASMUS QUELLINUS THE YOUNGER
Christ in the House of Martha and Mary
(*Musée, Valenciennes*)

painter's youthful production, of which the lesser examples have been lost, and in particular that some years of development took place between the *House of Mary*, the only picture in which the painter is predominantly influenced by the international style of the southern Netherlands, and *The Procuress*. If Vermeer's evolution obeyed the usual laws the inference would be justified. This is not the case. We have no record of this phase and whatever slight indication may be gleaned from the presence in Holland of the painter whom Vermeer certainly imitated, at a time not very far from that of *The Procuress*, tells against the usual view of the date of *The House of Martha*. It would be strange if none of Vermeer's early pictures were lost, but there is no evidence that the view of his activities at their outset which emerges from the works we have is not substantially correct.

The signature which connects this picture with Vermeer was uncovered in

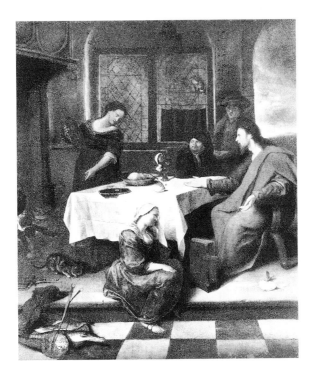

1901 when it passed into the hands of a London dealer. Its Italianate flavour is evident and Dr. Borenius pointed out a similarity of the figure of Christ to a Neapolitan Caravaggesque painting of *The Death of St. Joseph* which is now attributed to Andrea Vaccaro.[7] The pose and gesture in which the resemblance lies were in fact part of the common rhetorical repertory of the sixteenth and seventeenth centuries;[8] a purely Caravaggesque prototype would hardly account for the obtrusive rhythmical flourish which distinguishes the Edinburgh picture from the rest of Vermeer's work. It rather recalls the school of Rubens and there is no doubt that Vermeer's chief source was the rendering of the subject by Erasmus Quellinus the Younger which is now at Valenciennes.[9] Both the heavily stylized folds of drapery and the handling of paint with which

they are conveyed follow Quellinus closely; the group of Christ and Mary is clearly modelled upon his arrangement. It appears that Vermeer, like Jan Steen, knew the actual picture.[10] Quellinus himself must have passed through Delft more than once in the middle fifties between Antwerp and Amsterdam. In 1656 he painted the ceiling of Amsterdam Town Hall, part of a grandiose scheme that introduced more than one exotic motif to the school.[11]

It remains likely that Vermeer was aware of other versions of the subject.[12] The possibility cannot even be excluded, and the fact will be enough to demonstrate at the outset that no occurrence in the work of Vermeer has any simple or single origin, that he knew of one of the chief iconographical sources of these renderings, the picture of a similar subject by Moretto in S. Maria in Calchera at Brescia.[13] Not only Moretto's Christ but the intent attitude of Simon and the strangely suggestive detail of the hanging end of his turban seem to point an ancestry of the Edinburgh picture which though doubtless indirect is by no means remote.[14] Moretto's cloth-covered tables and the simple and memorable still-lifes which they bear often foreshadow the place which such things take in the world of Vermeer. For all the orderliness of Vermeer's conception a Caravaggesque influence is nevertheless visible. The colour of Mary's skirt is the saturated green-grey favoured, in various equally pregnant hues, by the painters of Utrecht. Analysis of the picture's sources seem to leave one passage of it unscathed as Vermeer's own, an example in embryo of the realism characteristic of his later style, that of Mary's head resting upon her hand. The detail, like much in the work, must indeed have been studied from life, but in view of what we know of Vermeer's habit it would not be surprising if even here he had some prototype in mind.[15] Both methods evidently contributed to the making of the picture; occasionally some hiatus between them is visible and in the light of what we learn from later works of the painter's temperament certain inconsistencies here, in Martha's right arm, for instance, whose structure is so difficult to construe, have a particular interest.

In the case of another painter such elaborate derivation would be hard to credit. But *Christ in the House of Martha and Mary* is no more than the beginning of Vermeer's complex synthetic grasp of current motifs. His natural clarity of thought, already so evident in the Edinburgh picture, was equalled by the peculiar acuteness with which, throughout his work, he drew on the resources of his time.

(7) Museum of Naples. T. Borenius, 'Vermeer's Master', *Burlington Magazine*, XLII p. 37.

(8) E.g. the figure of Moses in Tintoretto's *Gathering of Manna* in S. Giorgio Maggiore. It is particularly common in the work of Moretto.

(9) *Catalogue*, Valenciennes, 1931, Tome I, No. 90. Noted by E. Trautschold in Thieme-Becker, *Künstlerlexikon*, XXXIV.

(10) Two renderings of the subject of Christ in the house of Martha and Mary by Jan Steen exist, both based on Quellinus. In one (now in a private collection in Nijmegen, Steen arrives at a composition not unlike that adopted by Vermeer; the similarity, particularly of the profile of Christ, is of interest in confirming how largely the formation of the Edinburgh picture was governed by generally available material. In the other example (in the collection of Sir John Stirling-Maxwell, H. de G. 51) Steen elaborates characteristically the part played by Martha and the still life. (These elements in the Valenciennes picture are credited to Adriaen van Utrecht. Comparison excludes beyond doubt the suggestion of De Vries that the Stirling-Maxwell picture was based on Vermeer.) An earlier and more obscure chapter in the history of the subject is indicated by marked points of resemblance to the picture by Quellinus in a drawing by Rembrandt (Teylers Museum, Haarlem; Valentiner, *Des Meisters Handzeichnungen*, I, no. 396, as about 1636.) The group of Christ and Mary is reversed. The iconographic tradition which these works took up was decisively influenced by Rubens's picture at Dublin (*K. der K.* p. 222) and his *Christ in the House of Simon* in the Hermitage (*K. der K.* p. 179). The earlier form of the subject is shown by M. Gheeraerts (Amsterdam, Prentenkabinet); it is followed by, among others, Hendrick Sorgh (Cheltenham, dated 1645). The influence of Quellinus might perhaps be detected in Metsu's religious subjects.

(11) H. Schneider, 'Erasmus Quellinus te Amsterdam', *Oud Holland,* XLII p. 54. Vermeer shows no knowledge of those parts of the Valenciennes picture which were not due to Quellinus.

(12) Allessandro Allori's rendering of the subject (Kunsthistorisches Museum, Vienna, Cat. no. 59a) has been suggested as a prototype of Vermeer's composition (W. Drost, *Barockmalerei in den germanischen Ländern*, Potsdam, 1926, p. 209). Martha's place in the action and the position of the table is somewhat similar; there is no positive resemblance.

(13) The connection is suggested by Mr. Derek Hill.

(14) At least one of Moretto's paintings reached Holland in the seventeenth century and the appearance of his influence is not unknown. Rembrandt's Emmaus subjects contain resemblances to Moretto's version in the Martinengo Gallery. Such motifs may have been spread in the north by drawings like that of the Martinengo composition at Copenhagen. Moretto's *Easter Feast* in the Chapel of the Sacrament in the Duomo Vecchio at Brescia suggests a connection with the mannerist genre painters of the Netherlands in the sixteenth century, and thus with their successor, Jan Steen.

(15) It may be noticed that a parallel to the uncommon motif of the head of Mary, and the play of light which casts a telling shadow upon the foreshortened profile, is to be found in another Brescian picture by Moretto, in the St. Joseph who appears in the *Coronation of the Virgin* in SS. Nazzaro e Celso. (Gombosi, *Moretto da Brescia*, Basle, 1943, pl. 34, 36, 100.) Again, a direct connection can hardly be supposed. Vermeer's style has affinities with

the realism and attention to light characteristic of Moretto; it may be thought that the indications in favour of Brescia are no weaker than those which have led some critics to suggest for him an apprenticeship in Rome or Naples. Such conjectures have no weight against the positive evidence that connects Vermeer's formation with the Dutch school. Leonard Bramer, the Delft artist who was among the witnesses at Vermeer's marriage, had travelled to Rome and returned by way of Padua, Mantua and Venice in 1628–29; he may well have visited Brescia.

Plates 4–5
THE PROCURESS
$56\frac{1}{4}$ × $51\frac{1}{4}$ in. (1429 × 1302 mm) Signed and dated 1656
Gemäldegalerie Alte Meister, Staatliche Kunstsammlungen, Dresden

We have no record of the conditions in which Vermeer's style was formed. If he served an apprenticeship we do not know of it and there is no reason to think that the eulogy which couples his name with Fabritius means more than it says. It does not seem, although conjecture has been rife, that the obscurity hides any very exotic influence; wherever Vermeer's sources can be traced beyond doubt it is clear that they were common knowledge among the artists of his school. Of Vermeer's links with his contemporaries we have indeed a wealth of evidence throughout his career. When his pictures are examined in their historical context it is seen that they present numerous and close similarities of matter to works by other artists of the time. Here many of Vermeer's interpreters appear to suffer a certain embarrassment. One of them, grappling boldly with the difficulty, suggested that the explanation is simply that Vermeer originated the motifs in question; the great part of his achievement and his widest influence were assigned in consequence to the time of *The Procuress* and the preceding years.[16] Amateurs of the controversy will notice that the present study agrees with the consensus of recent opinion at least in differing from the views of Dr. Valentiner. If we cannot with reason regard Vermeer as one of the most inventive of Dutch masters it is necessary to examine the alternative and at this point critical logic has hesitated. Yet the issue is relevant to any consideration of the artist's temperament. Investigation

URS GRAF
Venal Love
(*Woodcut*)

must begin with our single piece of direct and undoubted evidence, the date of 1656 borne by *The Procuress*.[17]

Venal love is among the commonest subjects of northern genre painting in its earlier phases, and in particular of the school of Utrecht. Vermeer's rendering differs notably from the sumptuous and lascivious transactions of his predecessors; the bravo of Utrecht is here exchanged for the humane and domestic characters who people the painting of the school of Delft. These figures and their milieu, transposed into Vermeer's native clarity and dignified beyond measure, are in fact precisely those of Pieter de Hooch's pictures of about three years earlier. One of them, the famous example in the Boymans-van Beuningen Museum, anticipates something of the counterpoint of Vermeer's

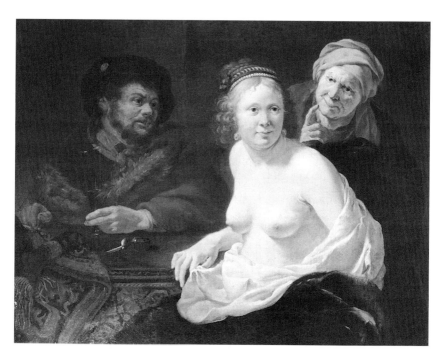

JAN VAN BRONCKHORST
The Procuress
(*Brukenthal Museum, Sibiu, Romania*)

arrangement.[18] Nevertheless *The Procuress* retains a definite flavour of the Caravaggesque, perhaps the clearest appearance of it anywhere in Vermeer's work; the subject, the hint of candle-light which never appears again, and the composition, although there is nothing chaotic or voluminous here, all convey it. Groups of half-length figures arranged behind carpet-covered tables which, seen rather from below, make a sharp horizontal division of the picture, were a common theme of the painters of Utrecht.[19] It is unlikely that Vermeer had far to look for an example. Barent Fabritius, who can hardly have been unknown to him, painted a few months earlier a family portrait which is precisely similarly planned.[20] Very possibly both compositions descend from a common source.

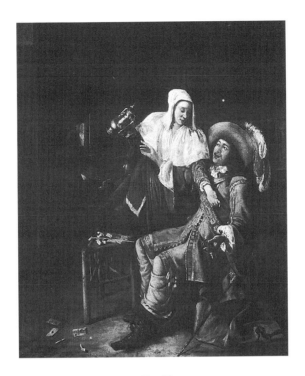

PIETER DE HOOCH
The Empty Glass
(*Boymans-van Beuningen Museum, Rotterdam*)

In later pictures Vermeer assimilated the device and put it to his own characteristic use. The obstruction of space held peculiar advantages to the painter's temperament. The roots of this design stretch far beyond its immediate sources; as so often, Vermeer owes his strength to his position at the meeting of several currents. His composition was not only identified with the beginnings of genre painting,[21] it was particularly associated with the theme of venal love. One of the early appearances of the subject in northern art, a broadsheet bearing the monogram of Urs Graf, presents an exact prototype of *The Procuress*.[22]

(16) W. R. Valentiner, 'Vermeer und die Meister der Hollandischen Genremalerei', *Pantheon*, October 1932.

(17) Read and recorded in catalogue of 1835. Attributed to Vermeer of Utrecht until 1862.

(18) *Klassiker der Kunst*, 1930, p. 16. The view accepted here of the date of this picture, and others in which the same figures appear, is that of the editor, Dr. Valentiner.

(19) E.g. pictures of *A Concert* by J. van Bronckhorst at Utrecht and Brunswick. A colour scheme of primary red and yellow often appears in the work of A. Bloemaert. How largely the formation of Vermeer's picture was governed by current usage is indicated by the appearance, probably quite independently, of several similar features in a picture, *The Choice of a Lover*, by N. Moeyaert, in the Rijksmuseum. (It has indeed been suggested that the work inspired *The Procuress*. W. Drost, *op. cit.* W. Martin, *Frans Hals en zijn Tijd*, Amsterdam, 1942, pl. 85.)

(20) Rijksmuseum, signed and dated Sep. 30, 1655. It is possibly a chance that a similar arrangement makes an appearance in the work of Rembrandt in the same year, in Lord Crawford's *Titus* now in the Boymans-van Beuningen Museum.

(21) E.g. Jan van Scorel's family portrait at Kassel, dated 1562. If this design provided genre painting with some of its earliest material, the theme of Christ in the house of Martha and Mary and related subjects formed one of the chief iconographic vessels in which the art developed. A recapitulation of history, an involuntary consolidation of his ground, may be noted in the early development of more than one great painter but rarely in so complete a form as in the first works of Vermeer.

(22) 1511. See also Lucas Cranach (Stockholm) and Quentin Massys (M. J. Friedländer, *Burlington Magazine*, LXXXIX, p. 119). The most famous of courtesan pictures, Holbein's *Lais of Corinth*, follows the same pattern. Cf. Paris Bordone (Brera).

Plates 6–7
A GIRL ASLEEP
$34\frac{1}{8} \times 30\frac{1}{8}$ in. (867 × 765 mm) Signed
Metropolitan Museum of Art, New York

In *A Girl Asleep*, the *Soldier and Laughing Girl* and the Dresden *Letter Reader* Vermeer's matter is stated in a vocabulary not essentially different from that current among his contemporaries. In *The Letter Reader* the hands are modelled with almost painful attention to their known anatomical form;[23] the same uneasy linear definition of these details appears in the Frick picture. Both reveal the painter experimenting with a manner which is the antithesis

[88]

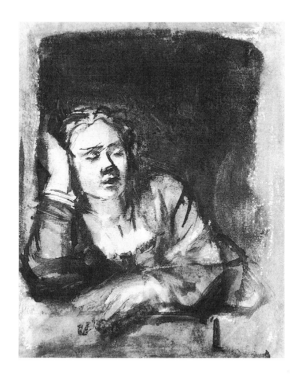

of that which he later developed. The *Soldier and Laughing Girl* is also marked by an unhappy jocularity, an ingredient of the painting of the time which hardly appears again in Vermeer's work. Equally unlike his ultimate style is the Rembrandtesque continuity of modelling in *A Girl Asleep*.

Both the modelling here and the type of model, with her prominent peak, are reminiscent of Nicolaes Maes. Her pose, too, is characteristic of him; it occurs not only in the picture in the National Gallery called *The Idle Servant*[24] but in the great *Lacemaker* at Brussels and many others of the early works.[25] Vermeer may have derived the theme from any of them;[26] it is clear that he profited in the *Girl Asleep* from both the humane gravity and the inventiveness which Maes learned in the studio of Rembrandt.[27]

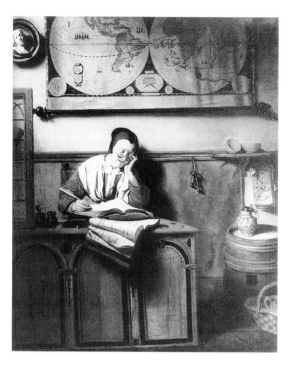

NICOLAES MAES
The Housekeeper
(*1656. City Art Museum, St. Louis*)

The vista opening into another room also appears in *The Idle Servant*; it is often suggested in the work of Rembrandt. But the form in which it is used here is closer to De Hooch. This feature, which became such an integral part of De Hooch's typical compositions, is to be seen in some of his earliest works;[28] its evolution continues throughout his years in Delft and it appears fully developed in a drinking scene in the Rothschild collection painted at about the time of the *Girl Asleep* and *The Procuress*.[29] There can be little doubt that De Hooch's example suggested the use of it here. Like the motif from Maes it does not appear in this form in Vermeer's work again.

The mood of *A Girl Asleep* is none the less for the first time recognizably Vermeer's own; the girl barely visible behind the furniture, inactive, wrapped

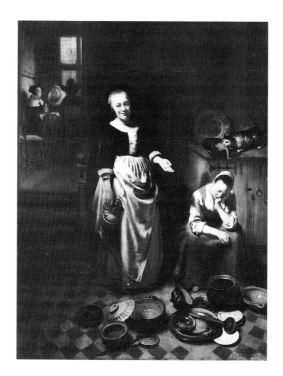

NICOLAES MAES
The Idle Servant
(1655. National Gallery, London)

up in herself, even the barely perceptible intrusive note provided by the mask in the picture on the wall, both belong to his world and no other. There were to be many more lucid expositions of it. The picture on the wall later becomes familiar; it is the Cupid in the style of Cesar van Everdingen which is seen again in the Frick music scene and in one of the pictures in the National Gallery.[30] It then becomes clear that the mask was specially added for the purpose of the *Girl Asleep*. It illuminates the theme with a typical reference; sleep admits a fantasy of love.[30]

(23) Compare P. L. Hale, *Vermeer*, ed. Coburn and Hale, London, 1937, p. 196.

(24) Compare Valentiner, *op. cit.* The picture (no. 207) is dated 1655. Some such work perhaps suggested the similar piece of Esaias Boursse (W. Heilgendorff, Berlin, Rotterdam, 1935 no. 8, pl. 124); the picture belonged to Thoré who attributed it on the basis of a false signature to Vermeer.

(25) The original of *The Housekeeper* by Maes, dated 1656 and surely among Vermeer's sources, is in the City Art Museum, St Louis. The motif appears in the work of Rembrandt at this time, in the drawing reproduced here (formerly in the Heseltine collection, H. de G. 1000). The drawing is connected with the picture at Stockholm: Maes later reveals his acquaintanceship with the window portraits of this phase. No better illustration could be found of the coalescence of an almost classical formality which occurs in Dutch painting in the middle of the century than a comparison of the serene frontal arrangement of these renderings by Rembrandt, Maes and Vermeer in the *Girl Asleep* with Jacques de Gheyn's version of a similar theme (Berlin, Kupferstichkabinett). It will often be noticeable that Vermeer chooses instinctively the genre motif with the longest history and the richest accumulation of meaning. In the drawings of a model resembling *The Idle Servant* (formerly in the Pierpont Morgan, Dalhousie and Oppenheimer collections) Maes may be seen evolving further themes of the same kind.

(26) The most exact parallel to the figure of the *Girl Asleep* is to be found in the little panel of *A Woman Reading* by Claes Hals in the Mauritshuis; the resemblance is beyond coincidence. It would be difficult to place so nondescript a painter among Vermeer's sources; his works are few and he is said to have abandoned painting when he took a tavern in 1664 at the age of thirty-six. Nor does he imitate the specific features of the Delft picture. Perhaps the precise origin of both compositions is lost; the Haarlem work indicates the currency of Vermeer's theme.

(27) Valentiner (*op. cit.*) conjectures that Maes stayed at Delft when he left Rembrandt's studio for Dordrecht, perhaps in 1653 although a later date has been suggested. There was however, as Van Regteren Altena and Martin (*op. cit.,* p. 65) have observed, much freer intercourse between the schools of various towns than is sometimes allowed. There is also some indication, considered below, that Vermeer had access to at least drawings by Maes throughout his career.

(28) From about 1648 onwards, e.g. *K. der K.* pp. 5, 10, 14 and 23.

(29) Repr. *K. der K.* p. 33.

(30) Vitale Bloch in *Oud Holland*, LIII, p. 262. J. van Bronckhorst has also been suggested as the author of the Cupid. The picture is now lost. Perhaps here it has a hardly deliberate double reference; sleep is also the discarding of a mask.

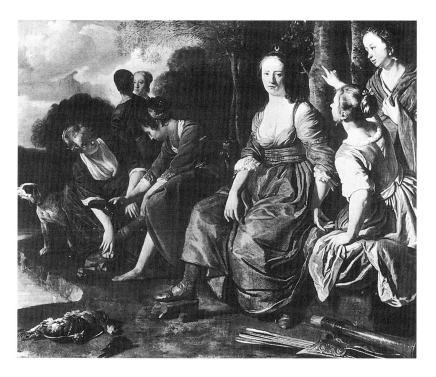

JACOB VAN LOO
Diana
(1648. Gemäldegalerie, Staatliche Museen, Berlin)

Plates 8–9
DIANA AND HER COMPANIONS
$38\frac{3}{4} \times 41\frac{1}{3}$ in. (984 × 1050 mm) Signed
Mauritshuis, The Hague

The Italianate subject and style of the *Diana*, with its size and comparatively conventional facture, have inspired general agreement that it is a very early picture, perhaps the first by the painter that we have. In the case of Vermeer such indications are not always reliable. Certainly there is something in the picture, and particularly in the explanatory use of tone, which distinguishes it from the three pictures which have just been considered. The light falls gently

[93]

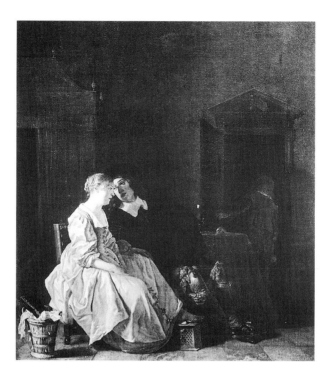

JACOB VAN LOO
Young Couple in a Chamber
(*Mauritshuis, The Hague*)

and broadly across the form, making the subtlest modulation precisely apparent yet preserving most completely the unity of the whole. This comprehensive breadth is hardly approached again by Vermeer until the time of the conversation pieces. Some distance must lie between it and the bare tonal differentiation of *The Procuress* or the heavy flourish of *The House of Martha and Mary*. The point is clearer in photographs than when we are confronted with the polychromatic richness of the original. Perhaps it was the painter's intention to fabricate a conventional Italianate and especially, as Dr. De Vries has suggested,[31] Venetian colour scheme. There is none the less much in the colour of the Diana, particularly in the combination of orange-pink and yellow, which

[94]

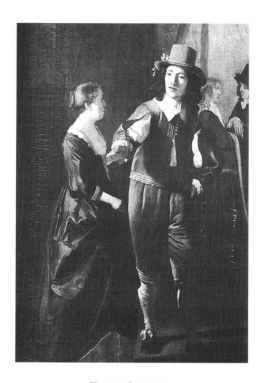

points toward the early genre pictures. It seems that the dress of the attendant who dries Diana's feet, and perhaps the model who wears it, are the same which appear in the *Girl Asleep*. The two works may well date from the same phase. Possibly *Diana and her Companions* represents the culmination of Vermeer's wider ambitions. It shares the fundamental uncertainty of style in all the early pictures. The head of Martha, that of the standing nymph and the mirror in *The Music Lesson* tell the story of its resolution, and the development of the painter's surprising independence.

The picture was for a time ascribed to Vermeer of Utrecht. The signature was once altered to that of Nicolaes Maes; it is now completely obscured.[32] Writers on the *Diana* have followed Bode in recognizing that the arrangement

is based on a rendering by Jacob Van Loo at Berlin.[33] It seems that Vermeer was in fact familiar with more than one of the artist's versions of the subject; the attendant here whose cloak falls across her back, baring her shoulder, is a direct quotation from a picture which is now at Copenhagen.[34] This is not the whole of the debt. The motif of Vermeer's chief figure has no analogy in either work and it can hardly be by chance that a precise parallel to it, even to the memorable fall of light upon the head, appears in a third picture by Jacob van Loo, a genre-piece of a *Young Couple in a Chamber*.[35] A Delft picture which has points of resemblance to the *Diana*, a mutilated canvas called *The Minuet*, was evidently suggested by the same work.[36] It provides a further indication that even the more remote of Vermeer's sources were equally available to other members of his circle.

There were other currents to confirm Vermeer's choice of subject. In 1654 Rembrandt designed just such a pose and action for his Bathsheba.[37] It appears that the Diana had some influence on the later treatment of such subjects. The picture was a link between the Italianism of the first half of the century and that of the decline; no doubt its example contributed something to the arrangement of the little *Venus* of Frans van Mieris,[38] one of the first of the mythological panels which became a staple product of the family. From Vermeer's own world the Italianate and pastoral style was now cast out. It does not appear again until, according to the habit of condensation which is typical of his thought, similar figures in the manner of Jacob van Loo are seen at last extending their elegant limbs in the Finding of Moses which appears behind the Dublin *Letter Writer*, a picture hanging on the wall.

(31) *Op. cit.*, p. 40.

(32) Transcribed in the Catalogue of 1895 and reproduced in that of 1935. Its form was evidently entirely typical.

(33) Dated 1648. W. Bode, *Rembrandt und seine Zeitgenossen*, Leipzig, 1906. The resemblance is in reverse.

(34) The figure is peculiarly characteristic of the Copenhagen picture, a *Diana*; several variations of the motif appear at different points in the composition. (Catalogue of 1922, no. 344).

(35) Mauritshuis. Formerly Alfons Jaffé; *Archiv für Kunstgeschichte*, 1914–15, pl. 112. Another parallel with Van Loo may be noticed. No painter came so close to the precise mixture of the international with the realistic style which is seen in Vermeer's *Christ in the*

House of Martha and Mary; compare his *Coral Glass Factory* (Copenhagen). There is indeed a certain analogy between the two compositions.

(36) Formerly in the Coats collection, Skelmorlie, where it bore the name of Vermeer (cat. no. 38), *Pieter de Hooch K. der K.* p. 245 (as by H. van der Burch). Now in a private collection in New York. It is not quite impossible that evidence might emerge which would enable us to connect *The Minuet* with the unknown juvenilia of Vermeer himself: a certain uneasiness in the picture, as much as any virtue, is suggestive.

(37) In the Louvre. The similarity of arrangement, and in particular of the detail of the hand, might suggest that Vermeer had knowledge of the picture. No comparison illuminates better the essentially different temperaments of the two masters.

(38) Wallace Collection, dated 166(5?).

Plates 10–11
A LADY READING AT THE WINDOW
$32\frac{3}{4} \times 25\frac{1}{8}$ in. (832 × 645 mm) Traces of a signature
Gemäldegalerie Alte Meister, Staatliche Kunstsammlungen, Dresden

In the Dresden picture the characteristic form of Vermeer's work and his arrangement of genre subject matter both become evident. It is the first work in which we see his mature simplicity and with it the curious element of deception, of visual counterfeit. The sources on which he draws are still many—for all its originality no picture has less appearance of inventiveness than the *Letter Reader*—but they no longer account for the character of the result.

Behind the girl, precisely defining her shape, a plain wall catches the light; it is the first appearance of the basic feature of Vermeer's architecture.[39] The device was not a new one, it owes its currency in the seventeenth century to Caravaggio. The Haarlem genre-painters of the previous generation habitually set their picturesquely tangled incidents against relieving expanses of bare plaster and Vermeer's treatment here recalls them unmistakably. There are other signs of the influence of Haarlem on the school of Delft which will require to be considered. But this immovable and unchanging element in Vermeer's compositions must owe much, as has long been recognized, to the most profound influence in his own circle. As it takes on in succeeding pictures its characteristic luminosity it recalls in increasing measure the wall, bathed in

[97]

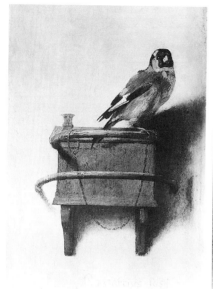

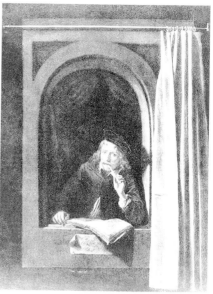

CAREL FABRITIUS
The Goldfinch
(*1654. Mauritshuis, The Hague*)

GERARD DOU
Self-portrait
(*Rijksmuseum, Amsterdam*)

light, which bears the perch of Fabritius' *Goldfinch*.[40] That little masterpiece has sometimes perhaps been made to account for too much. But there is a suggestion in it, almost alone in the painting of Delft, if not of the closed perfection of Vermeer's world, at least of its immaculate simplicity and its light. The peculiarity of Fabritius' picture itself is thus worth attention. In spite of his contact with Rembrandt and Paul Potter the *Goldfinch* traces a very different descent. In form it takes its place in the tradition of *trompe l'œil* painting which dates from the famous example by Jacopo de Barbari now at Munich, the representation of objects (often including birds) suspended against a surface deceptively parallel to the plane of the picture, the tradition which Willem van Aelst was following in Delft.

[98]

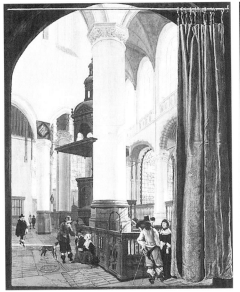

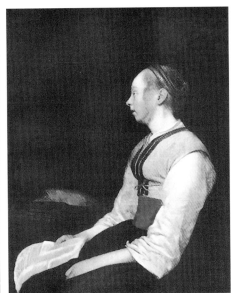

GERRIT HOUCKGEEST
Interior of the Old Church at Delft
(*Rijksmuseum, Amsterdam*)

GERARD TER BORCH
A Girl Reading
(*Rijksmuseum, Amsterdam*)

But there are more palpable *trompe l'œil* elements in the Dresden picture. To the question of precisely what the curtain represents, whether it covers an opening, or the picture itself,[41] the only answer is that its ambiguity is its purpose. It subtly claims a place both in the letter reader's world and ours, defining not only her presence but her distance. It is no more than a rudiment of the infinitely complex solutions of such problems in later works, solutions which come to embrace Vermeer's style itself. The place of curtains in Vermeer's scheme becomes finally clear in such pictures as the *Studio*; the indications of their origin which may be gathered here are of interest. The painter is using a sophisticated and familiar pictorial artifice. The picture within a picture that gains from its deceptive frame a paradoxical and baffling kinship to reality is as

old as the European tradition itself. It was with the illusion of a curtain that Parrhasius outshone Zeuxis—Dutch painters and their public had the Greek legend very much in mind.[42] The High Renaissance had little taste for such a disruptive effect (a certain disrepute still adheres to it) but in the seventeenth century it gained a new significance from the naturalism of Caravaggio.[43] No painters profited more from his revolution than the Dutch and in their pursuit of nature no illusion was beneath their notice. Throughout the school, from the still-life painters to Rembrandt, the deceptive curtain often appears in the form which Vermeer adopted; even a landscape painter found a use for it.[44] In a self-portrait painted in the middle forties Gerard Dou leans through a window covered by just such a curtain as that in the *Letter Reader*.[45] The motif was clearly congenial to him and in succeeding pictures, framing in turn his kitchen, his cat and his *trompe l'oeil* still-life subjects, it often encloses the condensed and self-sufficient trivialities that he painted.[46] He was much imitated and his use of the device no doubt spread the fashion for it in the school. It is possible that Vermeer had Dou in mind when he painted this curtain; the sharp and narrow folds turned back in meditated disarray are precisely like his. Vermeer's later development of the motif recalls Dou as well as the bolder handling of the Haarlem painters before him. But of all the forms of the device none is more likely to have been familiar to him than the current use of it in his own town.

We no longer welcome a quality of counterfeit in art and the *trompe l'œil* element in Dutch architectural painting is commonly overlooked. It is surprising to find even Jan van der Heyden turning from his atmospheric prospects to paint the curious piece now in Budapest. The church painters of Delft fortified solemnity with artifice and the curtain is a part of their apparatus. It appears enclosing a well-known view in the Old Church painted by Gerrit Houckgeest in the fifties,[47] it is green, in straight folds and beyond it a column occupies the centre of the picture, catching the sunlight. There are equally strong suggestions of Vermeer in the work of Hendrick van Vliet. He uses the deceptive curtain in several forms,[48] but the relation between the artists extends further. Among the themes of Dutch painters only the massive single pillar which he often painted, standing alone in measured space and light, has any affinity with the immobile and independent ladies of whom the *Letter Reader* is the first.

Another parallel may be noted, for links between Rembrandt and Vermeer

are always of interest. Rembrandt was responsible for the most notable of previous treatments of the subject of reading at a window.[49] The curtain itself decorated more than one of his pictures. There is no reason to think that Vermeer paid attention to his version, but Nicolaes Maes with whom we may suppose some contact certainly did.[50] The relationship, antithetical yet analogous, between Rembrandt and the *Letter Reader* and the works which follow it, is quite apart from the motifs that they share. In the Dresden picture Vermeer's peculiar sensitivity to the emotional implications of figure painting and the placing of figures in space becomes apparent. There are pictures by Maes in which the Rembrandtesque style suggests something of his early manner and certainly only Rembrandt and his pupils endowed the conventional forms of domestic painting with as profound a meaning as Vermeer.[51] But whatever stimulus was needed to awaken a nerve which was rooted in the painter's nature might have been drawn from almost any source. A whole generation of artists, imitating in one form or another Rembrandt's humane understanding, was grappling with a knot which Vermeer's temperament led him alone to cut.

The Dresden picture is perhaps the first clear sign of this personal process. Ter Borch had painted profiles of a hardly less enchanting simplicity and none of the increasing refinement of genre painting in the later fifties can be quite dissociated from his example,[52] but the figure of the *Letter Reader* is Vermeer's own. It is his first invention, indeed perhaps essentially his only one, for the motif sustains him throughout his most characteristic work, but an invention of a curious kind. It is a solution of the genre problem in terms so simple that it virtually evades it.

(39) It has been suggested that Vermeer's light walls and clear contours owe something to the skies of Paul Potter who was in Delft from 1646 to 1650 (M. Eisler, *Alt-Delft*, Vienna, 1923, followed by A. B. de Vries). The relation is not supported by any definite resemblance. A picture (formerly in Vienna and now again in the hands of the Dutch authorities) which may indeed show Potter's influence has often been ascribed on grounds of a signature to Vermeer (by Plietzsch, Martin, by De Vries, who has excluded it from his most recent editions, and doubtfully by Bodkin and Goldscheider who reproduce it in colour, *Vermeer*, London, 1940, p. 5;) it is an open-air adaptation of motifs from Rembrandt's portraits of the fifties (cf. that dated 1645 and strongly suggesting the Delft school, published by Dr. Bredius, *Paintings*, 1936–7, no. 238). The picture may have been painted in Delft but the artist remains uncertain.

(40) Mauritshuis, dated 1654.

(41) Compare Wilenski, *Introduction to Dutch Art*, London, 1929, p. 283. Cases in which it is possible to discern the exact function of the curtain (e.g. in the pictures by Rembrandt, Houckgeest and Hondius) do not suggest that it is ever to be understood as covering a mirror, nor were curtains commonly so used in Holland.

(42) W. Martin, *op. cit.*, p. 26. In Romanesque illumination the curtain, often shown as suspended from the border of the page, was associated with the iconography of the Evangelists, e.g. the St. Matthew in the Lindisfarne Gospels (British Museum) and the St. John in the Lorsch Gospels (Vatican). The medieval interest in such devices persisted in fifteenth-century painting, e.g. Hugo van der Goes' *Adoration* (Berlin), in which the rod is imitated in gesso on the panel, and Botticelli's *St. Augustine* (Uffizi, E. Michalski, *Bedeutung der ästhetischen Grenze*, Berlin, 1932).

(43) There is a curious instance in a *Narcissus* by Longhi's Cecco del Caravaggio. (Roberto Longhi, *Proporzioni I*, Florence, 1940, pl. 58.)

(44) E.g. the *Vanitas* among the gifts of Dr. Bredius to the Mauritshuis (Cat. no. 654 as c. 1650). Michalski reproduces a *Mountain Landscape* by A. Hondius in which the curtain casts a shadow across the picture.

(45) Rijksmuseum. (*K. der K.* p. 16, as about 1645.) See also *K. der K.* pp. 159, 144.

(46) Cf. *K. der K.* pp. 159, 144. The latter, like others of Dou's still-life panels (and perhaps *The Goldfinch* which has marks of hinges), formed the door of a case enclosing a picture. Such cases afforded not only protection but also further opportunity for deceiving the eye: Vermeer's *Gold Weigher* was enclosed in one in 1696. (K. Boström, *Kunsthistorische Mededelingen*, 1949, 1–2.)

(47) Rijksmuseum, the last figure of the date is obliterated. The rod appears to cast a shadow on the picture. Another form of the motif, in which the curtain is looped over the rail from which it hangs, appears in a picture of *The Great Church at Bergen-op-Zoom*. (Copenhagen Museum, no. 251, dated 1655. Dou's picture at Dresden dated 1656(?) shows a similar form.) In this shape it appears in a picture in Pieter de Hooch's style of the middle fifties (formerly Leon Lilienfeld collection, Vienna, *K. der K.* p. 25) and, more elegantly, in the works of the next decade (Copenhagen and J. Boehler collection, Munich, *K. der K.* pp. 84 and 85) Jan Steen makes similar use of it in his great essay in the style of Delft now in the Mauritshuis (no. 170, see also the *Christ in the House of Martha and Mary,* Stirling-Maxwell collection, and *The Marriage Contract* at Brunswick).

(48) H. van Vliet uses the hanging curtain (in a picture, for example, that was at Messrs. Gottschewski, Hamburg, in 1935 and another at Messrs. Asscher and Walker, London, September 1929) and the looped-up form (Leuchtenberg Gallery, Munich, Cat. of 1857, No. 161, dated 1659 and formerly Cook collection, 1914, No. 375, probably c. 1656, cf. the dated *Oude Kerk* sold at Christie's, 11. 6. 37, No. 32). In one of his pictures of *The Nieuwe Kerk at Delft* the two forms of the motif appear together. (Plautier-Sachswitz collection, exhib. Leipzig, 1929, n. 24, the date of 1636 was probably a misreading of 1656.)

(49) E.g. the etching of Jan Six (1648) and the oil sketches connected with it (Bonnat Museum, Bayonne, and Ny Carlsberg, Copenhagen, *K. der K.* I. pp. 344, 338).

(50) Rembrandt's *Holy Family* at Kassel (1646) is enclosed in a painted frame with a

rail from which a curtain hangs. (The frame is certainly that of the picture rather than a mirror; it follows the one that Rembrandt designed, in a drawing in the Louvre, for the Berlin grisaille of *John the Baptist Preaching*.) Maes made a drawing after the Kassel picture. (Oxford, Dr. K. T. Parker, to whom the writer is indebted for knowledge of it: the copy shows both the curtain and the full extent of the painted frame, now considerably cut away at both sides of the original. Another, incomplete, study by Maes is in the British Museum.) The curtain appears, in heavier folds, in the free and very beautiful variation (formerly in the Huldschinsky Collection, Berlin) which Maes based on Rembrandt's treatment of the subject now in St. Petersburg. Maes also knew (see note 51) the *Emmaus* of 1648; a curtain hangs over the Copenhagen version of the composition.

(51) Among the pictures of Maes such works as *A Mother Nursing her Child* stand half-way between the style of Rembrandt and that of Delft (versions were in the Kappel Collection, Berlin, and the Lanz collection, Mannheim. The subject, framed in a niche like that of the *Emmaus*, was perhaps suggested by Rembrandt's *Holy Family* in the Louvre). The interiors which Rembrandt painted in the forties, the Louvre panel and the *Tobias* pictures (Gemäldegalerie, Berlin, and formerly Cook Collection), were in form and mood the true predecessors of the genre-painting of Delft. (Rembrandt's works provided the basis of a rendering of the subject, now in the Ferdinandeum at Innsbruck, variously attributed to Carel and Barent Fabritius.)

(52) E.g. Ter Borch's *Maternal Care* in the Mauritshuis, *The Reading Lesson* in the Louvre and the work in the Rijksmuseum reproduced here, all painted in the early fifties. The closest analogy in Ter Borch's work of this time to the figure of Vermeer's *Letter Reader* appears in a circular picture of a girl holding a toilet box (Paris, Georges Renand) published by S. G. Gudlaugsson (*Ter Borch*, The Hague, 1959, 1, pl. 77, as c. 1648–9) to whose courtesy the writer is indebted for knowledge of it. The painters of Leiden under Ter Borch's influence are among the most remarkable of Vermeer's immediate predecessors. In pictures by Quiringh Brekelenkam, for instance, a steady light floods an interior whose further wall is decorated with a map (e.g. works in the Zatka collection, Budweis, and L. D. van Hengel, Arnhem, both dated 1655, and a portrait, at Benedict and Co., Berlin, in 1928, dated 1652) and the foreground is occupied by a still-life of musical instruments (an example dated 1655 was at Van Diemen and Co., in 1932). Such affinities make it difficult to trace with certainty any influence of Vermeer's *Letter Reader*. Possibly, however, it is reflected in *The Duet* by Frans van Mieris at Schwerin, dated 1658. (The picture bears no resemblance to Vermeer's *Concert*, although a connection has been suggested.) The governing influence on the development of Van Mieris remained, as the related *Toilet* at Berlin makes clear, that of Ter Borch.

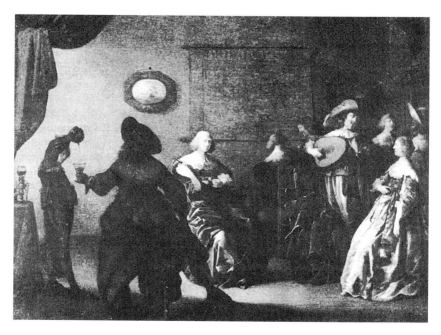

ANTHONIE PALAMEDESZ

A Merry Company

(Formerly Porgès collection, Paris)

Plates 12–13
SOLDIER AND LAUGHING GIRL

19 × 17 in. (483 × 432 mm)

Frick Collection, New York

The subjects of the *Soldier*, the *Girl Interrupted* and the drinking scenes at Berlin and Brunswick follow closely the genre convention of the time. Vermeer is never quite as ease with it; his impersonality and his detachment sit a little incongruously on the careless air which the subjects affect. As his deliberation and his diffidence become more evident they give rise to curious inconsistencies of style. The subject of this picture has an evident relation to De Hooch. A rudimentary version of the soldier appears in one of his earliest military scenes, painted ten years or so earlier, and the evolution of the figure may be

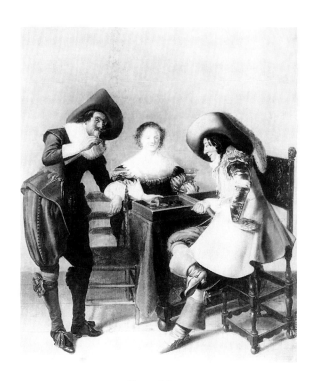

DIRK HALS

Backgammon Players

(*Formerly Liechtenstein Collection, Vienna*)

clearly traced in succeeding works.[53] Often De Hooch seats him opposite a woman in a linen hood and more than once he serves to enclose a composition, shrouded as here in shadow. There are several versions of the group (a remarkable example is at Dublin) from any of which Vermeer might have derived it in very much the form which it takes in the Frick picture.[54] De Hooch himself doubtless owed the notion to the painters of Haarlem; such cavaliers were a part of their common stock.[55] The device of enclosing the composition with a darkened figure outlined against the light is equally characteristic of them; among the artists who used it was J. van Velsen who worked in Delft.[56]

Other elements in the *Soldier and Laughing Girl* were of more lasting use to the painter; his architecture and the light which floods it appear here in their

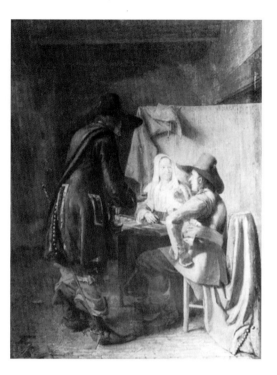

PIETER DE HOOCH
Backgammon Players
(*National Gallery of Ireland, Dublin*)

mature form. The enclosing wall parallel to the plane of the picture and the
windows on the left receding obliquely towards it make up the unvarying
pattern to which he held throughout his work. This consistency in itself yields
little evidence about the painter; the light in his interiors falls almost invariably
from the left but it would not be easy to find a genre picture by one of his
predecessors lit very definitely in any other way. The interiors of Rembrandt,
rustic and hoary, radiant with piety and learning, and those of the meanest
followers of Frans Hals and Dou share an architecture that is essentially the
same and Vermeer adheres to it conservatively. The opening vistas which were
the particular theme of De Hooch seem, although one of his variations is lost,[57]
to have held hardly more interest for him than the shadowy spaces that Ter

[106]

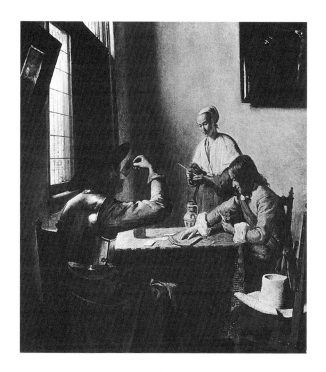

Borch was popularizing as a setting for elegant society. Few Dutch painters, but none less so than Vermeer, expended originality on innovation for its own sake.

The convention of form which Vermeer took up was of about thirty years' standing; the works of Rembrandt and the style which Dou derived from them, the painting of Haarlem under the influence of Frans Hals and the courtly cabinet pieces of the thirties,[58] as well as reflections of the proliferating architectural fantasies of the perspectivists all contributed to it. One can trace in Vermeer's clear and rigid rectangle of space another sign of his acute eye for the essence of the varied elements in his tradition. The more elaborate of his last works tend towards the pattern propagated by the painters of Leiden. But

there is no doubt that in the form, as in the figure motif, which he adopts in the *Soldier and Laughing Girl* one origin predominates, the school of Haarlem. Perhaps he owed it to the same immediate example, that of Pieter de Hooch. Vermeer's pattern is very close to a picture called *The Card Players*.[59] The Delft painters may have drawn the suggestion from many sources; a number of their contemporaries arrived at similar solutions at about the same time or a little earlier.[60] De Hooch elaborated the structure in later works but he did not develop it. The form of *The Card Players* was one of the many fertile arrangements which he lighted on during his remarkable period of vitality. It would indeed be hard to imagine the unique potentialities of this hollow cube of lighted space if we had not Vermeer's mature pictures to help us.

(53) E.g. *K. der K.* pp. 4 (as c. 1648), 10, 17, 18, 19, 26. The use of the group in one of the earliest of the courtyard scenes which were his most remarkable works is of interest. Valentiner published a work, if the De Hooch signature is one of those that can be relied on, in which the soldier possibly owes something to Vermeer (*loc. cit.* and *K. der K.* p. 261).

(54) The curiously bent hand of the soldier, often visible in Haarlem pictures, later becomes a common mark of De Hooch's influence. E.g. Brekelenkam's *Soldier and Laughing Girl* (Pannwitz collection, probably based on such works as that in the Van Gelder collection, Uccle, rather than on Vermeer's rendering. Another of Brekelenkam's variations is in Dr. W. M. Moser's collection, Brooklyn, in which the soldier is standing, Christie's, 17. 3. 44. no. 78). Metsu's *Smoker*, formerly in the Czernin collection, Vienna (H. de G. 203), evidently belongs to the same phase.

(55) E.g. Dirk Hals' *Backgammon Players* (formerly Liechtenstein Collection, Vienna), Pot's *Convivial Party* (National Gallery).

(56) E.g. his *Music Party* in the National Gallery, dated 1631. The painter was a master in Delft in 1625. The device descended from Caravaggio; it was well known to the school of Utrecht (e.g. *The Concert*, signed by Gysbrecht van der Kuyl, collection of Sir George Leon, Rotterdam, 1935, no. 3).

(57) No. 5 in the 1696 auction.

(58) Several Delft artists practiced in this style. E.g. Gerrit Houckgeest's *Interior with a Gentleman Making Music* (formerly A. Kay collection, Edinburgh, dated 1(6)33). Cf. also *Christ in the House of Mary and Martha* by Hendrik van Steenwyck the Younger in the Louvre, dated 1620.

(59) Now in a private collection in Switzerland (formerly Pereire collection), *K. der K.* p. 32 as about 1655. The date, however, is a matter of conjecture. The picture is clearly related to the *Soldier and Laughing Girl*. The evidence suggests that the De Hooch was the earlier of the two works, but since neither can be dated with certainty it is not quite conclusive. It is clear that Vermeer and De Hooch were working in close contact between 1656 and 1660

or later and no doubt both artists were affected by the relationship. There is, however, no indication that De Hooch in this most personal and original phase of his work owed anything material to the younger artist. Where a definite connection between them is discernible, as it is in the figure motif of the *Soldier and Laughing Girl*, it is clear that Vermeer was the debtor. In the sixties, when De Hooch responds to Vermeer's influence, the impact and the attenuation of his own style are unmistakable.

(60) Among parallel developments there may be noted Isaäk van Koedyck's *Empty Glass*, dated 1648 (Van Aalst collection, Rotterdam, 1935, no. 63a,) and a *Backgammon Players* by Gerbrand van den Eeckhout (1651, in 1935 at Messrs. A. S. Drey, Munich) which seems to be related both to the Haarlem school and to De Hooch. (A variation of the subject was exhibited at Stockholm, September 1938 no. 16, dated 1653.)

Plates 14–15
A STREET IN DELFT
$21\frac{1}{4} \times 17\frac{1}{4}$ in. (540 × 438 mm) Signed
Rijksmuseum, Amsterdam

Plates 16–17
A MAIDSERVANT POURING MILK
$18 \times 16\frac{1}{8}$ in. (457 × 410 mm)
Rijksmuseum, Amsterdam

The *Maidservant* has on the surface some resemblance to the painting of Vermeer's predecessors, but both the plan of the picture and the refined style of representation belong to his maturity. The detail of life is rendered here as a bare map of the incidence of light. The optical vocabulary becomes at once so convincing and complete that it is not always recognized how deep is the change, how unexplained in this head for instance the accent of the cheek, how unexpected the omission of drawing at the base of the nose and across the expanse of shadow. There is a wide gulf between this confident manner and the head of the *Laughing Girl*. The maid's left arm, as comparison with the passage in the Edinburgh picture demonstrates, draws from its contour neither form

[109]

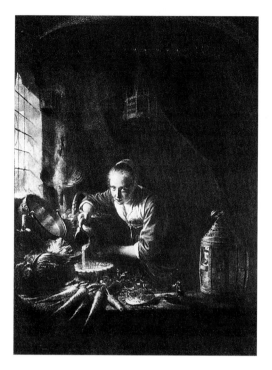

GERARD DOU

The Cook

(*Louvre, Paris*)

nor supporting detail; the record of tone is bare of the structural modelling of the Dresden *Letter Reader*. The other arm, equally independent of convention, of necessity relies more on its defining outline, and round it are visible, strangely, the *pentimenti* which rarely occur in the painter's work.

The *Maidservant* has been a favourite picture of those who have seen Vermeer as a simple precursor of Chardin and of Corot.[61] It is perhaps largely in the interests of a uniform progression, in whichever direction, that it has commonly been counted among his early works. Few have followed Dr. Valentiner to the extreme, in dating the picture two years before *The Procuress*. There is in fact little reason in the view of Vermeer's development as a steady and elegant decline. For all the weight and continuity of modelling in the

Maidservant its beauty lies as much in the elements which contradict them. It is perhaps only the radical change of method, approaching an abdication of the traditional demands upon painters to know and understand, that allows the painter here to make his single frontal assault on the problem of physical immediacy which lies at the heart of his development. We may imagine a mood of confidence, a liberation; the boldness does not quite agree with his temperament and it is possible to prefer the tender yet inflexible system of tone against which he balances the magnetism of the *Lacemaker*. In the *Maidservant* he treats a common subject of genre painting in previous decades, following precisely the pattern of Gerard Dou.[62] The lustrous simplicity with which he handles the material of commonplace things pays another distant tribute to Carel Fabritius. But the vision that emerges is his own.

Vermeer's deliberation and his reserve complicate greatly the study of his development. He often reverts to his sources or appears to repeat himself, and as often foreshadows elements of his meaning which are not to come to fruition until a later phase. His colour, his subject matter, even his handling of paint are so deliberately contrived that they may well mislead the historian accustomed to artists who readily reveal themselves. Nevertheless his technical evolution yields certain useful historical criteria and one in particular concerns us here. In the early pictures Vermeer's touch is never without descriptive purpose. Even in the *Street* each fleck of paint palpably constitutes leaves or mortar. But in succeeding pictures the *pointillé* loses its function of representation; the touch which has embroidered the sleeve of the *Letter Reader* gains its independence. Granules of light are scattered irrespective of the textures on which they lie. There is no plainer sign of Vermeer's direction, his movement of withdrawal from the substantial world. At some point, probably at a time a little after the completion of the *Street*, paint revealed its capacity to provide a glittering, barely relevant commentary of light. Once discovered, the device, so germane to the essence of Vermeer's thought, is hardly used except in its fullest form.

There is no doubt that the *Maidservant* dates from after this crucial development. By how long we can hardly tell; the development may have been achieved in this very picture. In the *Maidservant* light collects into pearly globules. The surface of the bread is lost under a separate crust of incandescence.[63] On the skirt, where it is gathered at the waist, the points of paint lie like jewels, lending

the cloth an independent and immaterial lustre. The picture must belong to Vermeer's full development, as a broader view of it was enough to suggest, to the phase, that is to say, of the *View of Delft* rather than that of the *Street*. For a more precise indication of its date we may compare it with the Berlin drinking scene, the first conversation piece in which points of paint have a similar independence. The clotted paint which is so conspicuous here appears again in the lady's bodice. Her skirt shows just such forms as that of the *Maidservant*; they do not appear in Vermeer's work again. Perhaps the two pictures were not painted far apart.

The use of Vermeer's *pointillés* continues with increasing economy and refinement in later works; they are absent only in the modest style in which the jewelled subjects of the pearl pictures are set. Finally even this concession to the natural world becomes flattened and elaborated into the symbolic, lucent facets of the last works. Some reflection of the *Maidservant* can perhaps be discerned in pictures by De Hooch in his style of the early sixties.[64]

(61) The resemblance is the theme of E. de Goncourt's famous passage (*Journal* 1887).

(62) E.g. *The Cook* in the Louvre (*K. der K.* p. 118).

(63) The view that passages of this kind might appear without incongruity side by side with the linear manner of the Edinburgh picture can be discarded; Van Meegeren who propounded it so conspicuously was doubtless a student of the more speculative flights of Vermeer criticism.

(64) See *K. der K.* p. 76, also *Maid with a Glass* (Rotterdam 1935, no. 47).

Plates 18–20

A GIRL DRINKING WITH A GENTLEMAN

$25\frac{1}{2} \times 30\frac{1}{4}$ in. (648 × 768 mm)

Gemäldegalerie, Staatliche Museen, Berlin

JACOB DUCK

A Merry Company

(Hermitage, St Petersburg)

Plate 21
A GIRL INTERRUPTED AT MUSIC
$14\frac{1}{2} \times 16\frac{1}{2}$ in. (368 × 419 mm)
Frick Collection, New York[65]

It has long been recognized that these two pictures and the drinking scene at Brunswick are related.[66] In fact the Brunswick picture stands a little apart. A considerable development of style separates it from the *Girl Drinking* at Berlin. Both pictures, moreover, evidently represent scenes of fashionable life rather than the domestic milieu which remains almost unchanged from the time of the *Letter Reader* to that of *A Young Women with a Water Jug* and the dresses which

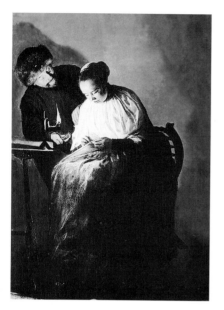

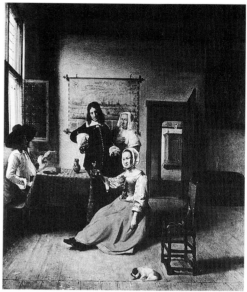

JUDITH LEYSTER
The Rejected Offer
(*1631. Mauritshuis, The Hague*)

PIETER DE HOOCH
A Drinking Party
(*Louvre, Paris*)

appear in them belong to rather different dates.[67] It seems that, whenever the Brunswick piece was planned, it must belong in its final form to a time several years later than the *Girl Drinking*. Nevertheless the three are closely linked. The rooms we see are similarly arranged: in two of them the same theme is enacted and the pictures at Berlin and Brunswick are based on the same dominant colour, a brilliant orange-pink. In these three pictures Vermeer embarks on the elegant anecdotes which his contemporaries were elaborating under the influence of Ter Borch.

The theme of the interruption in the Frick and Brunswick pictures has at first sight an incongruous look in the world of the painter of the *Letter Reader*.

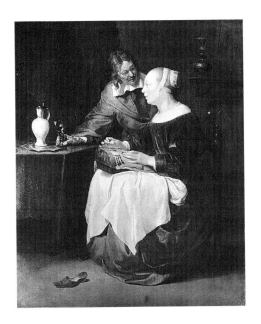

GABRIEL METSU
An Offer of Wine
(Kunsthistorisches Museum, Vienna)

It rather recalls the ruthless conviviality of Haarlem and there is no doubt that the circle of Frans Hals originated the motif. The ladies of Jacob Duck enjoy similar pressing attentions; just such a cavalier intrudes upon the *Flute Player* of Dirk Hals.[68] One appearance of the theme is particularly interesting. Although there is no reason to add still further to the list of Vermeer's sources, it is difficult to avoid reference to the most beautiful of such works, Judith Leyster's *Rejected Offer*.[69] The quality of the picture, its reticence and the light, direct yet gentle, would have been congenial to him; its theme, the theme of venal love which he dealt with in several forms, might have attracted his attention. Certainly there are few closer parallels to the motif of interruption as he uses it. It is tempting to think that Judith Leyster may have suggested the quality of

[115]

those preoccupations over which Vermeer's ladies often intently bend; at all events her picture enables us to understand the associations of such subjects in the painting of the time.

Among the artists of Vermeer's own generation the motif of the interruption makes its appearance in a music scene by Gerbrand van den Eeckhout painted in the year before Vermeer's *Procuress*.[70] The general plan of the Brunswick picture appears in a drinking scene by Pieter de Hooch dating from about the time of *The Card Players*.[71] Metsu's version of the arrangement is seen in a picture called *The Collation* at Brussels; he often uses the motif of interruption.[72] The elements which Vermeer assembles in these three pictures were clearly in general currency. Yet in them his peculiar contribution becomes apparent.

Some writers have discerned points of weakness in these works.[73] Although the painting of accessories meets with approval, fault has been found with heads, hands and draperies. In the Brunswick picture the cavalier is generally declared to be execrable and the dress studied on a lay figure. The hand that rests upon the lap is admired. However we view such judgments it is to the point to notice that there is something ill at ease in the artist's handling of these figures. In the Frick picture the treatment must always have been summary. Where this gives place in the work at Berlin to a naturalistic minuteness inconsistencies arise. The painter, in displaying his faith in his impeccable still-life method, protests too much, and where the human detail emerges the style becomes evasively general, even primitive. We must seek other causes for these inconsistencies than the external circumstances which have sometimes been suggested. To suppose that they indicate simply that the painter was badly served by his models is to overlook his profound resistance to the naturalistic description of life. With a stroke whose unexpectedness is a measure of his genius he proceeded to embody this depth of feeling in the matter of his art.

When we turn to the later work, *A Couple with a Wineglass* at Brunswick, we discover the lines of Vermeer's solution. The subject and its arrangement seem to belong in essence to the earlier phase; the execution of the picture may have been prolonged. It is as likely that the work was the outcome of an impulse to define an issue which the earlier versions had left open, to satisfy an ambition still not quite fulfilled. The figures that we see on the canvas at Brunswick are far removed from the particular, tangible beings of the naturalistic style. Substance and intimate details have drained away. Within the sharp,

simplified contours which map them out these figures, so far as their human matter is concerned, are rendered with the barest economy. The heads have no surface nor even, when we examine them closely, volume; they are nothing but light and shadow, a bare scheme of tone which seems to carry the figments of features with something like irony as a necessary irrelevance. We might indeed have expected a quality of the sardonic, the quality which is confirmed by the commentary supplied by the painting on the wall, in the picture which finally incorporated this villainous theme into Vermeer's world. The economy here is still that of artifice, or design rather than of visual impression.

One particular emerges, that of the girl whose eyes meet the painter's as if in appeal to be released from the oppressive charade. Her direct look has something edged and memorable about it, an effect which is easy to understand in the context. Certainly Vermeer did not forget it; later pictures were devoted to the assimilation which defeats him here. One detail suggests the way he was to follow. On the lap lies a hand which is quite unlike anything in Vermeer's early work or indeed any other painting of the time.[74] Its foreshortening leaves all the receding surfaces unexplained. Yet it is entirely convincing. Its linear shape is insignificant, yet as a record it is entirely and effortlessly complete. The artist has discovered a new kind of representational consistency, one which omits everything that holds the Berlin picture together. He has replaced the naturalistic concept-painting of his school with an unsubstantiated visual record.

Vermeer's inconsistencies are hardly perceptible except by his own standards. To his contemporaries it was probably evident that even in these pictures he had given a classic definition to the style of Metsu and De Hooch. An elaborate work of unknown authorship called Refusing the Glass seems more likely to be an imitation than a source of the Brunswick picture.[75] There is a picture by Metsu, also in London, The Duet, in which the figures take up the positions of those in the drinking scene at Berlin. It is possible that Metsu drew on the same sources, and even that his picture preceded Vermeer. But his version has a spaciousness quite absent from his earlier work and one might perhaps form round it a group of similar pictures which seem to represent a stage in his assimilation of Vermeer's influence that is usually overlooked.[76]

(65) The usually reliable histories of the pictures given by De Vries may in this case be corrected. The picture passed from Woodburn to Francis Gibson, Saffron Walden, and thence (1859) to Lewis Fry, Bristol. In 1900 it was at Lawrie and Co.

(66) P. Johansen, *Oud Holland*, XXXVIII 1920, p. 185.

(67) The dress in the Berlin picture was worn before 1660. The fashion which is seen in the work at Brunswick does not appear until 1663 or later. The writer is indebted for this information to Dr. S. G. Gudlaugsson.

(68) E.g. Duck's *Merry Company* (St. Petersburg). *The Flute Player* of Dirk Hals (Hanover) appears undisturbed in a picture at Haarlem. Cf. also Duyster's *Conversation* (Copenhagen).

(69) Mauritshuis, dated 1631. Her *Flute Player* at Stockholm has been remarked as foreshadowing Vermeer. (Van Regteren Altena, *Proceedings of Anglo-Batavian Society*, III.)

(70) Copenhagen. (Cat. of 1922, no. 304, dated 1655.) The lady holds a book of music very much as in the Frick picture (the resemblance is in reverse).

(71) The Louvre, Paris. (*K. der K.* p.33 as c. 1655–6.) This picture and *The Card Players* which has been illustrated may seem hardly of a quality to bear comparison with the works of Vermeer. Their interest lies in the probability of their early date: as a corrective the famous examples in the National Gallery at London and at Buckingham Palace, painted nearer the time of Vermeer's pictures, may be borne in mind.

(72) E.g. in *The Flute Player* (Kassel, H. de G. 146), *The Meal of Oysters* (St. Petersburg. H. de G. 174) and the picture at Vienna (H. de G. 81).

(73) E.g. the observations of an American painter first published in 1913. Hale, *op. cit.*, pp. 120, 190, 192.

(74) It may be compared with what so brilliant an imitator as the painter of *Refusing the Glass* made of the passage.

(75) National Gallery, Hoogstraten, Pieter de Hooch, Vermeer himself and Emmanuel de Witte (*Cleaned Pictures*, 1947, no. 76) have all been suggested. Valentiner (*K. der K.*, p. 244) included it with a related picture, *The Terrace* in Chicago, in the group ascribed to Hendrick van der Burch. N. Maclaren in the Gallery Catalogue (1960, pp. 96–100) has marshalled arguments for C. Fabritius. The evidence that the style was possible before 1654 is by no means clear. Certain features and notably the use of reflections, for example that of the dress in the marble floor, do not enter genre painting in this form until the sixties, e.g. de Hooch, *K. der K.* pp. 79, 72. Given a certain archaism of scale and handling, the picture is not inconsistent with this date. The alternative is to regard the picture as among the chief sources of the Delft genre style; while not impossible this remains on present showing unlikely. The points of connection with Ludolf de Jongh, suggested in the first edition of this book, are hardly conclusive. It is nevertheless necessary to seek some such painter, of whom there are gaps in present knowledge. The woman in *Refusing the Glass* is apparently another indication of the influence of Jacob van Loo in the school. Imitations of Vermeer's three pictures include a work by Ochtervelt (Art Institute of Chicago); a curious and feeble work by Brekelenkam (Cologne, 10. V. 1916, at Messrs. Fleischmann in Munich in 1929) combines elements drawn from them and from the *Soldier and Laughing Girl.*

(76) The pose of Vermeer's gentleman is characteristically vacuous and in *The Duet* he is equipped with a violin (National Gallery no. 838). But by comparison with the rendering in St Petersburg (H. de G. 151) the change of atmosphere is clear. With *The Duet*, the *Letter Writer* (Wallace Collection, H. de G. 186) and *The Sportsman's Return* (Rijksmuseum, H. de G. 180) might be included in the group. The riddle presented by the masterpiece of the painting under Vermeer's influence, *The Sick Child* (Rijksmuseum), remains unsolved. Probably it depends from such works as the *Girl Asleep* and the *Soldier and Laughing Girl*. The foreshortened head is uncommon in Metsu's work (it appears again in a later picture derived from Vermeer, the Dublin *Letter Reader*) but, like other features of the picture, it is characteristic of Maes, and of Vermeer under his influence. The freedom and fluency of *The Sick Child* are unlike Metsu's later manner. It is however clear that Metsu was apt to practise several styles concurrently.

Plates 22–23

THE CONCERT

28 × 24¾ in. (711 × 629 mm)

Isabella Stewart Gardner Museum, Boston

(Present location unknown)

Plates 24–29 and 37

THE MUSIC LESSON

28½ × 24⅝ in. (724 × 625 mm) Signed

Buckingham Palace, London

The contradictions which have intruded upon the consistency of earlier works are here assimilated. Henceforward they are, as they have hardly been before, an essential part of Vermeer's subject; to reconcile them becomes perhaps the profoundest purpose of his pictures. In these two the surprising stroke is brought about. The reconciliation is accomplished in the first place by a device of pictorial design; the whole plan of the pictures is based on a distaste for physical closeness and direct contact. In *The Music Lesson*, instead of human matter, the chief object of the painter's scrutiny is the great perspective.[77] But the mirror foreshadows the incorporation of the paradox into the painter's style itself. The picture is not at first sight one of the most compelling of

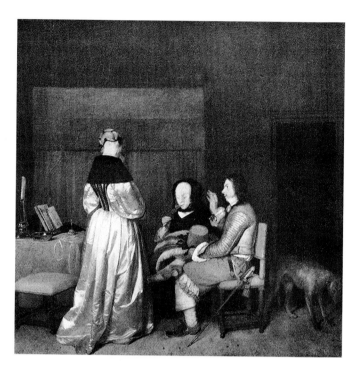

GERARD TER BORCH

The Admonition

(Rijksmuseum, Amsterdam)

Vermeer's works. There is indeed a kind of prosaic tiredness about the representation, as if it showed the furthest ebb of the painter's confidence in the common forms. Its significance is in its design and in the scheme which it completes; only at one point, in the reflection, is Vermeer's fantasy fully extended in style.

It is not easy to be sure when these pictures were painted. The scenes have the domestic air of Vermeer's most characteristic works. The dresses seen in them were evidently in general use in the household; they cannot be precisely dated.[78] Traces remain of the encrusted pigment typical of the early works, notably in the carpet which appears in *The Music Lesson*. But there are equally positive affinities with the later phase. Concurrently with the painting of the

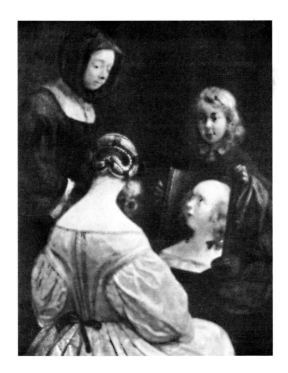

GERARD TER BORCH
The Toilet
(Rijksmuseum, Amsterdam)

fashionable conversation pieces it seems that Vermeer also pursued his object in this other more private, more oblique direction, the direction which was properly his own. And in the passage of the reflection in *The Music Lesson* we have a beginning of the deliberate and marvellous style which distinguishes the latter half of his work. Behind the head in the mirror an easel is visible. It is often said that the *Music Lesson* indicates the way in which Vermeer worked.[79] But if it does so it is hardly in the usual sense. To complete the story we should probably need to discover the nature of the box which stands immediately behind the easel in the reflection, where we might expect to see the painter himself. Possibly his intimates understood the reference.[80]

However personal his purpose here, Vermeer draws further on the resources

[121]

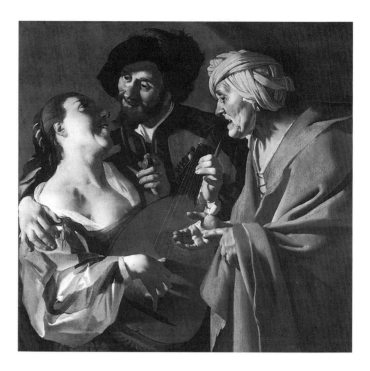

THEODOR VAN BABUREN

The Procuress

(1622. Museum of Fine Arts, Boston)

of the time. The general scheme of composition recalls Leiden and such parties round the virginals were a subject of the genre painters of Haarlem. Similar still-lifes of musical instruments often furnished the foregrounds of both schools. But the chief source of *The Music Lesson*, as of Vermeer's Leiden contemporaries, was the painting of Ter Borch. To him the genre school owed the device of the enigmatic lady who turns her back upon the spectator. In Delft De Hooch often made use of such figures, though not of their dramatic possibilities, and in later years he followed more and more closely Ter Borch's characteristic form.[81] Very possibly Vermeer's debt goes further. Among Ter Borch's early uses of such figures were toilet scenes in which the theme is a delicate interplay between a lady and the reflection of her features in a mirror.[82]

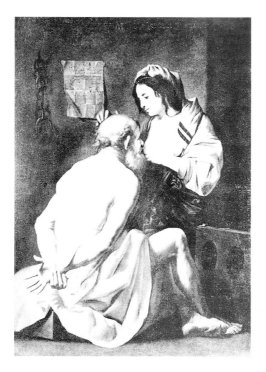

The Concert and *The Music Lesson* present elements of the style and the design of Vermeer's maturity; they also introduce that studied obliquity of theme, with its delicate symbolic accompaniment, which provides the matter of his later works. In such earlier pictures as the *Girl Asleep* as well as in the drinking scene at Brunswick we can discern a certain wit in the choice of the paintings which hang on the walls. They provide a barely noticeable embroidery of the painter's themes. So it is at first sight with *The Concert*. Here, hanging on the right, is a picture which can be identified. It is a *Procuress* painted by the Utrecht artist Theodor van Baburen a little less than forty years before. A version of the composition, as has often been remarked, is in the Rijksmuseum; the original, no doubt the picture that Vermeer owned, has recently emerged

from an English collection.[83] It might seem that its appearance in *The Concert* was almost fortuitous. If it has any profounder purpose than the romantic landscape which hangs beside it Vermeer does not urge it. A connoisseur to whom its subject was legible might have gathered from the lascivious play that centres on Baburen's musician a sardonic reflection upon the appearance of disinterest with which the living figures take their places in front; he could hardly have been sure whether to credit it to the artist or his own fancy. The second picture removes the doubt. *The Music Lesson*, in which so much of the artist's thought is unfolded, illustrates perfectly, and we may be sure deliberately, the antithetical theme. The scene is decorated with a different subject, alike only in its lascivious reference. The subject is captivity; although only part is seen and the full perverse extremity to which the captive is reduced is veiled, no seventeenth-century connoisseur would have failed to recognize in it a *Roman Charity*.[84] Evidently the picture was one of the Dutch works inspired by the composition that Rubens originated in the thirties.[85] On the lid of the virginals Vermeer has inscribed, and surrounded with an unparalleled richness of minute embellishment: *Musica Letitiae Comes Medicina Doloris*.[86] The inscription is not only the legend of the instrument, it is also the epigraph of these two pictures and their oblique yet memorable celebration of the pleasures and sorrows of love.

Ter Borch's subjects influenced the whole of the genre school. But in later pictures a lady who turns her back on us is often discovered at the virginals, her head framed in a mirror or a picture on the wall.[87] Several painters must owe the form to Vermeer's example. A notable occurrence of it is in one of Emmanuel de Witte's rare and beautiful domestic interiors;[88] he may have taken it from De Hooch who used it similarly.[89] In the background of a picture which is possibly by the painter of *Refusing the Glass*, known as *A Soldier at a Window*, Vermeer's motif is exactly imitated.[90] Many of Vermeer's immediate followers note the value of a tilted mirror and its decorative dislocation of perspective; Metsu employs the device in the Dublin *Letter Reader*. More than one of them use it, as does Pieter Janssens Ellinga with delicate effect, to reflect the bold pattern of a tiled floor.[91] The artists who are to be seen in the genre paintings of the sixties seated at mirrors drawing sometimes recall not only the form but the vitreous impressionism of the passage in *The Music Lesson*.[92] His contemporaries were evidently aware of the beauty of Vermeer's glass. *The Concert* also had its imitators; possibly it suggested two pictures to Jan Steen.[93]

[124]

(77) The perspectives of Carel Fabritius, evidently influential in Delft, have disappeared. Some idea of them may perhaps be gained from Daniel Vosmaer's view of the town through a wide arcade (dated 1665, Rotterdam 1935, no. 95), Van Hoogstraten's pictures of ladies strolling in similar colonnades and Carel's *View of Delft* at London. Vermeer's perspectives, however, have a specifically personal value. Vermeer owned a picture by Van Hoogstraten, whose perspective box at London will be well known, and another of Van Hoogstraten's boxes is dated 1662 which must be very close to the date of *The Music Lesson*. Very probably the two artists were in contact. On the sides of the National Gallery box Van Hoogstraten inscribed and illustrated the three objects of painting: *Gloriae Causa, Lucri Causa and Amoris Causa*. The profoundest motives of painting, the pursuit of fame and riches no less than a love of art, were thus identified with the contrivance of a perspective so convincing as to deceive the eye. The association is of interest in connection with the perspective scheme of *The Music Lesson*; the picture stands mid-way between the open ambitions of the early works and Vermeer's oblique tribute to fame in the masterpiece of later years. H. E. van Gelder (*Kunsthistorische Mededelingen*, 1948, 3) has suggested that such pictures as *The Music Lesson* were intended for use in peepshow boxes. It may now be clear that another explanation is possible, and one more in keeping with the gravity of the result.

(78) The continuity of Vermeer's domestic subjects, and the difficulty of dating the pictures by reference to them, is illustrated by the *Woman with a Water Jug* who wears unchanged the dress of the Dresden *Letter Reader* yet is represented in the style of five years or more later. It has been suggested that the bodice worn in *The Music Lesson* and its pendant is that of the *Letter Reader* and the *Laughing Girl*, and thus that the pictures were painted close together. This remains uncertain. But if style was ever a man it was so here and Dr. Valentiner's confrontation of details (op.cit., pp. 314-15) illustrates, though in a sense that contradicts his thesis, the painter's development as well as could be wished.

(79) Vermeer's perspectives often yield enough information for a fairly accurate reconstruction of his room. The evidence suggests that the diagonal measurement of the squares of the marble floor in *The Music Lesson* was between 15 and 16 inches. On this basis it appears that when Vermeer sat down to paint the picture his eye was about 47 in. from the floor. He was about 6 ft. 1 in. from the nearest corner of the table, 13 ft. 2 in. from the lady and 17 ft. 4 in. from the far wall. (A similar calculation excludes the possibility that the *Studio* could have been painted, with any arrangement of mirrors, from the position of the artist who is depicted.) Few pictures so small as *The Music Lesson* embrace as wide an angle of vision. It is this which gives rise to the apparent exaggeration of perspective that is often noted in the works of Vermeer and Canaletto. It would be a technical task of extreme difficulty to record with conviction so great an angle of vision with no other guide than the naked eye. Canaletto is known to have had recourse to the aid of optical projections. Nicolson (*Vermeer's Lady at the Virginals*, London, n.d.) has recently observed that he may well have seen *The Music Lesson* when it bore the name of Van Mieris in the collection of his patron, Consul Smith, in Venice (with which it was purchased for George III by Richard Dalton). It is unlikely that Canaletto's procedure was suggested by such an example; in his time the camera was common knowledge. The proximity of the picture which of all in the previous history of painting most profoundly foreshadowed his method may indicate no

more than the consistency, whether or not under his guidance, of his patron's taste. There is no phase in the history of Vermeer's pictures on which one would be more glad of light.

(80) It was common practice to include in the centre of a subject, reflected in the surface of some still-life object or in a mirror, a miniature view of the artist at work: numerous instances are listed by W. Martin (*Gerrit Dou*, Leiden, 1901).

(81) Compare *K. der K.* pp. 133, 134, 136, 138 (dated 1675) and H. de G. 127 (in 1947 at Messrs. Slatter).

(82) E.g. *The Toilet* (Rijksmuseum, Amsterdam, see also Kunsthalle, Hamburg). The cavalier who presents his back to the spectator in *The Concert* is also foreshadowed by Ter Borch in a picture in the Haarlem style (*The Draughts Players*, Kunsthalle, Bremen. Cf. J. Duck, formerly Liechtenstein, Vienna.) Such figures were among Ter Borch's earlier subjects (as in the curious *Rider* published by S. G. Gudlaugsson, *Kunsthistorische Mededelingen*, 1947, 2).

(83) Signed and dated 1622. The picture's quality and the *pentimenti* which mark it leave no doubt that it was Baburen's original version. In the variant, of inferior quality, in the Rijksmuseum the composition has been curtailed on the right-hand side, reducing the design to a conventional symmetry, and the robe of the procuress is of a darker tone; it is clear that this is not the piece which appears in *The Concert* and the *Lady Seated at the Virginals*. Vermeer's representations in fact precisely follow the signed picture. (Formerly in the possession of Col. Sloane-Stanley, and thus perhaps from Sir Hans Sloane; Christie's 25. ii. 1949; later with Roderic Thesiger, to whom the writer is indebted for assistance, and now at Boston.) It may be observed, as a matter of sentiment as much as any relevance, that in Baburen's *Procuress*, a figure derived in Rome from Michelangelo's Cumaean Sybil who herself owed something to a memory of the aged Eve in the choir of S. Francesco at Arezzo, we find a tenuous and solitary link between two masters whose names must sometimes rise together to mind, a link between the imagery of Vermeer and that of Piero della Francesca.

(84) The subject originates from Valerius Maximus (V, iv); it was evidently commended to painters and their patrons by the fact that the writer had a picture in mind and made it the text for a discourse on the didactic superiority of painting. It is difficult to put limits to the meaning of Vermeer's web of symbolism and illustration. We need attach only the significance of an incidental association of ideas to the fact that the name of the protagonist in the Roman Charity appearing in this broad perspective, the name of Cimon, was also that of the ancient Greek painter supposed to have discovered perspective art. There might be discerned none the less a distant and private analogy between the man in *The Music Lesson*, held captive by the lady before him, and the artist himself.

(85) The work by M. Stomer in the Prado, reproduced here by way of example, is evidently not that which Vermeer represents. In his picture, among other differences, the girl's hand, just discernible, rests upon the back of the prisoner, as it does in the Rubens (now in the Rijksmuseum). Vermeer's example, if he had any specific original before him, was perhaps by Honthorst or his school. (Compare the similar figure in Honthorst's *Solon before Croesus* of which there are versions lent by an almshouse to the museum at Dordrecht, reproduced by Moes and Martin, II, pl. 40, and in the collection of O. Nottebohm,

Antwerp.) Allowance must be made for the fact that these passages in Vermeer's pictures have in both cases suffered with time; the subjects were originally rather clearer. The very lucid flat pattern with which Vermeer later renders the pictures on his wall develops, with the other elements of his mature style, only in *The Music Lesson* and subsequent works.

(86) The spacing of the lettering is distorted in the interests of legibility; the rare deviation from his objective standpoint indicated the significance which the artist attached to its meaning.

(87) E.g. Ochtervelt's *Music Party* (National Gallery, no. 3864).

(88) Rotterdam, 1935, no. 128, now Boymans-van Beuningen Museum, and Ottawa, National Gallery.

(89) *K. der K.* p. 130. It is uncertain which picture was the earlier. The form of De Witte's other genre-piece (formerly L. Fry, Saffron Walden, dated 1673) is equally derivative; in this case Metsu (perhaps the family portrait in the Gemäldegalerie, Berlin) provided the source.

(90) Robinson, Fisher II. v. 1922: Messrs. Sabin.

(91) E.g. the famous pictures at Munich and Frankfurt (and a variant of the latter reproduced in *Pieter de Hooch, K. der K.* p. 193, as in the possession of P. Bottenweiser, Berlin), also the *Empty Room* (Brockhaus collection), *A Man Reading* (A. de Copper collection), *The Messenger* (Oslo) and *The Smoker* (published with these pictures by C. Briere-Misme, 'A Dutch Intimist,' *Gazette des Beaux-Arts*, Nov.-Dec. 1947, Fig. 8). The motif, together with similarities to the Brunswick picture, appear in De Hooch's work in the Louvre *Card Players* (*K. der K.* p. 77 as c. 1665, see also *K. der K.* p. 195.) Hoogstraten places a mirror reflecting the floor in his *Peepshow* in the National Gallery.

(92) E.g. in *Refusing the Glass*. There is a similar feature in another perspective by Hoogstraten (C. Blathwayt collection).

(93) *The Music Master* (Wallace Collection and National Gallery). The date of the National Gallery picture, doubtfully read in the 1929 catalogue as 1656 and by Dr. H. E. van Gelder as 1671, is evidently illegible. It has been suggested that the style of dress in these pictures dates them, and thus *The Music Lesson* and *The Concert*, before 1660. In the case of such a painter as Jan Steen such a deduction remains very doubtful; fashion can indeed rarely give us a dependable terminal date. Moreover the appearance of one lost picture by Vermeer might demolish all arguments based on the borrowings of other painters. The influence of *The Concert* is clear in a number of pictures by Metsu, among them *The Music Lesson* (no. 389 in the National Gallery, also H. de G. 161 and Christie's 22. vii. 1938 no. 68, as well as formerly Cook collection, H. de G. 160, which seems to reflect both *The Concert* and its pendant).

VIEW OF DELFT

$38\frac{1}{2} \times 46\frac{1}{4}$ in. (978 × 1175 mm) Signed

Mauritshuis, The Hague

The direction that style and thought take in these central pictures is equally apparent in the two landscapes. In the *Street* there is no fleck of paint which does not immediately declare its descriptive intention. But in the *View of Delft* the *pointillé* has become disconnected from the substance on which it lies; unhindered by any obvious explanatory purpose it provides a glittering, irrelevant commentary of light. The wavy calligraphic stroke which described the cobbles in the *Street*—a counterpart of the linear drawing in the *Soldier and Laughing Girl* —is abandoned and the drawbridge of the *View of Delft* is described as are the forms of *The Music Lesson*. It is defined by the shapes that intervene between its beams. In front of it the points of paint on the barge recall those on the picture at Buckingham Palace and the scheme of colour is similarly based on flat blocks of a slaty blue which is as unlike the deep tone of the early pictures as it is the positive colour of succeeding works.[94] The pictures must be placed near together; both seem to refer to the same phase of the painter's thought.[95] The tones of the *Street* are less precisely recorded, the pattern is based on the accented indentations of a contour quite unlike that which the developed style displays and in the clouds relics of picturesque convention persist. In these respects the work that it recalls is again the *Soldier and Laughing Girl*. Like it the *Street* contains a reminiscence of Pieter de Hooch; many of his courtyard scenes are furnished with such figures as are seen in Vermeer's alley.[96] The composition of the picture is a little like that of a drawing of uncertain origin at Amsterdam.[97]

The landscapes were apparently painted from first-floor windows. They attract attention in connection with Vermeer's optical procedure for they have a suggestion of the effect, the only experience of the instrument that is now common, of the camera obscura often to be seen at public resorts. The bluntly undramatic slice of life presented, the ruthless revelation of the physical insignificance of people beside the world which they inhabit, both recall it. And, although such views of townscape and canal are common in Dutch painting from the time of Buytewech, both are surprising in the context here.[98] Even

Saenredam, Vermeer's chief predecessor in refined detachment, can show nothing like his freedom from the descriptive preoccupations of their time. In these pictures Vermeer's terms of reference remain his own. He carries them, as painters often do, with him wherever he goes. He seeks a constant architecture; indoors and out he faces the same square and stable walls. And the *View of Delft* presents us with our most memorable image of the remoteness which is the essence of Vermeer's world. In the reflecting expanse of this canal we look upon the very symbol of that cool zone, penetrable only by the light, which separates the artist from the matter of life.

(94) Yellow pigment has perished from the greens of the *View of Delft*; such deterioration, for which the yellow lake mentioned by Van Hoogstraten is doubtless responsible, is not uncommon in the painting of the time. A somewhat similar effect which is often noticeable and occasionally appears in the work of Vermeer, seems to be due to an instability in a blue pigment which now overwhelms the elements with which it was mixed. The Brunswick picture has suffered particularly from the emergence of traces of blue. The suggestion is often advanced, in explanation of the coolness with which the flesh is rendered in certain of Vermeer's works, that a cold underpainting, now unduly apparent, formed a preparatory stage in his procedure. This has not been confirmed by microscopic examination. The coldness which some find disturbing in such works as the *Lady Standing* in the National Gallery may in fact well be deliberate; the effect is in agreement with the painter's style. The *View of Delft* owes some of its present warm and comfortable tone to varnish.

(95) The signature might be held to tell against this view; the monogram initial resembles that of *The Procuress* and the *Letter Reader*. Evidence of this kind is however doubly doubtful in view of the number of such signatures on pictures, especially landscapes, for which Vermeer's authorship is no longer claimed (e.g. Thoré's nos. 52, 54, 55, 59, 61). Twenty-six pictures, by Vermeer or reputed to be, were at the time of his death in the possession of J. Coelenbier, a landscape painter as well as a dealer, who certainly had palette and brushes to hand. Such an inscription as that on the Frankfurt *Geographer* appears to have been added simply to authenticate a known fact.

(96) For example, *The Washerwoman* (Toledo, Ohio, *K. der K.* p. 40, compare also p. 41). The picture seems to have a relation to the *Street*. Although none of De Hooch's courtyard pictures, or indeed any of his works, bears a date earlier than 1658 it seems that this phase of his development began rather earlier; Jan Steen's Delft portrait group in a similar setting, which was evidently influenced by the painters of the town, is dated 1655. Dr. Valentiner suggested that the Toledo picture showed Vermeer's influence, but on any coherent view of his development the *Street* can hardly have been painted until later and there is little doubt that it contains reminiscences of the kind which can be clearly demonstrated in his other works of the time. It will be unnecessary to refer again to such arguments; the view that Vermeer is in the common sense an inventive painter does not

only do violence to the evidence, it diverts attention from the essence of his originality. The housewife who bends over the tub in her yard has a long history as a genre motif. She appears in a work by A. Bloemaert (drawing in the Leiden Prentenkabinet for a picture in the Engleson collection at Malmo).

(97) Attributed at the Rijksmuseum Prentenkabinet to Carel Fabritius.

(98) Here our perception is blunted by photography; Maxime du Camp (*Revue de Paris*, October 1857) found something brutal in the *View of Delft*. The arrangement of the Mauritshuis picture, uncommon elsewhere, was often adopted in representing The Hague, where a view across the Vijver shows to the best advantage the Stadhouderlijk quarter of the town (e.g. drawing by W. Buytewech, now in the Municipal Museum).

Plates 33–36
A COUPLE WITH A WINE GLASS
$30\frac{3}{4} \times 26\frac{1}{2}$ in. (781 × 673 mm) Signed

Herzog Anton Ulrich-Museum, Brunswick

Plates 38–39
A YOUNG WOMAN WITH A WATER JUG
$18 \times 16\frac{1}{8}$ in. (457 × 410 mm)

Metropolitan Museum of Art, New York[99]

The *Woman with a Water Jug* is linked both to the earlier and to the later phases of Vermeer's work. Evidently it belongs to the time whose masterpiece is the picture at Brunswick, the moment at which the painter's style took its most profoundly original turn. Here the lustrous handling and neatly accented tonal divisions are clearer than ever. There is indeed a certain display of them; shining metal is never so prominent again. Vermeer's method, elsewhere so impeccable, still falters when the crucial detail is reached. The head is a conventional summary and a far from confident one, but it is at least without any obtrusive expression. There remains a certain uneasiness. Elsewhere abundant signs of the painter's development are to be seen. With the Brunswick hand in mind we may notice the unconventional drawing of the arm which holds the

water jug. The other arm passing behind the window frame, displays Vermeer's innovation in another aspect. It is a statement of tone as unsubstantiated as it is decisive. Analogous passages are often to be found in De Hooch's *contrejour* effects; this picture has no doubt a distant relation to his style. But comparison with it conveys the difference. De Hooch supports his statements with linear detail in the convention of the time, the convention to which Vermeer still adhered in the cavalier's hand in the *Soldier and Laughing Girl*. Here descriptive line and the detail of life are finally cast off. The relation of the *Woman with a Water Jug* to the space around her, though not calculated with quite the profundity that became invariable, recognizably suggests the pattern of the later phase. In one corner there is seen the characteristic symbol of the pearl pictures, the necklace drawn from its decorated box. The inconsistencies of the work seem nevertheless to mark it as the most primitive of its type.

Vermeer deals here with a household occupation of the type which was a common subject of genre painting in the fifties. Many of the themes of De Hooch's *plein-airisme* were of this kind and it was particularly associated with the school of Gerard Dou in Leiden. Dou's ladies are indeed often made, with an appealing artifice, to turn from their work to arrange a curtain or a casement. Vermeer's other version of such a subject indicates at least a remote relationship with his work. But in the connection the essential incongruity between Vermeer's temperament and the sources of his motifs is again clear. The *Woman with a Water Jug* bestows no smile on her audience; her shape itself is hidden. She is riveted immovably by each arm to the window and the table which confine her within the picture. The anchors secure her, she is beyond contact, and the painter is free from such embarrassments as his encounters with the roving eye of the lady in the pictures at Brunswick.

(99) The history of the *Woman with a Water Jug* may be traced back a little farther than has been noted. The picture appeared in the Vernon sale, 21, iv. 1877, as by Metsu (and is thus recorded by De Groot, Metsu 62); it was bought by M. Colnaghi and sold to Lord Powerscourt (kindly indicated, with other points, by Mr. E. K. Waterhouse).

Plate 40
A LADY WITH A LUTE
$20\frac{1}{4}$ × 18 in. (514 × 457 mm) Signed
Metropolitan Museum of Art, New York

Of the changes in Vermeer's style one is immediately apparent; henceforward each picture forms a broad and definite pattern of tone. Such a development is a common feature in a painter's evolution and in Vermeer's case it was no more than incidental to his search for the decisive tonal interval, the bare statement of light which, pursued in the detail of representation, constituted the baffling vocabulary of the last works. If, as may be imagined, he resorted to an optical device some contrast of tone would have been necessary for its use. Certainly the depth of tone in such pictures as the *Lute Player* is intimately connected with the profundity and completeness of his vision. His scheme, a sharp overlapping of dark on light and light on dark in alternation, is the irresistible pattern which Tintoretto had given to seventeenth-century painting; Vermeer was very familiar with it. But beside the comparatively meagre version of it which is visible in the *Soldier and Laughing Girl*, it is clear that Vermeer's method, disengaging him from the claims of matter, now permits him an altogether more inclusive and confident hold, if not on life, at least on the mantle of light which half-reveals it. Henceforward, even when the contrasts involved are shallower, the lack of differentiation and the distribution of insignificant tonal incident which sometimes mark the earlier works are never seen again.

Vermeer's ladies who hold a lute or a guitar are not occupied with music-making. They turn away; there is some momentary distraction in the air to draw their attention. They are never discovered playing and they never confront us. The fact is of interest for it illustrates not only Vermeer's temperamental preference, his distaste for anything obtrusively purposeful or demonstrative in his subject, but also the way in which it governed his use of the resources of his school. The common role of such musicians in the work of his predecessors is as a victim of the perennial theme of interruption. Such is their usual role in the painting of Haarlem and when wine is brought to one of Metsu's ladies she turns from her lute in precisely the attitude which Vermeer's sitter takes up.[100] In one picture Vermeer supplies the intruder, the servant in

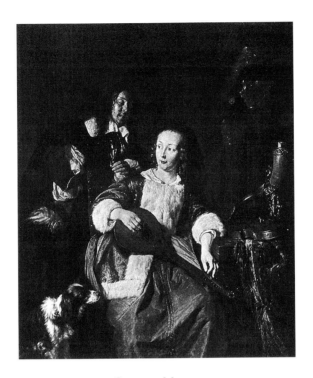

GABRIEL METSU
The Luteplayer
(Gemäldegalerie, Kassel)

The Love Letter; for the rest he produces a vestigial form of the motif, a scene of interruption from which the egregious cavaliers have long since been refined away, leaving only, in the lady's lateral glance, a reminiscence which is at once a tribute to tradition and an artifice to confine her lively nature within her own world.

A similar glance is the theme of the *Woman with a Water Jug*. Indeed there are several resemblances. The bobbin of the map-stick in each picture fits neatly with the nape of the girl's neck. In the *Water Jug* the contour of arm and hand is half-obscured, an arrangement naturally avoided by the conceptual draughtsman, and characteristic of Vermeer's freedom in this respect, which

reaches an extreme in the *Lute Player*. In the design here a flavour of perversity lingers; it has an element of recapitulation. The stylistic solution is now within the painter's grasp but of this the *Lute Player* tells us nothing for the picture is a ruin and the original surface of paint has long disappeared.

(100) Kassel, H. de G. 146. Such groups originated in the more complex compositions of the earlier phases of the school. E.g. a *Musical Conversation* by Jan Lys (*Belvedere* II, 1922, pl. LXII) and the *Concert* in the collection of Sir George Leon (Rotterdam, 1935, as by Honthorst) which is signed by Gysbrecht van der Kuyl.

Plate 41

HEAD OF A YOUNG WOMAN

$17\frac{3}{4} \times 15\frac{3}{4}$ in. (451 \times 400 mm) Signed
Metropolitan Museum of Art, New York

Plate 42

A LADY WRITING A LETTER

$18\frac{1}{8} \times 15\frac{3}{8}$ in. (460 \times 391 mm)
National Gallery of Art, Washington

Plate 43

A YOUNG LADY WITH A NECKLACE

$21\frac{5}{8} \times 17\frac{3}{4}$ in. (549 \times 451 mm) Signed
Gemäldegalerie, Staatliche Museen, Berlin

Plates 44–46

A LADY WEIGHING GOLD

$16\frac{1}{2} \times 14\frac{3}{4}$ in. (419 × 375 mm)

National Gallery of Art, Washington

Vermeer returns to the pattern of the Dresden *Letter Reader* throughout his career. Out of her shape he evolves, sometimes as directly as in the *Reader* at Amsterdam, the rapt, remote inhabitants of his world. But the devices that separate us from the girl at Dresden give place in later works to the isolating artifice of style itself. The subjects of the pictures become richer; they gather not the movement of life so much as of distantly related, barely perceptible symbolic meanings. In this picture a connection between the lady, who seems to be weighing pearls against gold, and the painting that hangs on the wall behind her, turns the incident into a fanciful allegory of the Last Judgment.[101] Elsewhere these references are more open; it is clear that we are intended to gather them from the *Gold Weigher*. Such subtle parallels have, as has been noticed, a deep significance for the painter. Yet there is no weakening of the visible subject. His purpose is entirely concerned with the forms that we see. Here it seems that the object of the allegorical play is to enrich with a depth beyond measure the nature of this lady and her commonplace act: she takes on something of the character of St. Michael, the weigher of souls in the part of the Last Judgment which is hidden. Others of Vermeer's allegories are less readily construed: they are of a kind beyond design whose keys are buried in the recesses of his nature.

Whether or not his meaning was within the grasp of the time, Vermeer's contemporaries clearly felt the magnetism of his later work. In the middle sixties De Hooch and Pieter Janssens Ellinga both painted imitations of the *Gold Weigher* and the pictures related to it.[102] It is curious how much of the development of De Hooch's work may be traced in the paintings with which he decorates his subjects. His removal to Amsterdam is signalized by the appearance on the wall behind one of his drinking scenes of the *Rape of Ganymede* by the great master of the town. But he turned in another direction; in the late sixties when he set a music party in a chamber of Amsterdam Town Hall he inserted the *School of Athens* in the place for which Rembrandt had designed his *Conspiracy of the Batavians*. It was a symbolic concession to taste, a denial of his

own tradition, and it heralded the elegant arrangements which occupied him in the last fifteen years of his life to the exclusion of the motifs whose development he had shared with Vermeer.

(101) Apart from the deliberate allegories of *Vanitas* many still-lifes of the seventeenth century, it might almost be said the majority, retain reminiscences of the subject. Several details of the *Gold Weigher* recall it, as does more remotely the still-life seen in the *Studio*. In neither case is it likely that any precise connotation of the theme was intended. (Compare H. Rudolph in *Festschrift für Wilhelm Pinder*, Leipzig, 1938.) In pictures whose symbolism centres on the motif of the balances it often seems that the reference is to the Vanity less of Ecclesiastes than of the Psalmist; his text (Ps. 62. ix) must have been the more congenial to Dutch taste. There is a further, and barely perceptible, overtone in the melancholy of Vermeer's pearl pictures, arising from the association of the casket spilling its jewels with the iconography of the Magdalen (e.g. the *Martha and Mary* by Rubens at Vienna). Even this depends from an old tradition. Vermeer followed, more closely than any artist of his time, the patterns of genre painting established in the sixteenth century. The first appearances of his subjects, the figures of Jan van Hemessen and the Master of the Female Half-lengths, are, in fact, almost invariably, representations of the Magdalen. (Cf. Van Hemessen: Berlin and Worcester, Mass.)

(102) De Hooch: Gemäldegalerie, Berlin (*K. der K.* p. 75, as c. 1664). P. Janssens Ellinga: Bredius Museum, The Hague. With regard to the history of the *Gold Weigher,* it may be noted that the Munich sale in which the picture figured as a Metsu (5. xii. 1826, no. 101) was that of the late King of Bavaria: it was bought by the Marquis (later Duc) de Caraman, then French Ambassador at Vienna. (T. von Frimmel in *Burlington Magazine*, xxii, p. 48.)

Plates 47–48

A WOMAN IN BLUE READING A LETTER

$18\frac{1}{4} \times 15\frac{1}{2}$ in. (464 × 394 mm)

Rijksmuseum, Amsterdam

Plate 49
HEAD OF A GIRL
$18\frac{1}{4} \times 15\frac{3}{4}$ in. (464 × 400 mm) Signed
Mauritshuis, The Hague

Vermeer is well protected; little of life or personality ever pierces his armour. And when some disturbing experience does penetrate within the shell he proceeds to enclose it in a pearly covering of style until its sharpness is assimilated. In the two variations of increasing refinement on the memorable theme of a girl who looks over her left shoulder into the painter's eyes, her head tilted a little back, the motif which intrudes into the work at Brunswick and the Frick music scene is at last resolved.[103] The four pictures record an almost continuous development, bridging the transition between earlier and later styles and illustrating typically the essence of the evolution. There can be little doubt about the order in which they were painted. This fragment of experience seems to have presented a difficulty characteristic, in the entanglement of technical and personal issues, of those around which his mature style forms. In its solution of optical impersonality he contrived to scan the face of life and record it while remaining himself detached, unimplicated.

Style and history have shown, perhaps, something of the way by which this solution was reached. There is additional and welcome evidence in the pictorial fabric itself. Radiography records not the visible surface so much as the layers of paint which underlie it, and in them predominantly the disposition of the pigments which are least penetrable by X-rays. In the radiograph of the *Head of a Girl*[104] (page 158) it will be clear that the solid painting on which the picture was based is arranged rather differently from the surface that we see. The first stage of painting evidently consisted of a sharply contrasted pattern of light and dark: it might have been accomplished by applying a mixture of white lead solidly to a toned canvas. There is nothing tentative in it. There has been no correction, nor is there evidence of line or design. The difference is rather in the fact that it presents us, when we rediscover it, with the raw material of that authenticity which compels our eye in the finished work. Nothing is recorded but the oblique fall of light on particular forms. And from it there emerges an impression of a specific person, of the depth of her eye for instance and her abject, patient mouth, more positively even than from the picture that we

[137]

know. No other artist's method reveals this immediate and perfect objectivity: the radiography of painting has indeed never shown a form in itself as wonderful as this strange, impersonal shape. We are in the presence of the real world of light, recording, as it seems, its own objective print.

Very possibly this first stage in the painting of the *Girl* was a direct transcription of the incidence of light on the screen of the camera obscura. The artist evidently proceeded, in finishing the picture, to mediate between objectivity and convention. He overlaid the sharpness of the optical pattern with delicate modulations and transitions, conveying the semblance of continuous modelling. The paint is so thin that radiography renders it invisible: to it we owe, for instance, all the light that rounds the right cheek, all the substance and the even mildness with which the head is now endowed. Yet the essence remains. We have only to seek the farther surface of the nose or the precise shape of the nostril to know that it was never there. These forms are never truly within our comprehension. And Vermeer's later development was the realization that such was their virtue. Progressively he left the optical record more and more bare of conventional veils. Finally it is seen in all the unexpected sharpness of the pattern which underlies the *Head of a Girl*. Indeed, if by some chance there was only the radiograph to judge by, it would seem that this picture dated from the time of the *Red Hat*.

The design of the pictures, the *Head of a Young Woman* and the *Head of a Girl*, in the Metropolitan Museum and at The Hague, like every statement of such boldness in Vermeer's work, owes something to precedent. There is indeed a flavour of archaism in it;[105] the girl in the Mauritshuis recalls the pattern of Jan van Scorel and the beginnings of the portrait tradition of Holland.[106] The drapery of the first picture is of interest. Its deep and narrow concave folds are one of the very few deliberately rhythmical passages of drawing in the painter's work as we know it. The turn in his development seems to have liberated momentarily a line which we can recognize as from the same hand as the *House of Martha and Mary*.

(103) Vermeer's typical sitters never look out of the picture except over their shoulders in this oblique fashion. (There is a single exception, a last miniature liberation, in the *Girl with a Flute*.) The device is most characteristic of him. The personal impact is deflected: these ladies never confront us.

(104) The writer is indebted for this radiograph, and the generous permission to publish

[138]

it, to Dr. P. Coremans of the Central Laboratory of Belgian Museums. Among the pigments of the *Head of a Girl* white lead is by far the least penetrable by X-rays. The shadows that it casts on the film, showing as light areas in the positive print reproduced here, thus correspond to the incidence of solid light tones with a lead basis. The irregular blackish patches, where no original pigment now remains, indicate damages to the picture which have been masked by restoration. The bands of light which cross the print vertically and horizontally represent the stays of the wooden stretcher to which the canvas is fixed.

(105) The last three items bearing Vermeer's name is the 1696 catalogue were: 'A Portrait in Antique Clothes, uncommonly artistic', 'Another, also by Vermeer' and 'A similar picture by the same'.

(106) Cf. Jan van Scorel's portrait in the Doria Gallery (1526) and that by his master Jacob Cornelisz van Oostzanen, in the Boymans-van Beuningen Museum (1511). The head formerly in the Boughton Knight collection, evidently by Sweerts, which has been attributed to Vermeer, can hardly have any connection with his work. Sweerts was in Brussels in 1656 and died in India in 1664. His pictures, like those of Emmanuel de Witte, are nevertheless of interest in the consideration of Vermeer. His manner was based on similar influences and has obvious affinities; comparison with it demonstrates clearly the subjective peculiarity of Vermeer's style.

Plates 50–52 and 60
AN ARTIST IN HIS STUDIO
$52\frac{1}{8} \times 43\frac{1}{4}$ in. (1324 × 1099 mm) Signed
Kunsthistorisches Museum, Vienna

The two largest of Vermeer's later works are both equally allegorical. One of them represents the Catholic Faith: in the other, painted rather earlier, Vermeer celebrates the triumph of his own art. On February 24th, 1676 Vermeer's widow made over to her mother 'a piece of painting by her said husband in which is depicted The Painter's Art'. No doubt it was the picture at Vienna that we know. The allegory is in fact typically complex. The model in this studio is Clio, and around her on the table lie the emblems of her sisters, the books of Polymnia and Euterpe and Thalia's mask.[107] Painting thus approaches Parnassus to take its place with the ancient muses; the idea was full of meaning in Vermeer's time and Metsu had illustrated it similarly some ten years before.[108] Here, however, the particular object of attention is the Muse of History and the choice of her among her sisters is significant. The essential subject of the allegory is the glory of painting, its undying fame; the fact

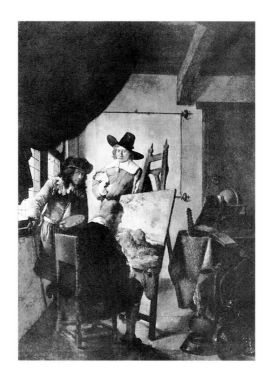

JOB BERCKHEYDE
The Painter's Studio
(1659. Hermitage, St Petersburg)

confirms our impression of Vermeer's temperament.[109] But the visible emblems are no more than the beginning of the meaning. This painter and his model seem to belong to separate worlds; not only the furniture but a more impalpable division lies between them. The girl has a radiance, an aura of intact divinity, which reminds us that of the studio pictures of the time none follows so closely as this the traditional iconography of St. Luke and the Virgin.[110] At the heart of the allegory there is a personal reference; the earliest representations of painting and its patron provide Vermeer with a form that, doubtless far from deliberately, symbolizes the barrier between painter and painted which so deeply affects his own art.

The general pictorial arrangement that Vermeer adopted here, and retained

as the staple composition of later works, was a familiar one. Consideration of his immediate sources demonstrates again how little part invention ever played in the development of his style. This design was evolved by Dou and his followers; the shape of the room, the picturesque clutter of detail with which it is furnished and the curtain that shuts it in all appear in their paintings of the previous decade. The *Visit to the Studio* which Job Berckheyde dated in 1659 shows the arrangement fully developed[111] and it remains the basis of the elaborate studio scenes which Frans van Mieris devised under the influence of Ter Borch.[112] In one respect Vermeer departed from the practice of the Leiden painters; his tapestry is never looped into the grandiose, pendulous curves characteristic of their style. The curtain in the *Studio* follows the older and simpler pattern of the hangings which sometimes enclose the Haarlem interiors of thirty years earlier. Similar diagonal folds frame a picture by Jan Lys of *A Lady Painting* that was well known in an engraving by Gilles Rousselet.[113] But, with all these affinities, Vermeer may well have been equally aware of the profounder treatments of such subjects, the studio pictures of Rembrandt and his school. A design very closely analogous to his was current in the school of Rembrandt in the previous decade. It is known to us from two drawings by different hands.[114] In both of them the arrangement of painter, model and the room in which they are seen foreshadow his; to the left the subject is framed in one case by the angle of an attic roof, in the other by a curtain. One of the drawings, and perhaps not by chance, is apparently from the hand of Nicolaes Maes. Some such example may have contributed to the form which the subject takes in Vermeer's *Studio*.

The picture is certainly not the self-portrait which appeared at the auction in 1696[115] but the question of whether or not Vermeer is represented in it remains a favourite subject of speculation. If he is, his best friend might very well fail to recognize him, and it cannot be supposed that the mystification was not deliberate. The only features which we are allowed to discern are, in another of the details to which we may attach as much meaning as we choose, those of the Italianate mask. It is improbable that Vermeer yields, in any simple sense, information here of the way in which he worked. It would be unlike him to do so. There is something in the stolid, ingenuous manner in which this artist sets about his canvas to suggest that his purpose, as usual, was nearer to dissimulation.

The condition of the *Studio* is far from perfect but the development of Vermeer's technique is traceable nevertheless. His *pointillé* evolves into the patterns of small rectangular dashes of flat paint which persist until they are replaced by the less obtrusive facets of the final works. Even here there may be detected the beginnings of the stylized and elaborate manner which was soon to be pursued, at the risk of inconsistency, with a deliberation quite absent from the earlier phase.[116] The intention remains the same. Wherever modelling approaches a palpable continuity there is a scattering of irrelevant light to contradict it. Representation involves an interplay of statement and the reticent retraction of it. Through the damage which the *Studio* has suffered we can still discern the painter's method. The folds of the stiff silk garment, just such folds as took on for his contemporaries such disconcertingly tangible shape, are conveyed in lights that, at the crucial point, the shoulder, have the character of a disconnected shorthand, disowning the form that they allow us to read. No doubt this inscrutable delicacy, which we can still discover intact in other pictures, was once the very essence of the Vienna *Studio*.[117]

(107) The subject of the allegory was identified by K. G. Hultén (*Konsthistorisk Tidskrift*, 1949) and J. G. van Gelder (*Oud Holland*, LXVI, 1951, 1) who pointed out a similarity to the Clio in Le Sueur's Hôtel Lambert decoration (Louvre, 1645). Several of the following references are owed to Professor Van Gelder.

(108) Writers often celebrated the place of Painting among the muses. Cornelis de Bie (*Het Gulden Cabinet*, 1661, p. 14) wrote: 'Now there is peace, Pictura goes to Parnassus; the nine muses, as true nurses of the arts, expect her and will give her a rightful place among the rest.' Vondel, in a St. Luke's day oration at Amsterdam in 1654, put similar lines into a painter's mouth: 'O noble love of painting, O tenth muse, we greet you beside the other muses of Parnassus.' The frontispieces of the nine books of Van Hoogstraten, dedicated to the muses, and the illustration (an artist drawing Urania) to the legend *Gloriae Causa* on his peepshow box, have a similar theme. Metsu's pictures shows the artist depicting Erato, represented as in Le Sueur's decoration. (H. de G. 226, 228b, in the collection of Clive Cookson. An inferior, unsigned version was in the Rothschild sale, Sotheby, 19. iv. 1937.)

(109) E. Neurdenburg (*Oud Holland*, LIX, 1942) previously identified the model as Fama; Vermeer's meaning is in fact not far removed from this. The ideas of History and Fame are closely related (compare Van Hoogstraten, *Inleyding tot de Hooge Schoole der Schilderkonst*, Rotterdam, 1678, p. 69) and more than one allegory of painting in the following century is open to both readings. It may not be without significance that the detail which engages the attention of the painter in the *Studio* is the laurel wreath.

(110) The devices employed in pictures of the Virgin and St. Luke to differentiate the spheres of painter and painted are often of interest. In the *Peringsdorfer Altar* by A. Kraft

(Nuremberg) the artist looks at his model through the frame of a doorway which separates them. Among other renderings of the subject which may be considered in relating to the studio pictures of the genre school is that by D. Baegert (Landesmuseum, Munster). In the Netherlands the subject was established in the sixteenth century in a constant and unvarying form, the form shown in an Antwerp drawing in the British Museum (perhaps by J. de Beer, *Catalogue*, V, p. 69, no. 22); among later renderings that of M. de Vos is well known (Albertina, no. 191; Antwerp Cathedral, 1602). The arrangement was often adapted to secular themes (e.g. Joos van Winghe, *Apelles Painting Campaspe*, Dusseldorf, no. 797).

(111) Hermitage, St. Petersburg. There was evidently a tradition of representing the painter in such studio pictures with his back turned to the spectator. Compare the *Painter in his Studio* (in a Swedish collection) by the obscure Leiden painter Jan van Spreeuwen (b. 1611), published by W. Martin (*Burlington Magazine*, VIII, p. 13).

(112) *The Artist Painting a Lady* and *The Connoisseur's Visit*, both at Dresden.

(113) Vitale Bloch (*Friedlanders Feestbundel*, 1942) has published a picture connected with the engraving, and perhaps its original, although the style is strangely close to the engraver's manner. (A version by S. de Vos also exists; *Oud Holland*, LXI, 1946, p. 122.) It was previously attributed to Judith Leyster; the subject was apparently unconnected with her.

(114) One drawing was formerly in the collection of Mrs. Morrison, Sotheby 22. v. 1922 (illustrated) as by Rembrandt. The other, the less finished and more suggestive, is in the Graphische Sammlung at Munich (Schmidt, pl. 160; H. de G. 479). The attribution of the former to Nicolaes Maes is that attached to it in the archives of the Prentenkabinet at Amsterdam.

(115) B. Nicolson (Vermeer's *Lady at the Virginals*, London, n.d., p. 12) reasons from the low price given that the picture was a small one. No. 3 in the 1696 catalogue may, however, conceivably have been the *Girl with a Red Hat*: it might well be taken at a cursory glance to represent its painter. The catalogue refers to the item as 'uncommonly well painted, with rich accessories'.

(116) The manner, a little like that of Emmanuel de Witte, in which Vermeer represents the painter's hose provides an example. Another, foreshadowing more fully the style of subsequent works, is the pattern of brush strokes which renders the chandelier.

(117) The value of the picture in the study of Vermeer's style of representation is reduced by the fact that the crucial passages have been slightly retouched, perhaps at the time when the work received a De Hooch signature. The detail of the face has been some-what hesitantly redrawn in a warmer tone than would agree with the pearly grey of the original shadows. The form of the mouth is altered, its corners are drawn up; the fingers of the hand that holds the trumpet have suffered similar treatment. Where the retouching encroaches on the map (just above the right wrist) and on the hair (to the left of the tip of the nose) it is particularly clear. Such an imposition of line upon Vermeer's record of tone contradicts its nature; the original form must have reached an extreme of delicacy which only the passage above the ear and the wreath now allow us to judge. The painter's hand which has been referred to and the plaster mask on the table—so unexpected a piece of modelling that many spectators altogether fail to construe it—convey something of the

state in which the picture left the artist. The impulse to adjust it to conventional requirements is easy to understand.

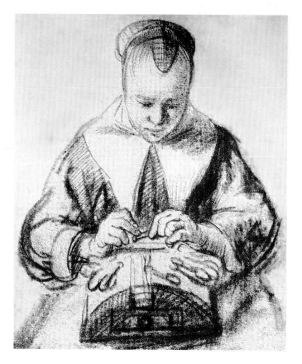

NICOLAES MAES
The Lacemaker
(Drawing. Boymans-van Beuningen Museum, Rotterdam)

Plate 53
THE LACEMAKER
$9\frac{7}{8} \times 8\frac{1}{4}$ in. (251 × 210 mm) Signed
Louvre, Paris

The method, which from the time of *The Music Lesson* onward has been progressively clarified and crystallized, here reaches the culmination, jewel-like,

[144]

immaculate and baffling, with which we are familiar. The result is a style whose very detachment conveys, resolved at last, the delicate tension of feeling which is the burden of the painter's work. The subject, the making of lace, had provided a favourite theme of all Vermeer's predecessors in the genre school. If he was particularly indebted to any one of them it was to Nicolaes Maes; in drawings of the motif by Maes dating from perhaps ten years earlier we find a similar arrangement, giving just such a value to the disposition of fingers and the form of the foreshortened head.[118] Without such precedents the boldness of Vermeer's treatment of the subject here might indeed seem a little unexpected. Vermeer translates the suggestion into terms agreeable to his temperament. The bowed, preoccupied pose, which is of all themes from the *Letter Reader* onwards the most congenial to him, here reveals its peculiar advantages. *The Lacemaker* bends intently over her pursuit, unaware of any other happening. It is perhaps the fact that she is so absorbed, enclosed in her own lacy world, that allows us to approach her so close.

(118) Drawings in the Boymans-van Beuningen Museum and formerly in the Dalhousie collection: a picture of the subject (H. de G. 66, collection of Mrs. Denniston, Chicago, 1935-6, no. 23) is dated 1655.

Plates 54–55
A LADY RECEIVING A LETTER FROM HER MAID
$39\frac{3}{4} \times 29\frac{7}{8}$ in. (1010 × 759 mm) Traces of a signature
Frick Collection, New York[119]

Plate 56
A GIRL WITH A FLUTE
$7\frac{7}{8} \times 7\frac{1}{8}$ in. (200 × 181 mm)
National Gallery of Art, Washington[120]

Plate 57
A GIRL WITH A RED HAT
$9\frac{1}{16} \times 7\frac{1}{8}$ in. (230 × 181 mm) Signed
National Gallery of Art, Washington

Some of Vermeer's themes develop from picture to picture in so uniform a progression that it seems that little can have been lost. Possibly we possess some aspects of his work, that for instance represented by variations on the Dresden *Letter Reader*, almost in their entirety. It is certainly entirely comprehensible, given the peculiar conditions of his activity, that his total production was very small; each picture carries, for all the restraint of style, a far heavier personal weight than any work by a normally prolific painter, and to the end each retains some of the quality of an isolated feat which is so evident in the earliest works. Nevertheless, as the way in which Vermeer's pictures evolve out of one another comes to be recognized, we may fancy certain gaps in the body of the work remaining to us. Our knowledge of Vermeer's evolution of the incident which appears in the Frick example and *The Love Letter* is particularly lacking. Some earlier treatment of a similar theme may well have disappeared.[121]

The Frick *Letter* is the largest of the mature genre pictures. For all its beauties it is also the least characteristic; Vermeer's most personal style and his accustomed obliquity of meaning are to seek.[122] If there were record of an assistant in his studio, it is here that we should suspect his hand. But the picture is perhaps better understood as one of the first, and indeed the plainest, of those attempts to enlarge the limits of his art of which there is more than one in the latter part of Vermeer's work. There is something of the same character in a smaller and more beautiful piece which is none the less far from typical. The *Girl with a Flute* is alone among the painter's sitters in boldly confronting us; she is also singular in the fact that we cannot be sure that her picture was ever quite finished.[123] Perhaps this was a work that the painter, in stepping subtly outside his field, was compelled to leave by his standards incomplete. In the *Red Hat* the oblique arrangement is restored and the wonderful definition is accomplished. Similarly, in *The Love Letter* even the unsubtle theme of the Frick picture was to be incorporated into Vermeer's world.

(119) Following Nicolson's observations on the prices (*op. cit.*, p. 12) the Frick picture can hardly be identified with no. 7 in the 1696 auction. No. 7 might be expected to be a little smaller then No. 6 which is probably the Buckingham Palace picture, a description which precisely fits *The Love Letter*. The fragment of a signature is said to be visible, though not in typical form. De Vries observes that the style of hairdressing indicated a date shortly after 1665. The appearance of the picture has remained unchanged at least since 1809 when it was engraved in the *Petite Galerie Lebrun* (II, no. 87).

(120) Doubts of the authenticity of the *Girl with a Flute* and the *Red Hat* have recently been expressed (e.g. by Van Thienen and Swillens); these seem quite unjustifiable. Had these pictures not existed no insight could have imagined them, at least until the radiograph of the Mauritshuis head showed that the style of the *Red Hat* had played an essential part in Vermeer's method. The *Red Hat* is certainly the picture which appeared at the Lafontaine sale in 1822.

(121) We may imagine a picture in which a writer or a recipient sits at a table, a composition of which the Washington and Frick pictures are repetitive variants and Dublin's an oblique and abstracted sophistication. Perhaps Metsu's pictures in the Wallace Collection and at Montpellier (H. de G. 186, 24) and the *Duet* in the National Gallery (no. 838) reflect it more directly; we may suppose that it belonged to the time of *The Concert* and *The Music Lesson* or a little earlier. Certainly it is from this phase, rather than from *The Love Letter* that Metsu's letter pictures in Dublin derive. A pair of pendants may be involved; we might expect to discover the beautiful detail of a sealed envelope held in a woman's hand. Unfortunately conjecture has proved itself the least useful of methods in the study of Vermeer. The uneasy arrangement of the Frick *Letter* may indicate that the theme had not received the continuous attention which was given, for example, to that of the *Lady Standing at the Virginals*.

(122) The linear definition of the lady's profile, no less than the strangely mobile expression of the servant, may be remarked. Moreover, the most convincing elements of the picture reproduce details of more typical works, notably the letter picture in the Washington National Gallery. The modelling of the ermine trimming where it turns away from the light is however precisely in the manner of the *Girl with a Flute*; possibly Vermeer was responsible for the picture, whatever transformation it may have undergone since it left his hands. The note of red which is seen between the edges of the jacket is of interest; it also appears in the *Gold Weigher*. This scarlet band, curving roundly over the belly, is discovered rather as is the Venetian red of the under-skirts of the *Maidservant* and the lady in *The Music Lesson* and the same colour in the painter's stockings in the *Studio*. They are indications of a warm-toned though impersonal core within the cool forms of these pictures.

(123) It is sometimes suggested that the panel has been cut. Even in its original form the arrangement can hardly have been characteristic of the painter. More of the table behind which the girl is placed may well have been visible. But it is difficult to imagine any addition to the curious hand which is seen to the left. (The nearest parallel to its form, and its linear definition, is in the similar details of the Frick *Letter*.) It is rarely possible to be sure that Vermeer's pictures are uncut; only the Kenwood *Guitar Player* seems to remain unlined on its original stretcher. Losses in course of time may well explain the present slight descrepancy between the dimensions of *The Music Lesson* and *The Concert*.

Plate 58
THE ASTRONOMER
$19\frac{3}{4} \times 17\frac{3}{4}$ in. (502 × 451 mm) Signed and dated 1668

Louvre, Paris[124]

Plates 59 and 61

THE GEOGRAPHER

$20\frac{7}{8} \times 18\frac{1}{4}$ in. (530 × 464 mm) Signed

Städel Institute, Frankfurt am Main

The later of Vermeer's two dated pictures was painted twelve years after *The Procuress* and seven years before his death. Half a dozen other pictures seem to show some affinity of style with this work, *The Astronomer* and its pendant; together they form the group which provides the last entries in the present list. Such evidence as we have of the order in which they were painted is far from conclusive. Some of them have a broad and sombre richness not quite characteristic of any earlier period; *The Astronomer* and *The Geographer* share the quality with the picture in which appears the boldest of all the painter's uses of his optical substitute for modelling, the *Red Hat*. In all three the light and shade on massive draperies make a sumptuous pattern liberated from form. The incomparable simplicity of the Dublin *Letter* approaches a similar effect. Further light on this phase may be gathered from the emergence of a decorative elaboration, the quality which appears in the bright enamelling of *The Love Letter*.[125] It is most marked in the *Allegory* and the pictures at the National Gallery, London.

These last stand rather apart from the rest of the group. In tonality and subject they represent one of those reversions which occur at intervals in the painter's development to provide a warning to the student. The *Allegory* and the *Guitar Player* evidently belong to the same phase and the styles, as well as the costumes, of the letter pictures at Amsterdam and Dublin can date from little earlier. These six are the only pictures which there is a reason to place after *The Astronomer* and *The Geographer* in the last seven years of Vermeer's life. Yet we have no sense that his activity was cut short: his style reached its natural conclusion. Vermeer's widow is recorded to have stated that he earned little in his final years. In the context the fact would be easy to understand.

In *The Astronomer* and *The Geographer* [126] Vermeer dealt, according to his habit, with subjects which were the common property of his school. In particular he can hardly have been aware of the numerous pictures of the scholars in their studies by Rembrandt and his circle. Among these it is interesting to notice that the nearest precedent for the arrangement of Vermeer's versions is

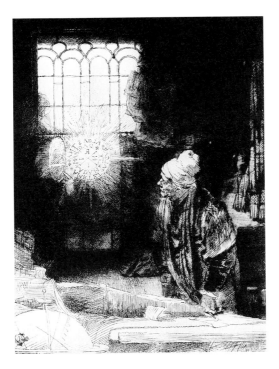

again to be found in drawings by Nicolaes Maes.[127] It does not appear that even these figures can be credited to Vermeer's invention. The Geographer takes up precisely the position of Faust in Rembrandt's famous etching[128] and in the resemblance we can for once trace Vermeer's radiant and contemplative moment to its source. Vermeer, whose cast of thought was as unlike Rembrandt's as that of any painter, yet must have owed some of the very foundation of it, some of the intensity with which the problems of figure painting presented themselves to him, to the example with which the master confronted his generation. But it is perhaps significant that only here, as the tension of his own pressing problem and the limitations it imposed at last relax, do we discover a direct link to confirm the relationship which his whole development suggests.

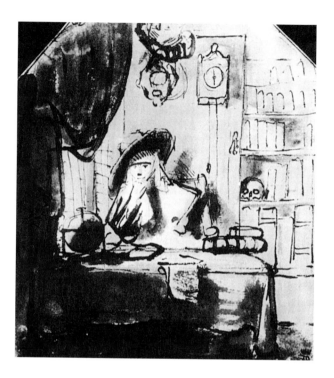

NICOLAES MAES
A Scholar in his Study
(*Drawing. G. Abrams Collection, Newton, Massachusetts*)

We have a curious evidence of the currency of Vermeer's motif in *The Astronomer*. Another *Astronomer*, now in an American collection,[129] which has sometimes been ascribed to him, shows the scholar in a very similar pose. Of the signature on which the attribution rests only the first letters are said to be visible—the name of Metsu would be among those which the general appearance of the work would call to mind[130]—but elsewhere the picture bears the trace of an inscription of greater interest, a date of 1665. Whether or not it can be credited this version of unknown authorship is evidently the older of the two. Possibly both derive from a common source; material to complete the history of the motif has disappeared.

(124) An important notice of Vermeer by C. Josi (1821), which has lately been remarked, includes a reference to *The Geographer*: 'J' achetai chez Nijman en 1798, *l'homme tenant un compas à la main* pour 7 louis, et, à la vente de M. de Lange, en 1803, il fut porté à 36 louis.' (S. Sulzberger in *Kunsthistorische Mededelingen*, 1948, 3.) An addition may also be made to the history of *The Astronomer* as hitherto recorded; it appeared in the Leopold Double sale, Paris, 30.v.1881, no. 17. The dated inscription of the *Geographer* is a later addition. (The form given to the artist's name follows that which is used in the signature of the *Studio*.) The original signature is that on the panel of the cabinet. The date of *The Astronomer* was once read (by De Groot and Vanzype) as 1673.

(125) A striking feature of *The Love Letter* is the bold flourish of the brush which renders the veining of the marble floor; a similar quality appears in numerous details of the *Allegory*. In a drawing the decorative bravura of these curling strokes would call to mind the name of Caspar Netscher (compare the embellishment of map and carpet in the drawing of a letter writer in the British Museum for pictures painted in 1664-5). There are other affinities between Vermeer and Netscher who was seven years his junior (see the *Lacemaker* in the Wallace Collection, dated 1664); it may be that they were in contact in the middle sixties. The tendency of Dutch taste, in which Netscher was a leader, towards elegant elaboration, however damaging to the consistency of Vermeer's style, liberated certain unexpected qualities of his talent. The marbling of the virginals of the *Lady Seated* in the National Gallery has the kind of life which a Sung painter might discover in the leaves of bamboo.

(126) There is no reason to think that the later inscription on the *Geographer* was intended to mislead: the picture may well have been painted in 1669. This, as his biographer points out (Dobell, *Antony van Leeuwenhoek...*, London, 1932), was the year in which Van Leeuwenhoek qualified as a surveyor. In Verkolje's portrait (dated 1686) Van Leeuwenhoek appears with a globe and compasses similar to those which Vermeer, like other painters, incorporates here; both globes, apparently precisely alike, are of the celestial type. Vermeer's sitter, as Dobell observes, is not recognizably like Van Leeuwenhoek. Nor is he, given the lapse of time between the pictures, particularly unlike him.

(127) G. Abrams Collection, Newton, Massachusetts.

(128) H. 260, c. 1650-5.

(129) De Young Museum, San Francisco, formerly E. John Magnin collection. The resemblance is again in reverse.

(130) It is curious how many confusions in the study of Dutch genre painting have arisen from the number of artists whose names share the same initial. The signature on the *Diana* was once altered to that of Maes, while that on *The Music Lesson* was long supposed to belong to F. van Mieris. In the discussion of the De Young picture the writer is indebted to conversations with Dr. De Vries.

Plates 62 and 63
THE LOVE LETTER
$18\frac{1}{4} \times 15\frac{3}{4}$ in. (464 × 400 mm) Signed
Rijksmuseum, Amsterdam

In his mature work Vermeer does not often deal with action and anecdote. Yet they are not entirely abandoned; however foreign to his temperament the habitual subjects of genre painters, the lively movement of the world retains a fascination that is not easily forgotten. Once at least, as Vermeer's development passes its climacteric, the suspended animation of his pictures is near to being let loose. But the release is characteristically ambiguous. The movement of life is recorded with a startling brilliance and then the whole perverse complexity of the painter's artifice is invoked to soften and deflect its impact. Among the pictures that we have none is more elaborately or more curiously calculated than the little *Love Letter*.

Vermeer's facility rarely extended to inventiveness. In the consideration of his later works the paradox becomes clear that even when their evident refinement was already exercising a considerable influence on his associates Vermeer himself remained dependent on earlier pictures for the fundamentals of his motifs. One of his lost pictures seems to have contained a vista into another room[131] but whatever has disappeared it is doubtful if it could more than slightly modify the impression that Pieter de Hooch was primarily responsible for evolving the device of the doorway as a genre motif. It is a feature of his typical compositions throughout his career. But the form in which it appears in *The Love Letter* is a highly personal one. There are examples of similar compositions in the painting of Delft which can hardly have been due to the influence of Vermeer's picture;[132] possibly the device was in general use. It is nevertheless clear that the paradoxical quality of this arrangement is Vermeer's own. De Hooch himself imitated it in a picture of an elegant incident involving a parrot.[133]

(131) No. 5 in the 1696 auction; the catalogue entry has been quoted.

(132) A door, of which neither hinge nor top or bottom is visible frames the scene in *Refusing the Glass*, which has the appearance of belonging to an earlier phase of the school. (A picture in the Louvre called *The Slippers* which has a curious history has been ingeniously identified by Plietsch as a pastiche of about 1800.) The casually disposed slippers in *The Love Letter* have as a genre motif a history extending back to Jan van Eyck.

(133) H. de G. 118; Rotterdam, 1935, no. 53. The date of 1668 which the canvas now bears can hardly be original; the picture is evidently a work of the seventies.

Plates 64–67 and 70
A LADY WRITING A LETTER WITH HER MAID
28 × 23¼ in. (711 × 591 mm) Signed
National Gallery of Ireland, Dublin

Plates 68–69
A LADY WITH A GUITAR
19⅜ × 16¾ in. (502 × 425 mm) Signed
Iveagh Bequest, Kenwood, London

Plates 71–73
ALLEGORY OF THE NEW TESTAMENT
44½ × 34¾ in. (1130 × 883 mm)
Metropolitan Museum of Art, New York

The work in the Dublin collection appears to be the latest rendering of a household incident that we have. It is Vermeer's final evasion of the requirements of convential genre painting, the culmination of the process which begins with the Dresden *Letter Reader*. There is no invention, no anecdote, no petty description. These figures, the maid, descendant of all the immobile standing figures in earlier pictures, and the lady, close relative of *The Lacemaker*, are the elementary, universal figures of Vermeer's world with which we are familiar. The painter is at ease with them. In their presence he is able at last to look upon the scene without fear of the unpredictable claims of life.

Nothing is recorded but the unarguable, unfeeling fall of light; in style the picture is an extreme example of Vermeer's method. Nowhere in his work is the incidence of light and shadow mapped out with less regard for conventions of descriptive line, of continuity, of understanding. Indeed the mosaic of tones discovers patterns of its own, designs of symbolic facets in which we can discern the possibility of that abstracted artificiality which is reached in the pictures in the National Gallery. It has sometimes been thought that the Dublin *Letter* belongs to the period of the pearl pictures but the positive, inflexible method here is that of a different phase, a more complete control of the material, a classic hardening of thought. There are technical indications, the firmness of accent, the points of light which lie so flatly upon broadly modelled forms, to confirm that the picture should be placed among the works which concluded, so far as we know, the painter's career.[134]

[153]

The Dublin *Letter*, with the *Studio* and the Kenwood *Guitar Player*, may be very probably identified with pictures known to have been at the disposal of the painter's widow after his death; it is clear enough that all three were among the later works.[135] Details derived from both the *Studio* and the *Letter* appear together in an interesting work by Jacob Ochtervelt.[136] Other reflections of the Dublin picture may perhaps be detected in a lady who sits writing at her table at one side of a picture by Pieter de Hooch painted in the early seventies and in a work by P. Janssens Ellinga.[137]

In the *Allegory of the Faith*, where the influence of the ubiquitous Cesare Ripa makes its appearance,[138] Vermeer's subject matter, otherwise so circumscribed, takes an unexpected turn. There was a precedent for it among the works of his associates in the religous paintings of Gabriel Metsu, and the devotional gesture of Metsu's *Woman at an Altar* is indeed not unlike that of the lady here.[139] Of all Vermeer's motifs the massive and abandoned pose of this figure is furthest from his characteristic style. It was not his invention. Similar positions appear in more congruous circumstances in the work of Jan Steen, notably the famous *Twelfth Night* at Kassel.[140] The motif was evidently current in Haarlem; Jan Miense Molenaer made use of it in the fifties.[141] It was reflected in the work of Metsu at the same time.[142] No doubt it was drawn from some Italianate baroque source.

The *Allegory* is not the most memorable of Vermeer's works. The still-life in the foreground may none the less have had some influence on the imagery of his circle.[143] We have two other pictures from the time of the *Allegory*; in one of them the tapestry hanging, similarly painted, still lies in the same folds. These, the pair in London, are more modest and more characteristic; fortunately they convey more of the character of the painter's thought in this last phase.

(134) The paint has been somewhat flattened by relining; otherwise the picture is in good condition although there has evidently been some interference with the eye on the darker side of the lady's head.

(135) If reliance can be placed, as seems possible, on the testimony of de Monconys, who found no pictures in the painter's studio when he visited him in 1663 (see n. 2), these works must have been painted after that date. De Vries has pursued this reasoning in connection with the *Studio*; its application to the Dublin *Letter* appears to have escaped him. Van Thienen discounts the French traveller's evidence.

(136) Landesmuseum, Bonn.

(137) De Hooch: Errera collection, Brussels (*K. der K.* p. 95). P. Janssens Ellinga: Schloss collection, Paris (*Gazette des Beaux Arts*, Nov.-Dec. 1947, fig. 7).

(138) A. J. Barnouw in *Oud Holland*, 1914, p. 50. A Dutch translation of the *Iconologia* was published in 1644.

(139) Formerly in the Schönborn-Buchheim collection, Vienna (H. de G. 21); the picture is doubtless itself an allegory of the Faith.

(140) Dated 1668 (H. de G. 494). Similar motifs appear in pictures in the Rijksmuseum (H. de G. 100), the National Gallery, London (H. de G. 855), and the Municipal Museum at The Hague (H. de G. 828). An unkind picture in the Rijksmuseum of some children teaching a cat to dance is related. All these have thin and Italianate folds of satin drapery of the kind which figures in the *Allegory* alone among Vermeer's works.

(141) *Feast in an Inn* (Mauritshuis), dated 1653.

(142) Distantly related figures appear in the picture of an artist painting Erato (see n. 108) and in the *Music Party* in the Metropolitan Museum (dated 1659). The figure of Justice which Erasmus Quellinus included in the ceiling decoration of Amsterdam town hall in about 1656, though rather similar, can hardly have been the origin of the motif. Some such picture as the *Cleopatra* by Andrea Vaccaro (Prado) is a more probable source.

(143) Compare the serpent crushed under a square tombstone in front of the Muse Urania in the frontispiece to the ninth book of Van Hoogstraten's *Hooge Schoole der Schilderkonst* (1678; in the printed etching the detail is reversed).

Plates 74, 76 and 78
A LADY STANDING AT THE VIRGINALS
20 × 18 in. (508 × 457 mm) Signed
National Gallery, London[144]

Plates 75, 77 and 79
A LADY SEATED AT THE VIRGINALS
$20\frac{1}{4}$ × 18 in. (514 × 457 mm) Signed
National Gallery, London

These last pictures, polished addenda to the painter's history, summarize his development and even convey a little more of his meaning than has emerged before. They are characteristic of his method; we discover again the curious duality of his attitude to his material. One motif is entirely traditional. The

[155]

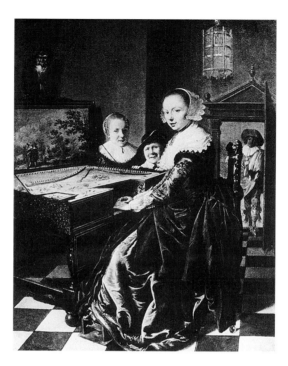

JAN MIENSE MOLENAER
A Lady at the Virginals
(Rijksmuseum, Amsterdam)

seated lady follows closely a familiar design, the design which had served Dirk
Hals and provided Jan Miense Molenaer with the pattern for his portrait of
Judith Leyster and her children,[145] a design deriving directly from the icono-
graphy of St. Cecilia.[146] The other, the motif of the standing lady, is Vermeer's
own. It is the last that we see of his typical invention, the final evolution of the
theme of the Dresden *Letter Reader.* There is matter for investigation in the
background of Vermeer's manner of painting women and these pictures pro-
vide a fruitful ground of inquiry. There is hardly a detail in either of them
which does not contribute to the pervading emotional meaning which each
conveys. From this standpoint these works may contain surprises for those who

[156]

have become used to references in the literature of the subject to the dull pictures in the London National Gallery.[147]

Théophile Thoré, who owned both these pictures, called Vermeer the Sphinx. The reference is appropriate. But we may fancy that Vermeer's role in the story was less that of merciless examiner than victim, condemned to try at his peril to resolve a riddle, and to frame his own enigmatic answer to it.

(144) An addition may be made to the recorded appearances at auction of the *Lady Standing at the Virginals*. It figured under the painter's name in the E. W. Lake sale (1st day, Christie's, II. vii. 1845, no. 5), from the collection of E. Solly.

(145) Rijksmuseum. Cf. the picture by Dou at Dulwich (before 1665).

(146) The current imagery of Saint Cecilia at the keyboard was of two dominant types. One, the older, presented the Saint looking down in strict profile, in the form on which Vermeer drew for the seated figure in *The Concert*. The other, showing her looking up in the moment of illumination, often surrounded by angels (as in the Honthorst school-piece at Kassel), provided the design of Molenaer's picture, where the angels are transformed into children, and of the *Lady Seated at the Virginals*. The alternative types appear, for example, in precisely the forms which Vermeer adoped, in two studies drawn on a single sheet by Mola (in the collection of the Earl of Leicester).

(147) W. R. Valentiner, *op. cit.*, p. 311.

Plate 80
A LADY SEATED AT THE VIRGINALS
$9\frac{5}{8} \times 7\frac{3}{4}$ in. (244 × 197 mm)
Baron Rolin Collection, Brussels (in 1970)

HEAD OF A GIRL
Radiograph of central part

INDEX OF ARTISTS

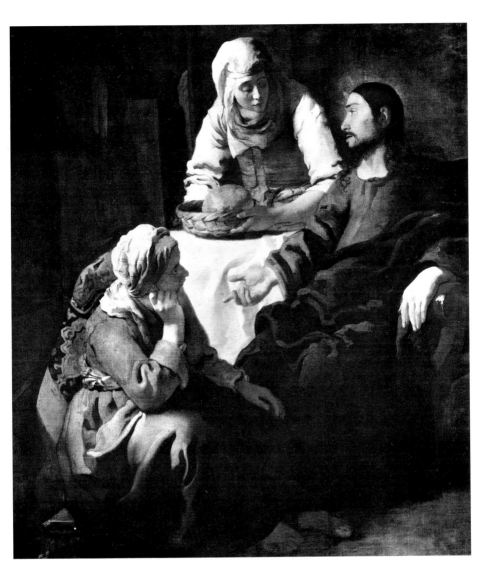

1. CHRIST IN THE HOUSE OF MARTHA AND MARY

Edinburgh

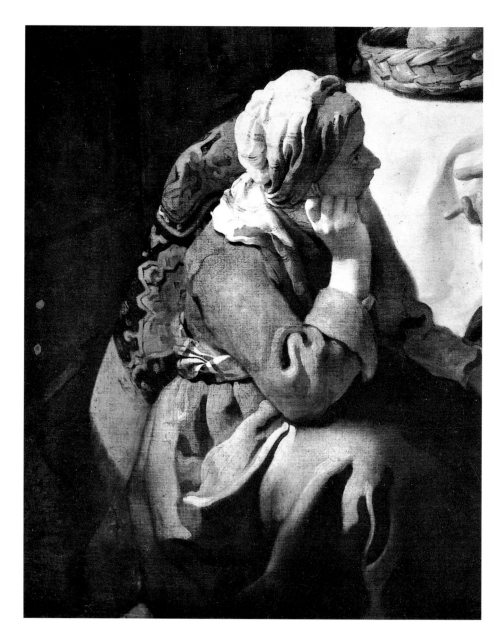

2. CHRIST IN THE HOUSE OF MARTHA AND MARY
Detail

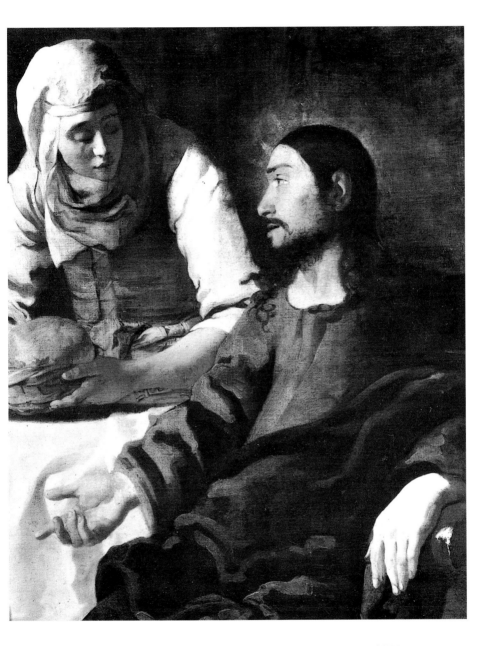

3. CHRIST IN THE HOUSE OF MARTHA AND MARY
Detail

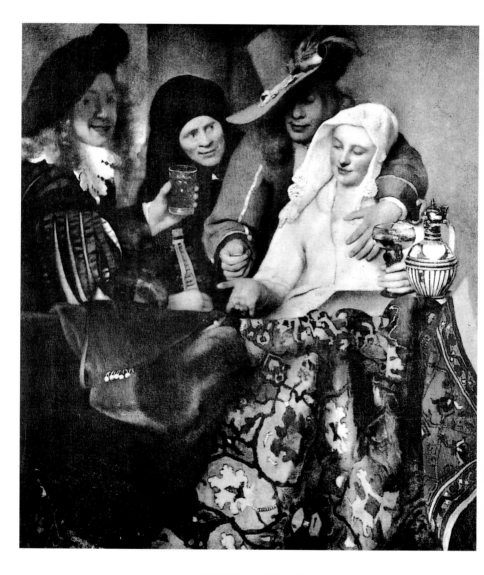

4. THE PROCURESS

Dresden

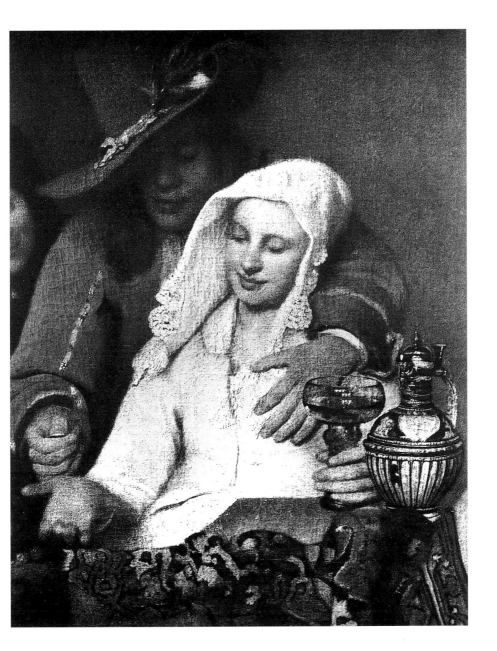

5. THE PROCURESS
Detail

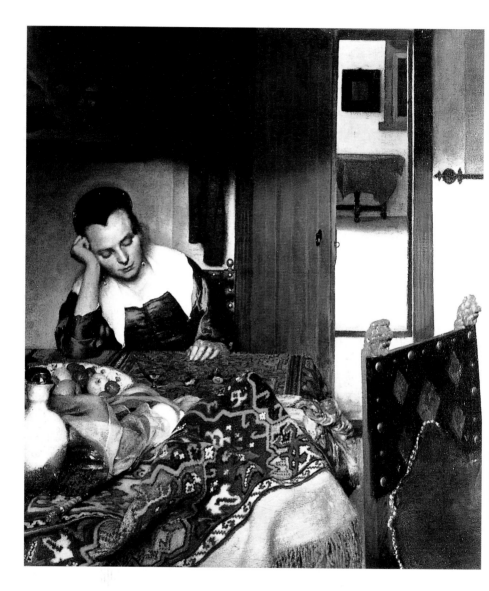

6. A GIRL ASLEEP
New York

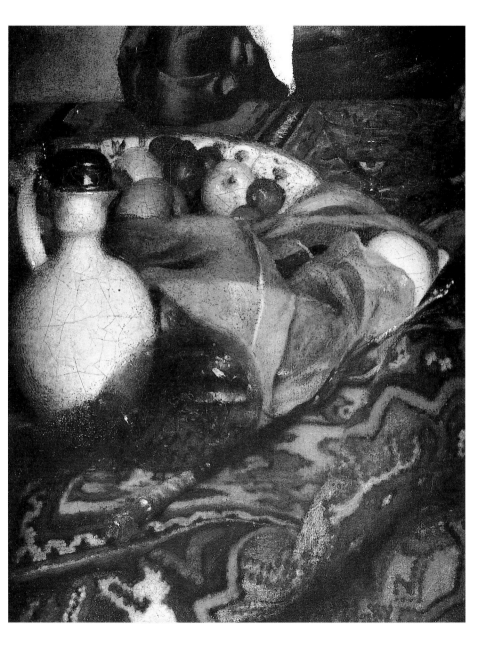

7. A GIRL ASLEEP
Detail

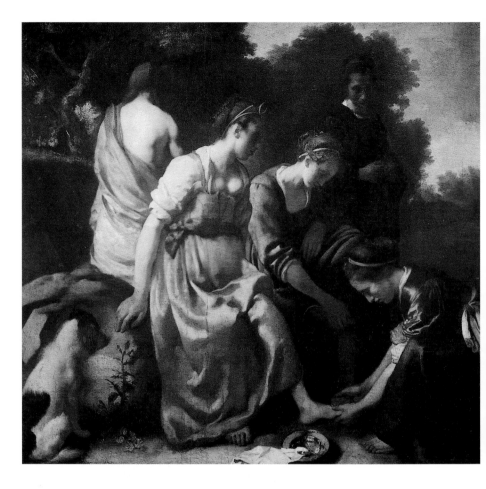

8. DIANA AND HER COMPANIONS
The Hague

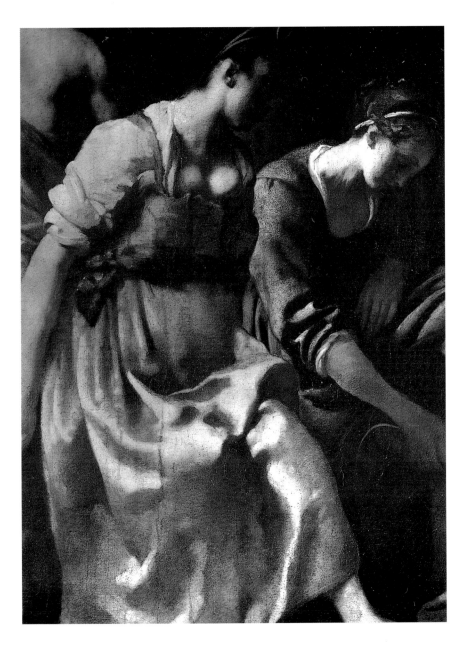

9. DIANA AND HER COMPANIONS
Detail

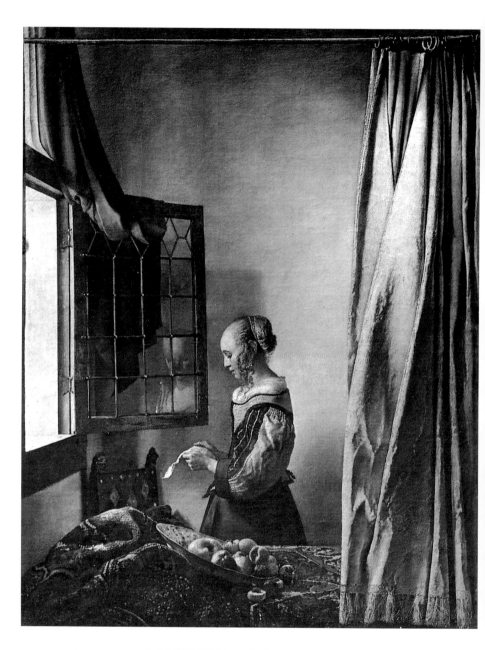

10. A LADY READING AT THE WINDOW

Dresden

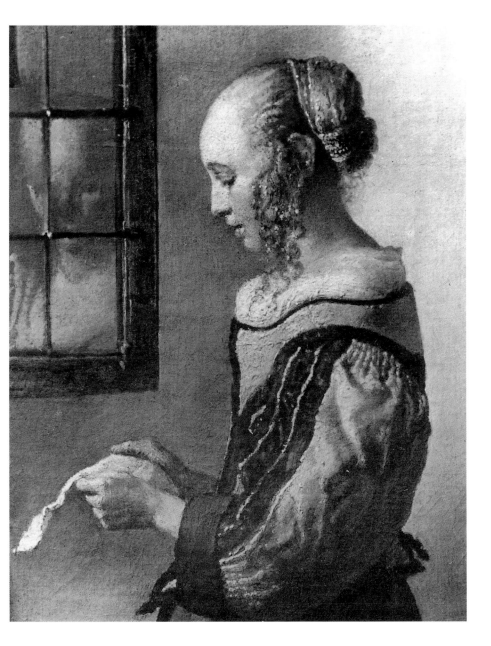

11. A LADY READING AT THE WINDOW
Detail

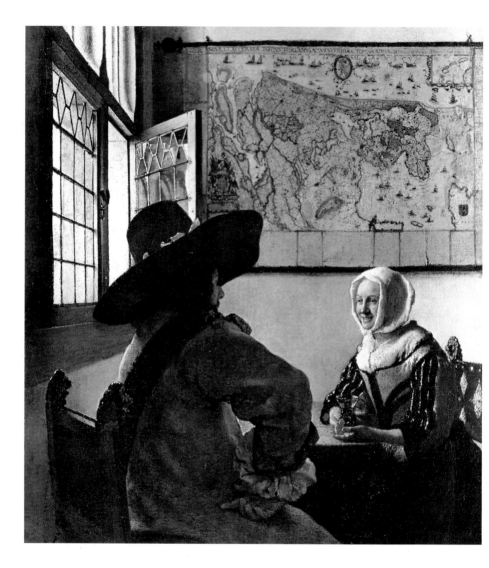

12. SOLDIER AND LAUGHING GIRL
New York

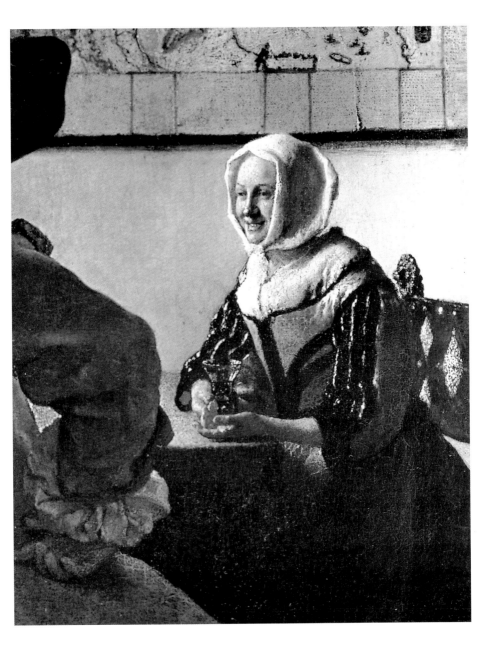

13. SOLDIER AND LAUGHING GIRL

Detail

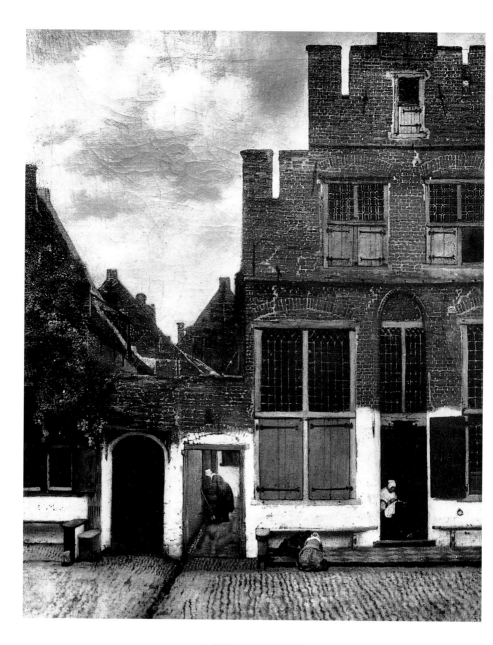

14. A STREET IN DELFT
Amsterdam

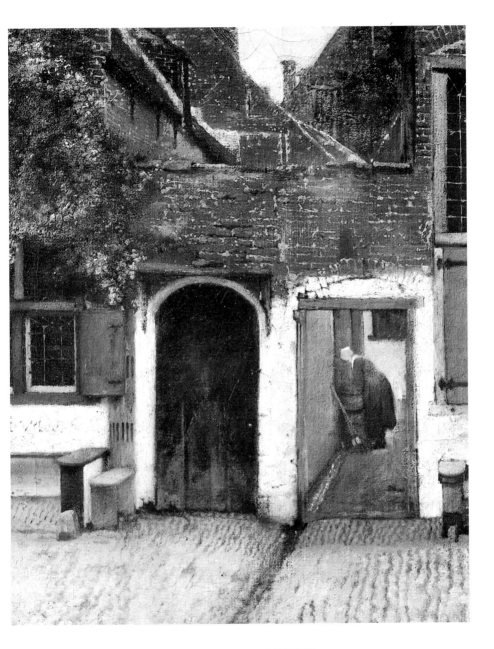

15. A STREET IN DELFT

Detail

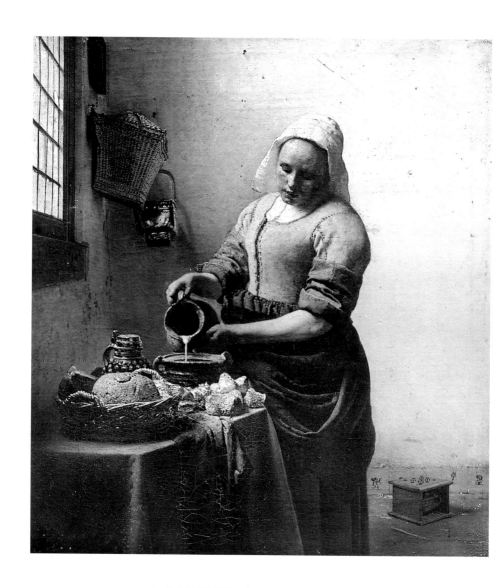

16. A MAIDSERVANT POURING MILK

Amsterdam

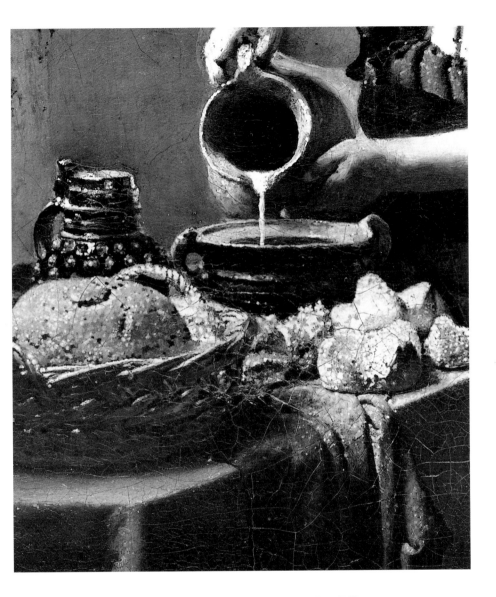

17. A MAIDSERVANT POURING MILK
Detail

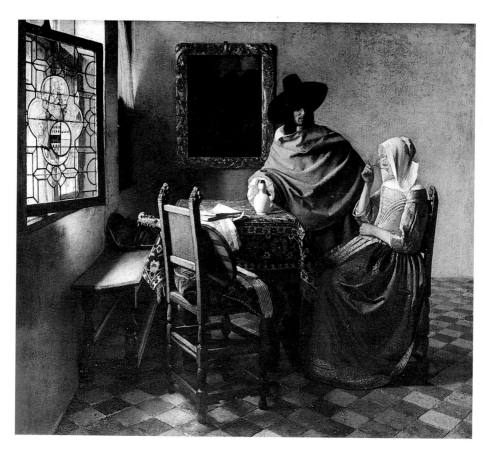

18. A GIRL DRINKING WITH A GENTLEMAN

Berlin

19. A GIRL DRINKING WITH A GENTLEMAN
Detail

20. A GIRL DRINKING WITH A GENTLEMAN
Detail

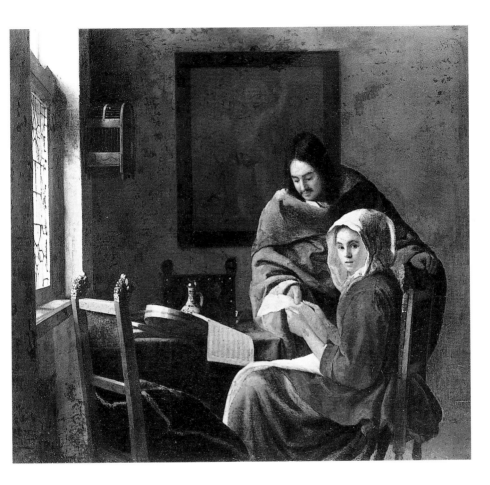

21. A GIRL INTERRUPTED AT MUSIC
New York

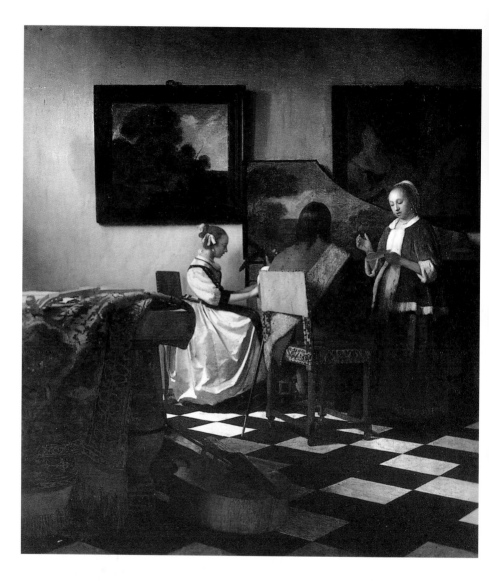

22. THE CONCERT
Boston
(Present location unknown)

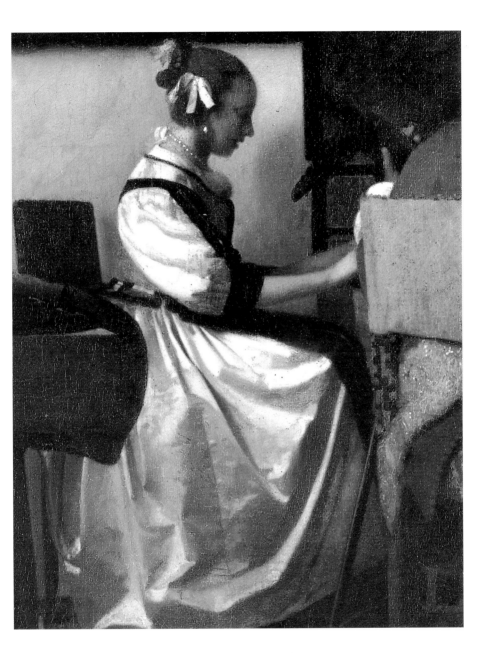

23. THE CONCERT
Detail

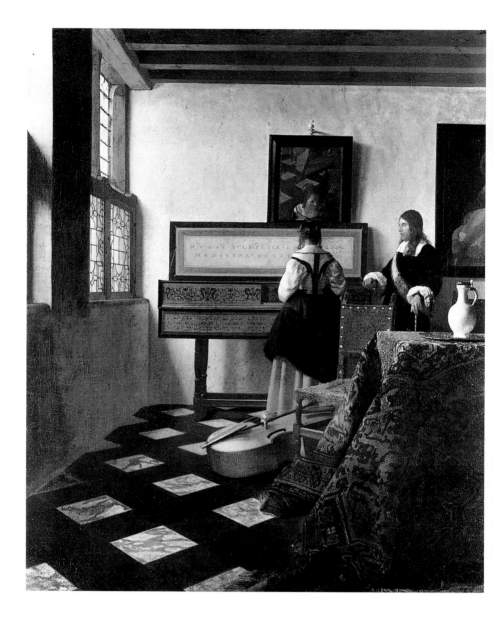

24. THE MUSIC LESSON
Buckingham Palace

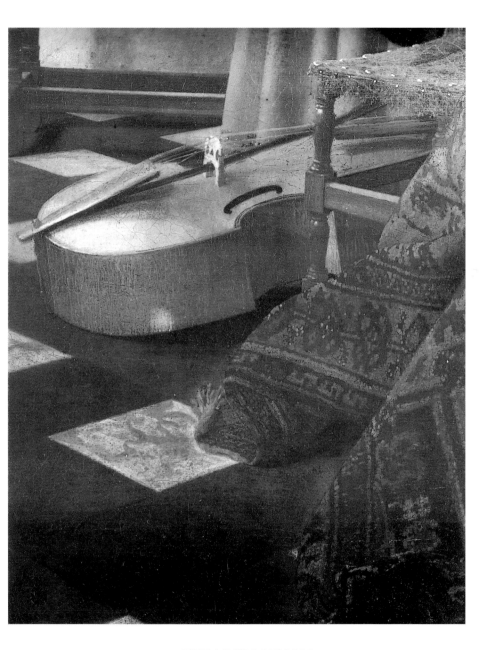

25. THE MUSIC LESSON
Detail

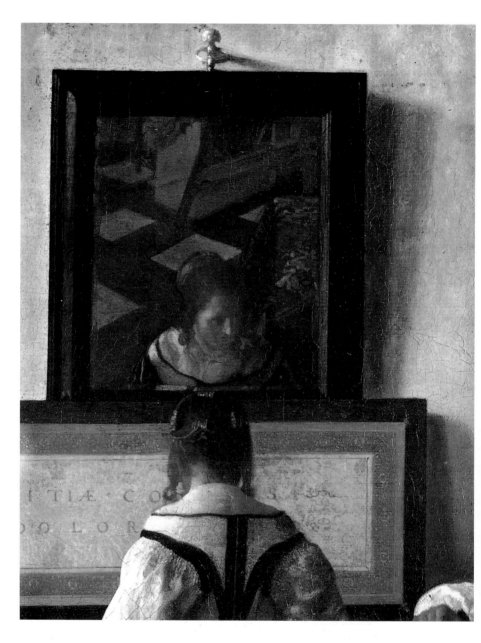

26. THE MUSIC LESSON
Detail

27. THE MUSIC LESSON
Detail

28. THE MUSIC LESSON
Detail

29. THE MUSIC LESSON
Detail

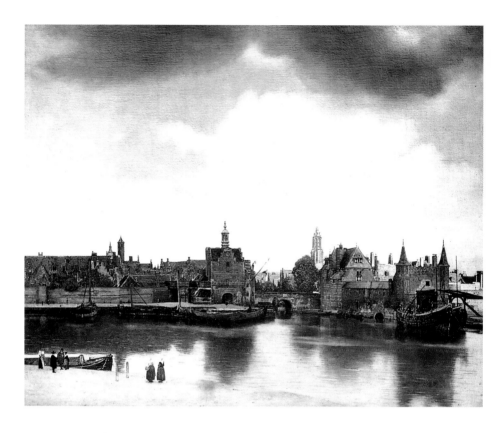

30. VIEW OF DELFT
The Hague

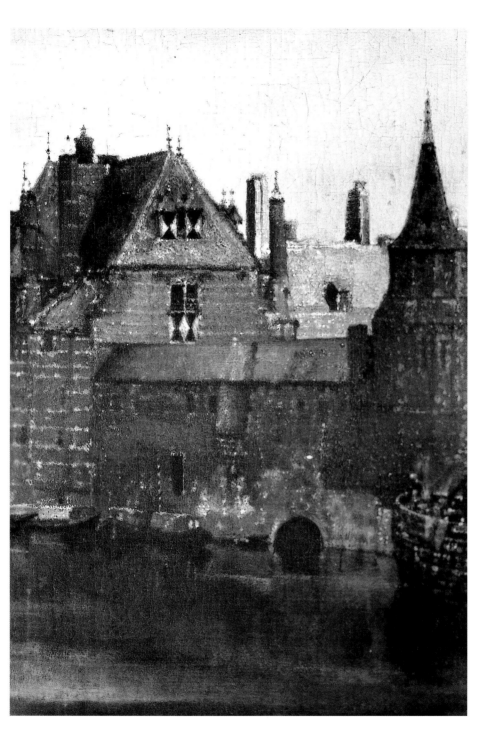

31. VIEW OF DELFT

Detail

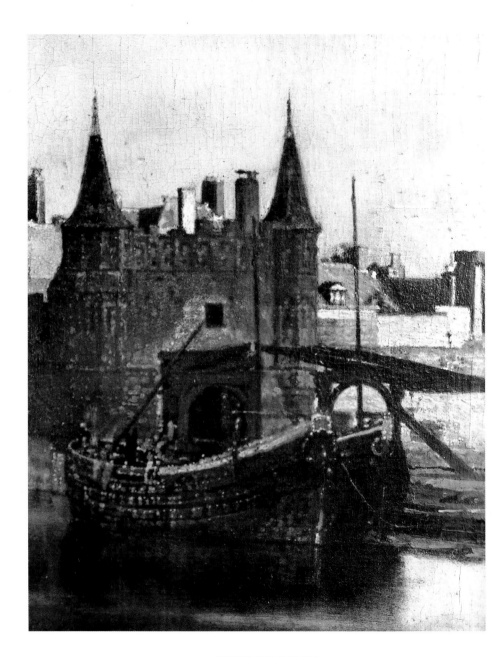

32. VIEW OF DELFT
Detail

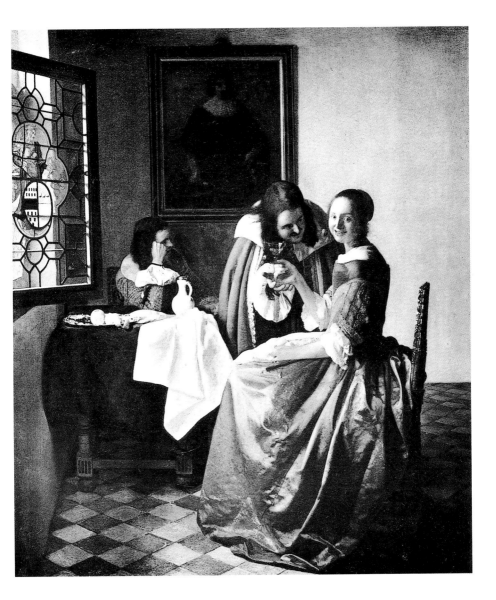

33. A COUPLE WITH A WINE GLASS

Brunswick

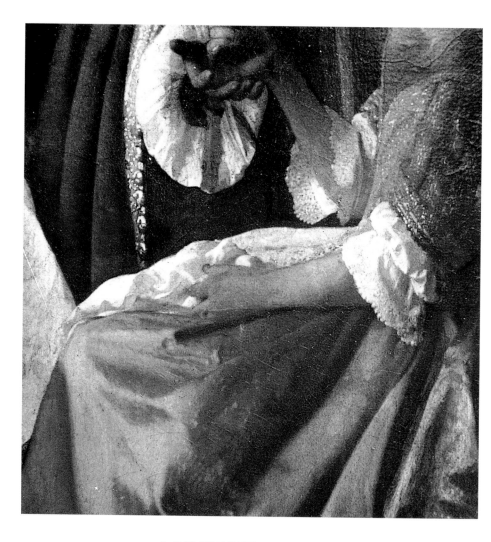

34. A COUPLE WITH A WINE GLASS
Detail

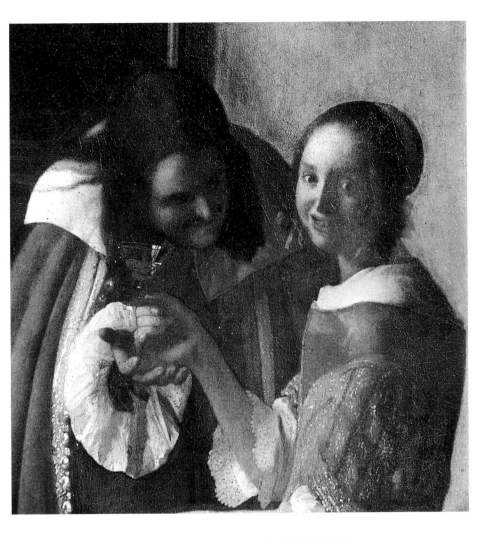

35. A COUPLE WITH A WINE GLASS
Detail

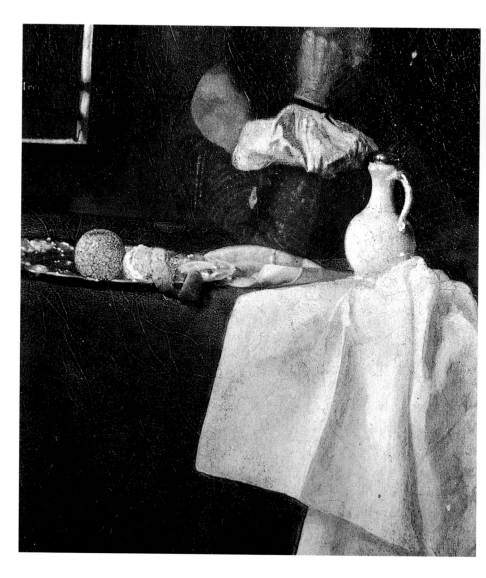

36. A COUPLE WITH A WINE GLASS
Detail

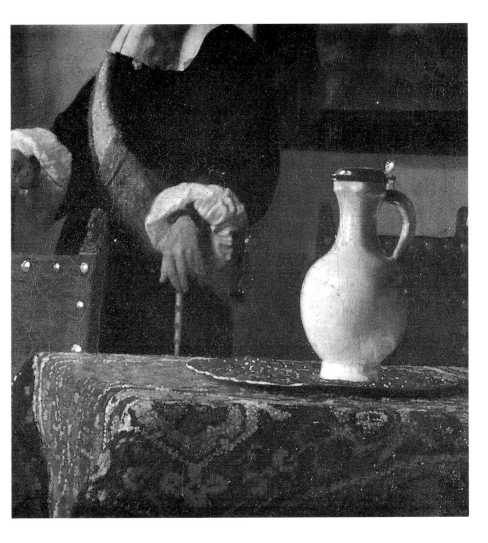

37. THE MUSIC LESSON
Detail

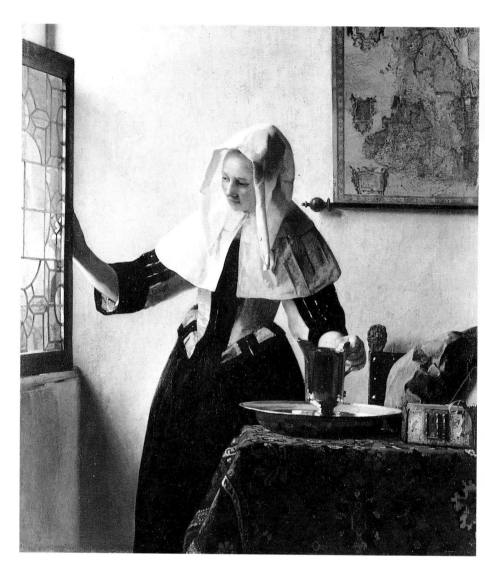

38. A YOUNG WOMAN WITH A WATER JUG

New York

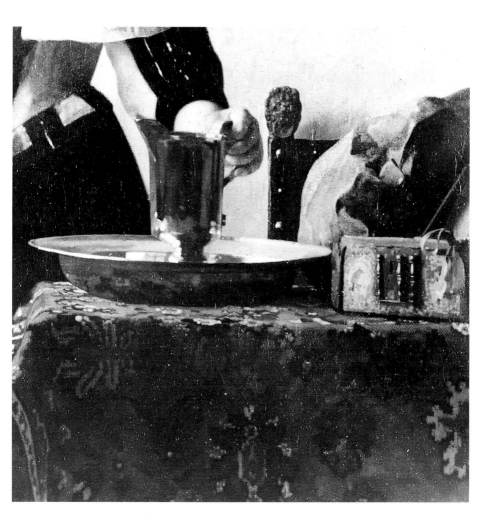

39. A YOUNG WOMAN WITH A WATER JUG
Detail

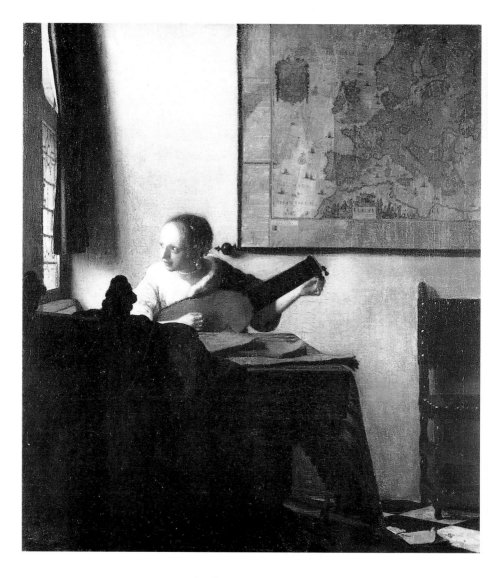

40. A LADY WITH A LUTE

New York

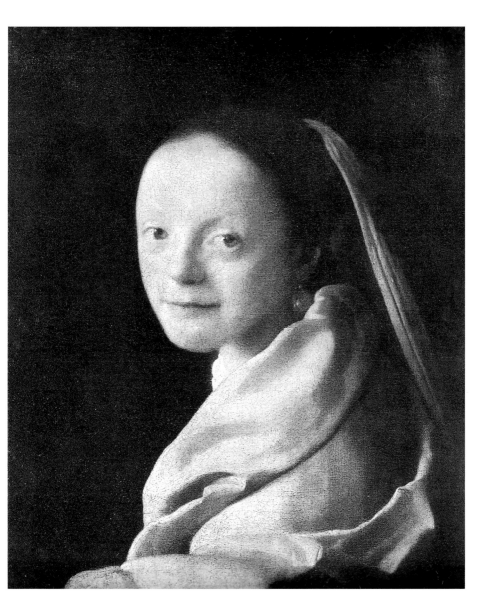

41. HEAD OF A YOUNG WOMAN
New York

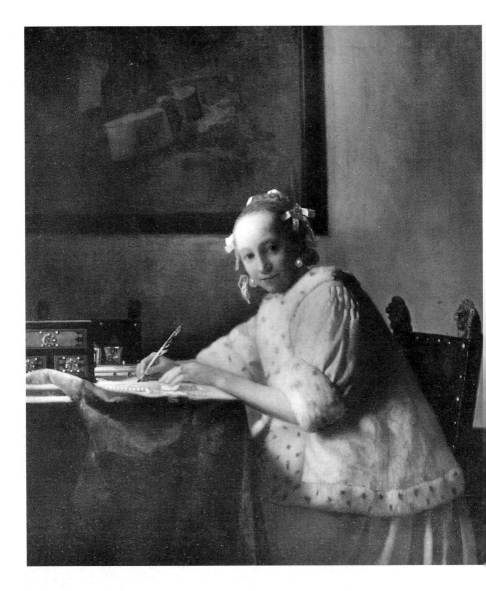

42. A LADY WRITING A LETTER
Washington

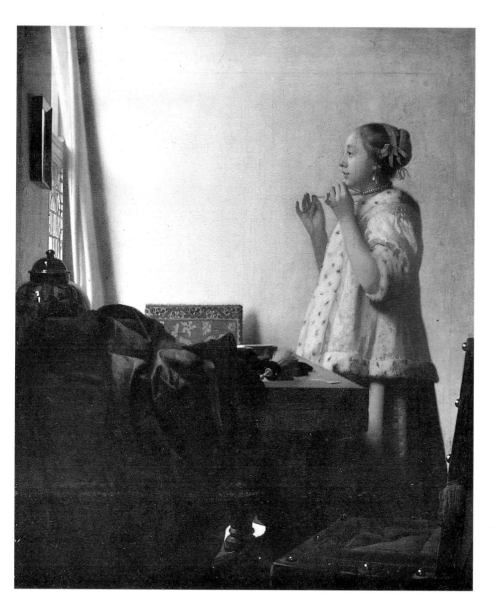

43. A YOUNG LADY WITH A NECKLACE
Berlin

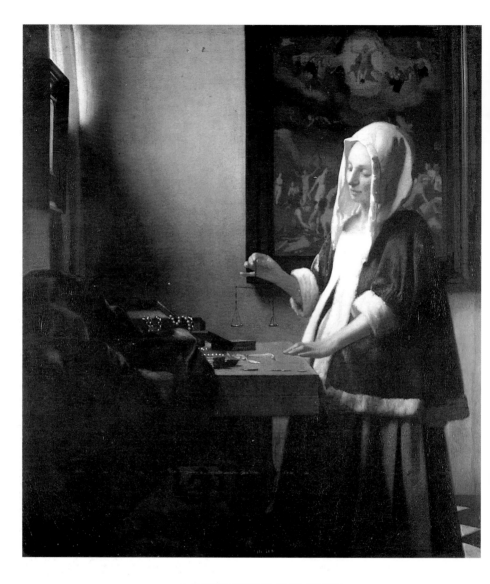

44. A LADY WEIGHING GOLD

Washington

45. A LADY WEIGHING GOLD
Detail

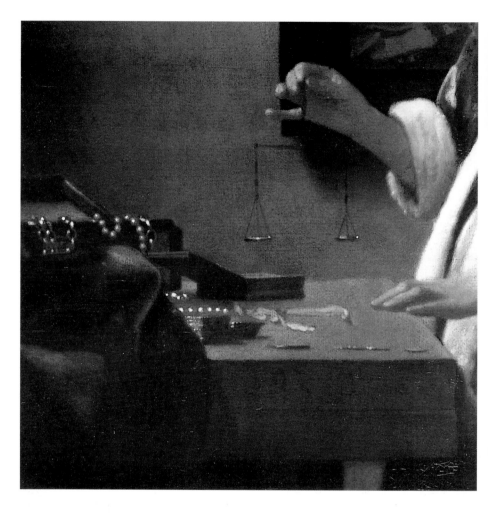

46. A LADY WEIGHING GOLD
Detail

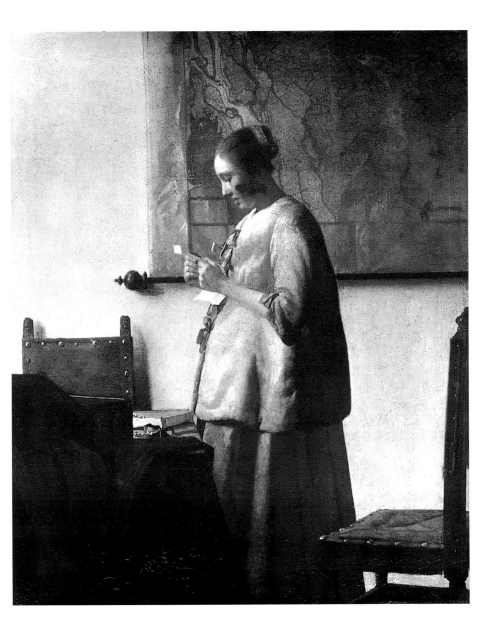

47. A WOMAN IN BLUE READING A LETTER
Amsterdam

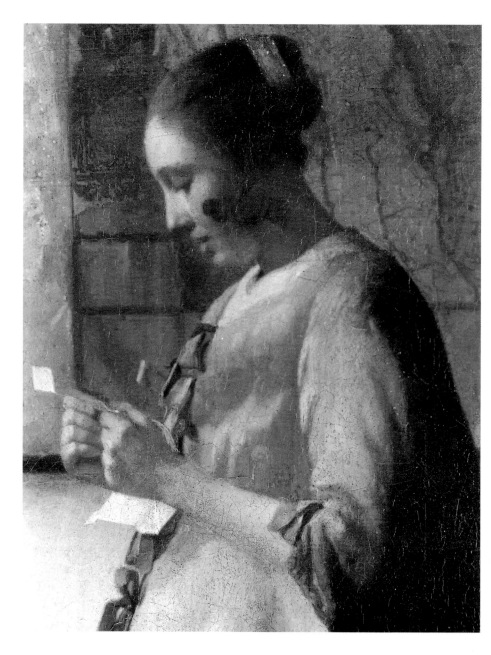

48. A WOMAN IN BLUE READING A LETTER
Detail

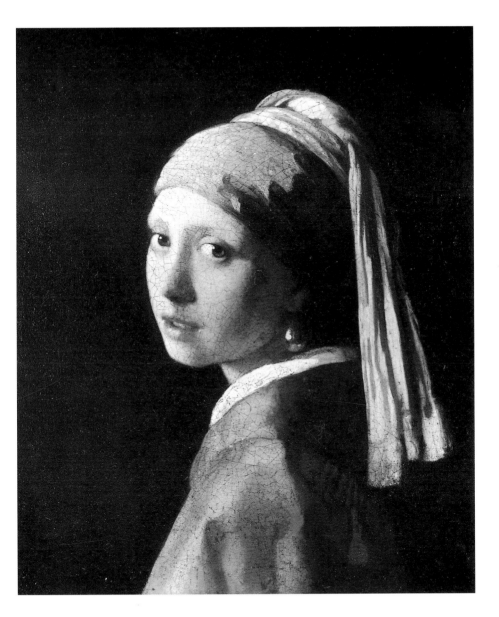

49. HEAD OF A GIRL
The Hague

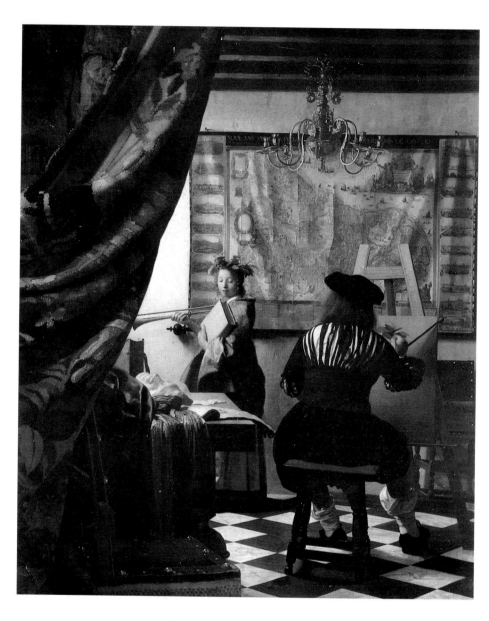

50. AN ARTIST IN HIS STUDIO
Vienna

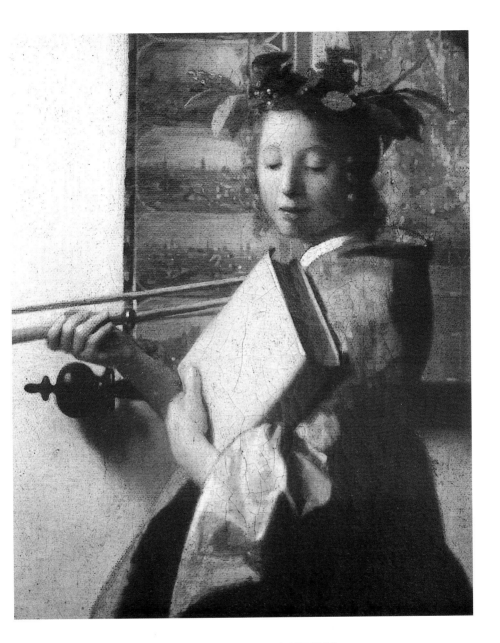

51. AN ARTIST IN HIS STUDIO
Detail

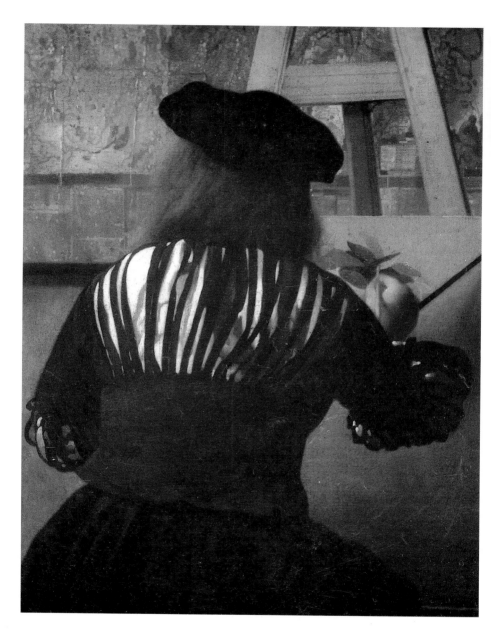

52. AN ARTIST IN HIS STUDIO
Detail

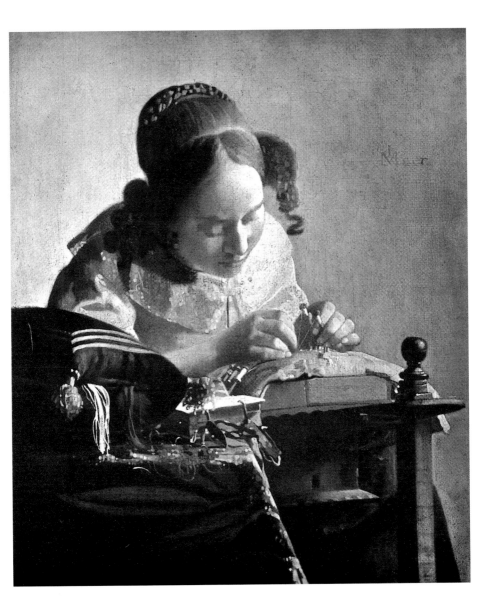

53. THE LACEMAKER
Paris

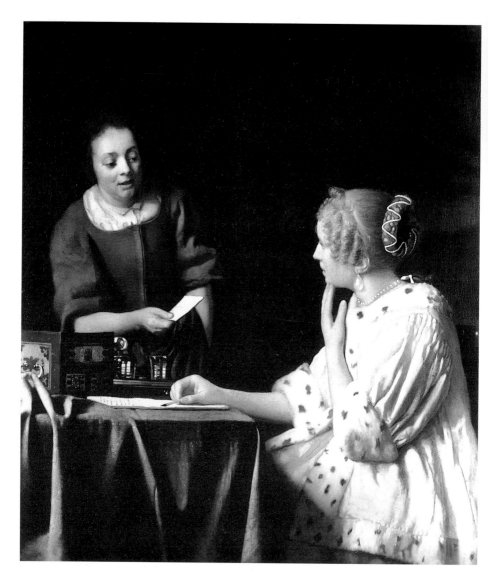

54. A LADY RECEIVING A LETTER FROM HER MAID
New York

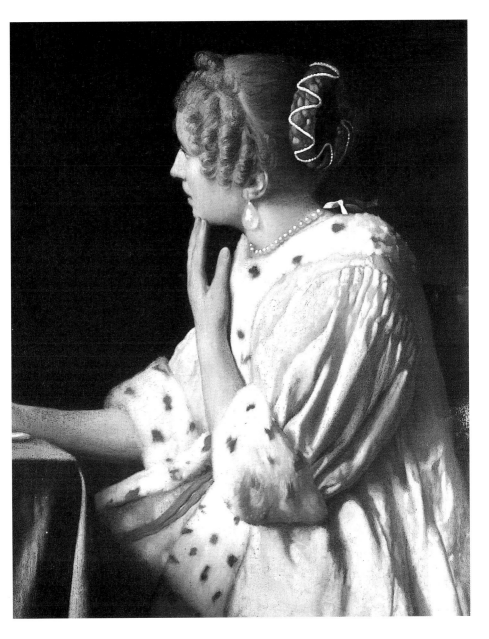

55. A LADY RECEIVING A LETTER FROM HER MAID
Detail

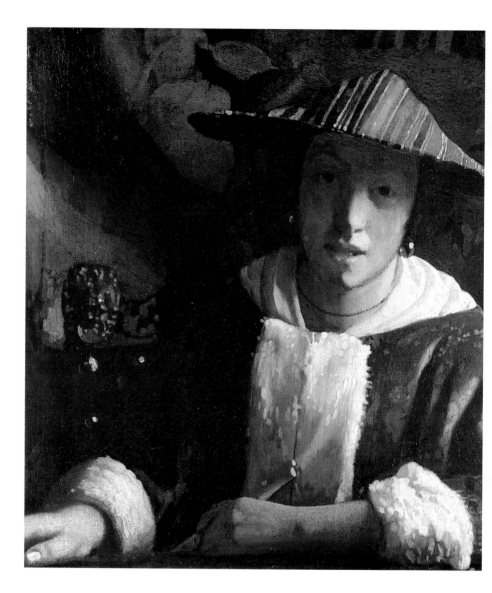

56. A GIRL WITH A FLUTE
Washington

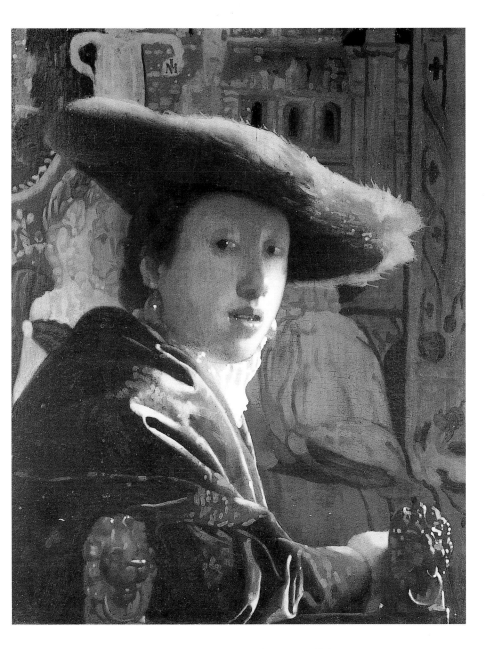

57. A GIRL WITH A RED HAT
Washington

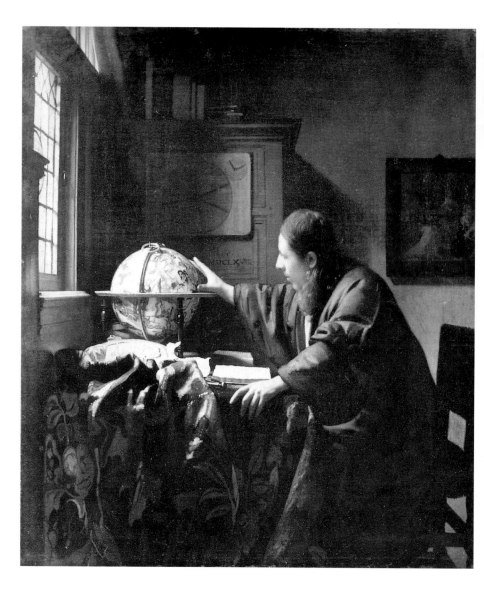

58. THE ASTRONOMER
Paris

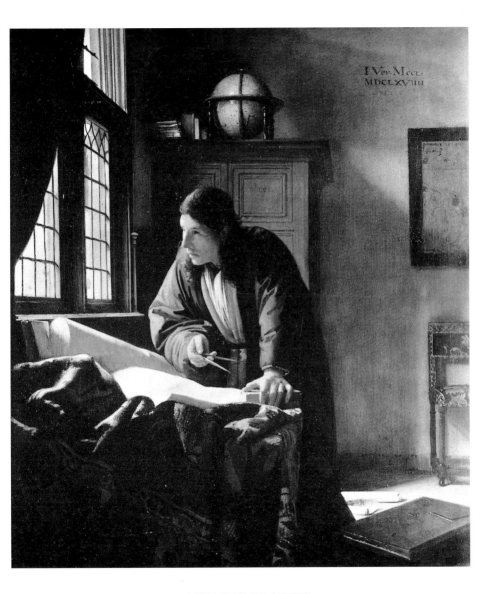

59. THE GEOGRAPHER

Frankfurt

60. AN ARTIST IN HIS STUDIO
Detail

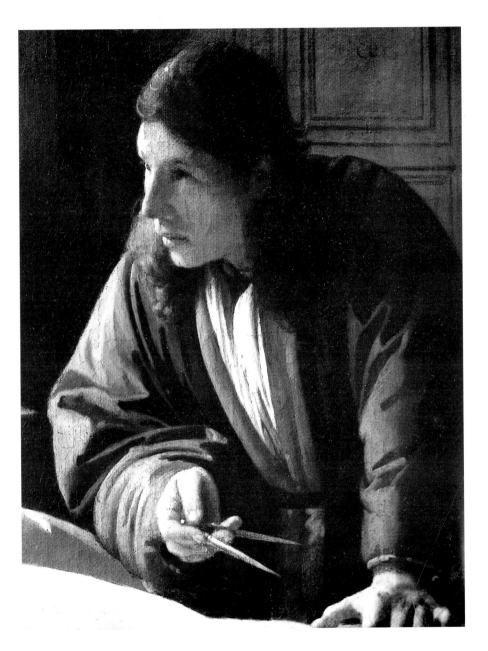

61. THE GEOGRAPHER

Detail

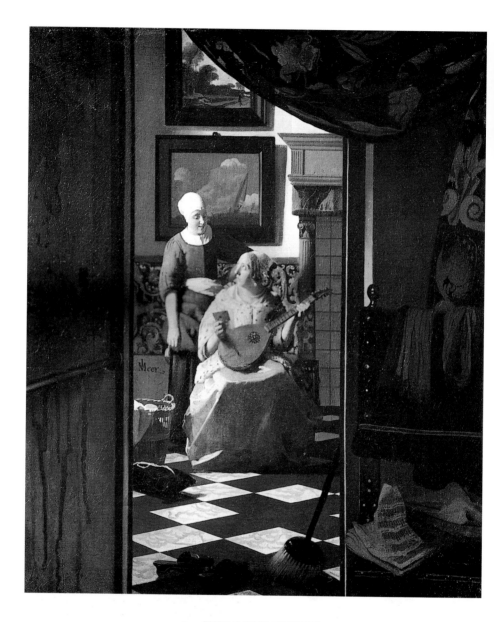

62. THE LOVE LETTER
Amsterdam

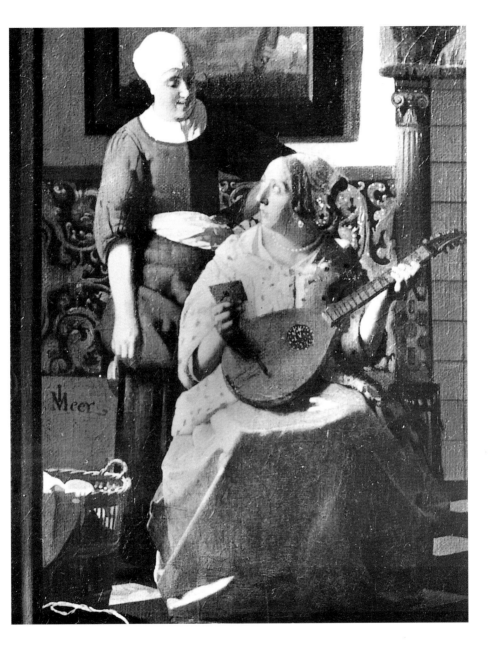

63. THE LOVE LETTER

Detail

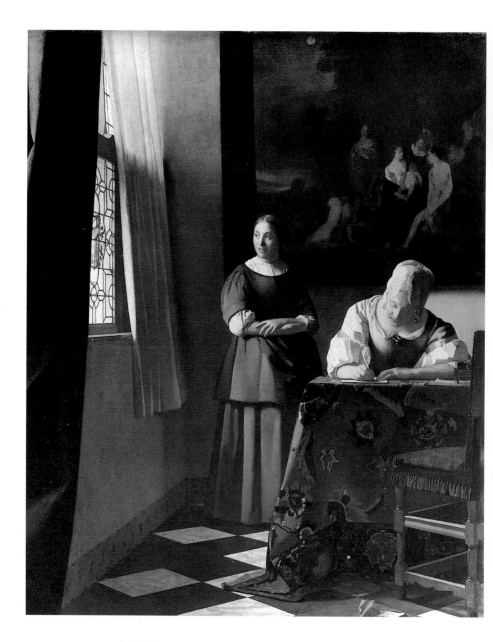

64. A LADY WRITING A LETTER WITH HER MAID
Dublin

65. A LADY WRITING A LETTER WITH HER MAID
Detail

66. A LADY WRITING A LETTER WITH HER MAID
Detail

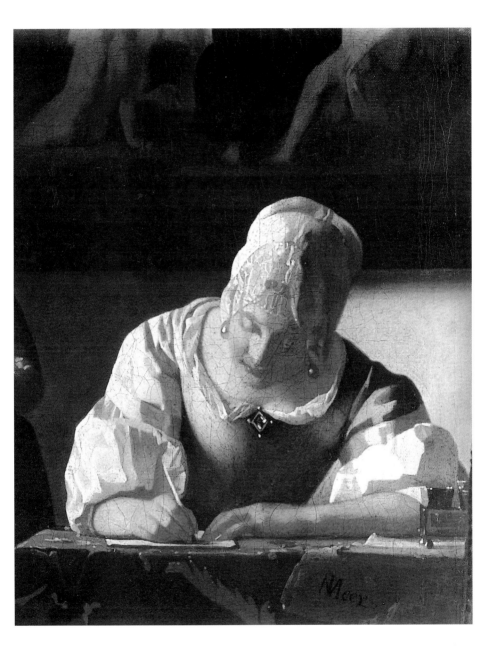

67. A LADY WRITING A LETTER WITH HER MAID
Detail

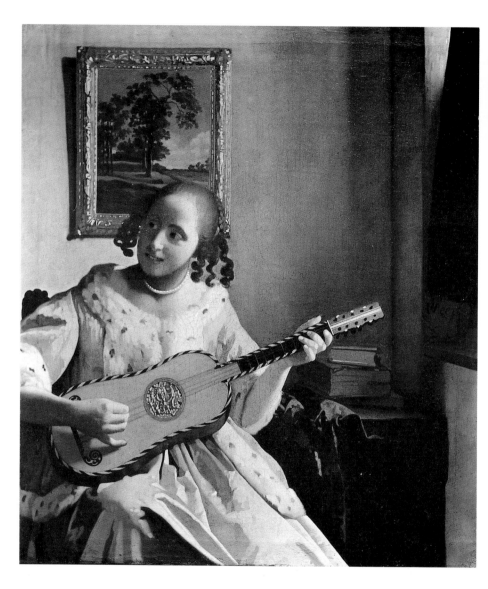

68. A LADY WITH A GUITAR

London

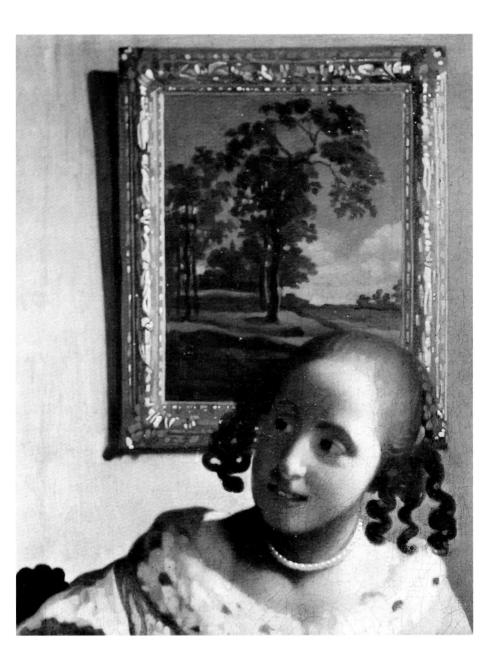

69. A LADY WITH A GUITAR
Detail

70. A LADY WRITING A LETTER WITH HER MAID

Detail

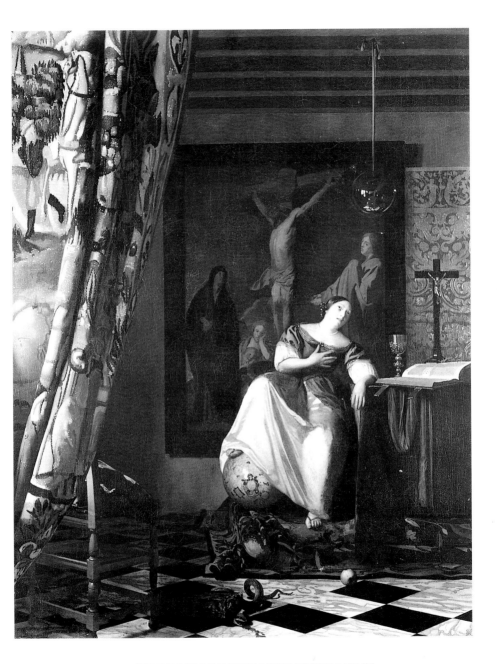

71. ALLEGORY OF THE NEW TESTAMENT
New York

72. ALLEGORY OF THE NEW TESTAMENT
Detail

73. ALLEGORY OF THE NEW TESTAMENT

Detail

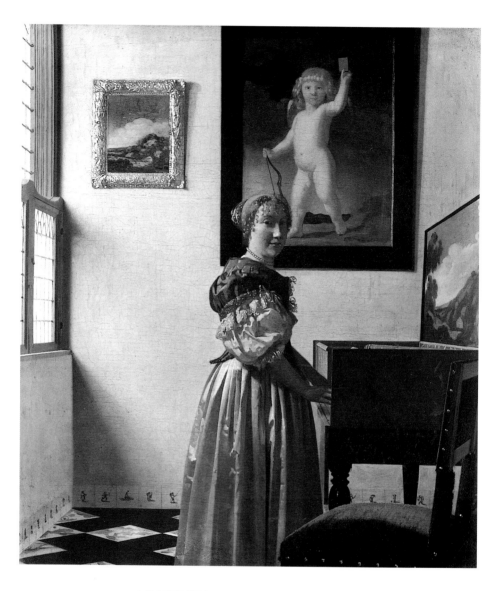

74. A LADY STANDING AT THE VIRGINALS

London

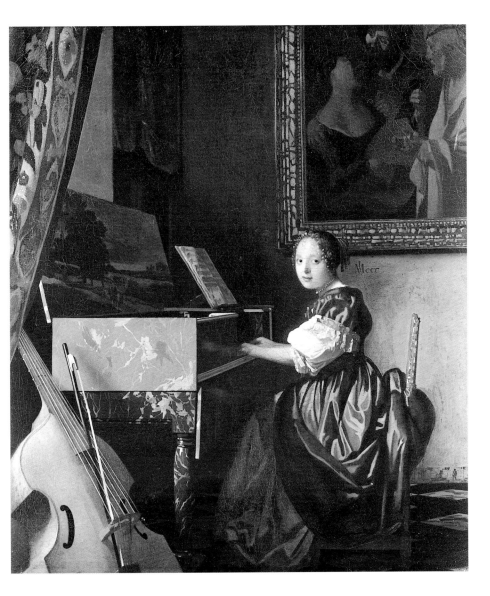

75. A LADY SEATED AT THE VIRGINALS
London

76. A LADY STANDING AT THE VIRGINALS
Detail

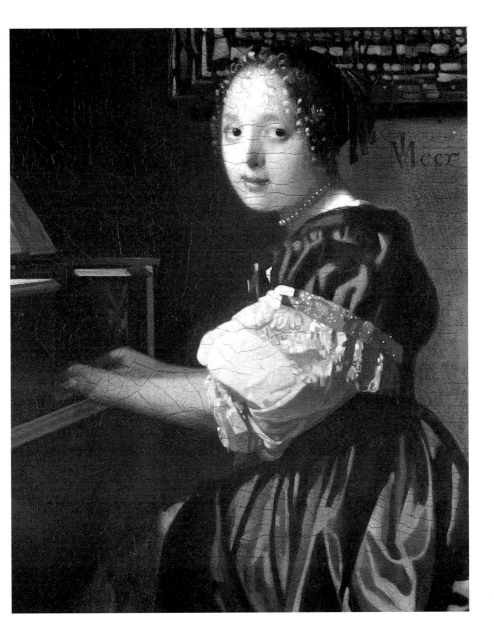

77. A LADY SEATED AT THE VIRGINALS
Detail

78. A LADY STANDING AT THE VIRGINALS
Detail

79. A LADY SEATED AT THE VIRGINALS
Detail

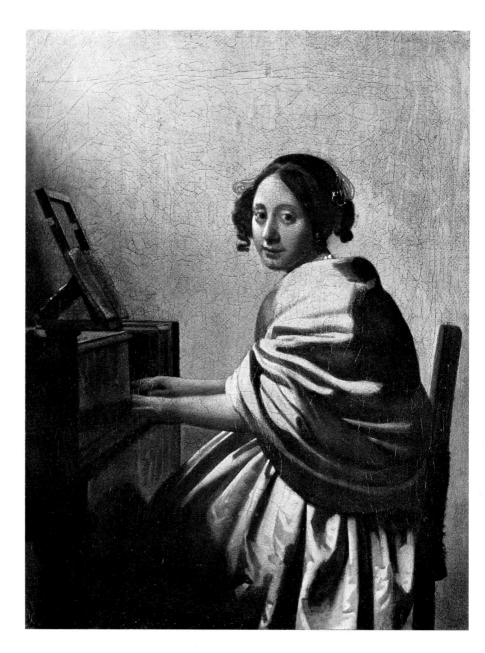

80. A LADY SEATED AT THE VIRGINALS
Baron Rolin Collection (in 1970)